PICTURES
—in—
THE POST

PICTURES
in
THE POST

The illustrated letters
of Sir Henry Thornhill
to his grandchildren

Edited by
MICHAEL BAKER

BANTAM PRESS

NEW YORK · LONDON · TORONTO · SYDNEY · AUCKLAND

TRANSWORLD PUBLISHERS LTD
61 – 63 Uxbridge Road, London W5 5SA

TRANSWORLD PUBLISHERS (AUSTRALIA) PTY LTD
15 – 23 Helles Avenue, Moorebank NSW 2170

TRANSWORLD PUBLISHERS (NZ) LTD
Cnr Moselle and Waipareira Aves,
Henderson, Auckland

Published 1987 by Bantam Press,
a division of Transworld Publishers Ltd
Copyright © Dealerpress Ltd 1987

Designed by Bob Searles
Production and typesetting by
A.D. Consultants, 25 Charlotte Street, London W1P 1HB
Reproduction by Pinepoint Ltd, London
Printed in Great Britain by W.S. Cowell Ltd, Ipswich

British Library Cataloguing in Publication Data
Thornhill, *Sir* Henry
Pictures in the post:
the illustrated letters of Sir Henry Thornhill
to his grandchildren.
1. Thornhill, *Sir* Henry 2. British in India – Biography
I. Title II. Baker, Michael
954.03'5'0924 DS480.45
ISBN 0593 01250X

Contents

BUCKINGHAM PALACE

In this busy, bustling age of ours when letter writing is no longer the fashion, it is touching to see a grandfather's devotion to his grandchildren finding expression in so many wonderfully illustrated letters, cards and envelopes.

But then Sir Henry was obviously a remarkable man, even in his own day. Despite a busy, eminent career he always seems to have found time for children, his affection for them extending beyond individual acts of kindness to a general concern for all children, in particular those suffering from misfortune or disability.

It is therefore, most fitting that Sir Henry's great-grandson, who rediscovered the letters after more than sixty years, should have decided that some of the proceeds from the sale of *Pictures in the Post* be donated to The Save the Children Fund.

I'm sure that this book will give pleasure to both the young, the slightly older, and the quite a bit older, and a great many more children will benefit from that enjoyment.

HRH The Princess Royal GCVO
President – The Save the Children Fund

INTRODUCTION

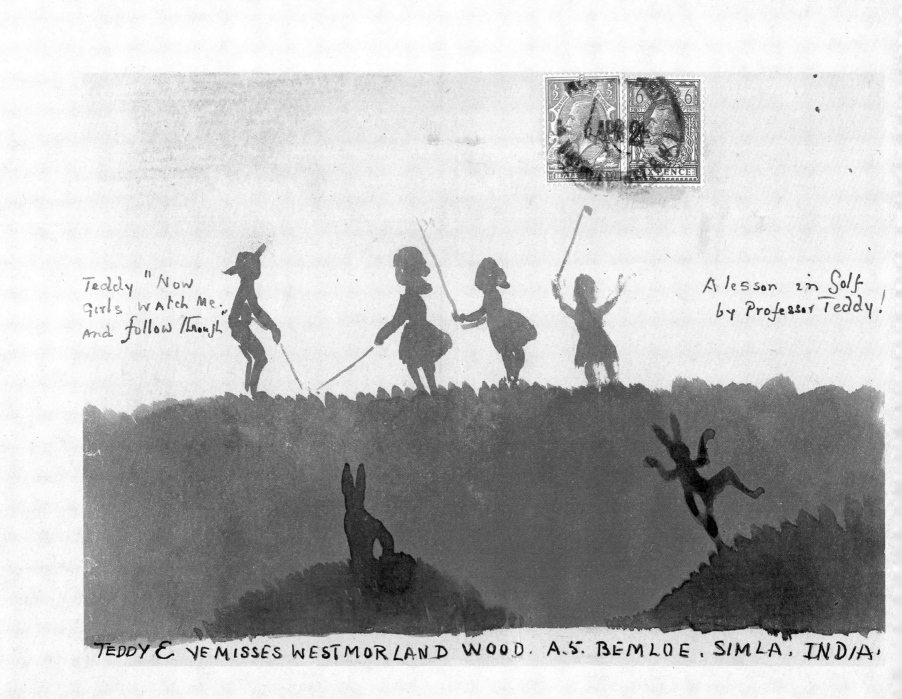

The letters and cards in this volume form a unique collection. They were mostly written between 1914 and 1923 and were later brought together and preserved in albums sewn into linen covers. All the items are part of a one-way correspondence (the replies have not survived) between Sir Henry Thornhill and his four young grandchildren. Sir Henry always signed himself 'Kaka' and wrote once a week with remarkable regularity. His practice was to send picture cards with captions as each child reached 18 months or so, then illustrated letters from about the age of five onwards. Some albums have not been found. Thus there are no cards to Margaret and no letters (with one exception) to Elizabeth. Nevertheless, the selection displayed here possesses an obvious coherence, not least in the way the correspondence grows as each succeeding grandchild appears on the scene. Ultimately Kaka's beautifully illustrated envelopes contained a colourful mixture of cards and letters to all four children at once.

Henry Beaufoy Thornhill was born in Agra, north India, in 1854. The Thornhill family's connections with India went back as far as 1726, when Henry's great-grandfather had run away from school in Hull and slipped aboard a sailing ship to the East. Henry's father Cudbert worked in the Bengal Civil Service, becoming Commissioner at Allahabad in the 1860s, and no less than four of his uncles also held administrative posts under the Raj. Three of these uncles, two of them with their wives and children, lost their lives in the violence of the Indian Mutiny in 1857. Before then the hazardous Indian climate had already claimed at least half a dozen Thornhill babies and would hasten the deaths of Henry's father (Cudbert died at the age of forty-eight), his twenty-four-year-old sister Ellen, his sister Henriette's husband and, later, two of Henry's own children. So the Thornhill stake in India in lives alone was considerable.

At the time of the Mutiny Henry was only three, surviving a long siege with his family in the fort at Agra. It was a colourful beginning to what proved to be a richly varied life. As a child he was chronically ill, suffering from a succession of nervous ailments, stammering, backache and insomnia, but he showed early on a natural resilience and irrepressible cheerfulness. After being sent to Eton, thousands of miles from home, he could write to his mother: 'How are you? How am I? Grand!!! Eton is the jolliest place I ever was at...!'

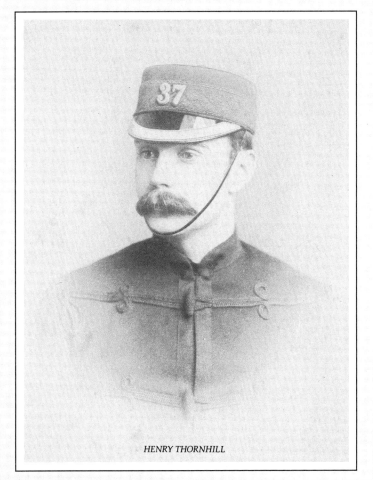

HENRY THORNHILL

At the age of nineteen he took up a commission in the Fifth Northumberland Fusiliers stationed at Bareilly (to the east of Delhi in the Himalayan foothills). Both his elder sisters had married officers in the Indian Army and Henry later transferred to an Indian regiment. He saw service in the Afghan War of 1878–80, won the Afghan Medal, and finally rose to the rank of lieutenant-colonel. In 1882 he married Margaret Wheeler, daughter of a lieutenant-general. Two sons, Cudbert and Charlie, and a daughter, Madge, were born to them in the course of the 1880s. During this time Henry retired from active soldiering and diverted his energies to civil administration, becoming Cantonment Magistrate first for the Andaman Islands, then for the North West Provinces, his father's old stamping ground.

Politically, his views appear to have been typical of an Indian Army man brought up in the generation after the Mutiny. He regarded reforming moves in British India towards a measure of democracy and 'Indianisation' as concessions to the 'seditious and disloyal native'. Ultimately such a policy was '*bound* to lose us the country – this is as certain as eggs are eggs', he wrote to his cousin Minnie in England.

A practical-minded man, Henry acquired considerable expertise in the field of drainage and sanitation and in 1902 he was appointed Special Magistrate and Executive Sanitation Officer in charge of the royal durbar to mark Edward VII's accession as Emperor of India. Nine years later he presided over another durbar, this time for George V, in the same capacity, erecting endless tents, building gardens and roads, and arranging for piped water to be brought to some 500,000 people – 'all this in a jungle place where partridges, hyaenas and jackals normally dwell', he commented. For these services Henry was made a Knight Commander of the Indian Empire, a title he had been offered earlier but turned down on the grounds that a knighthood would merely add ten per cent to his bills.

In 1911 his daughter Madge married Arthur Westmorland Wood, a naval

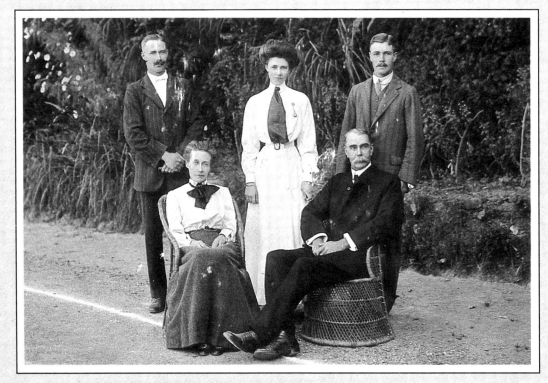

THE THORNHILLS IN INDIA – (Standing) CUD, MADGE, CHARLIE (Seated) MAGGIE, SIR HENRY

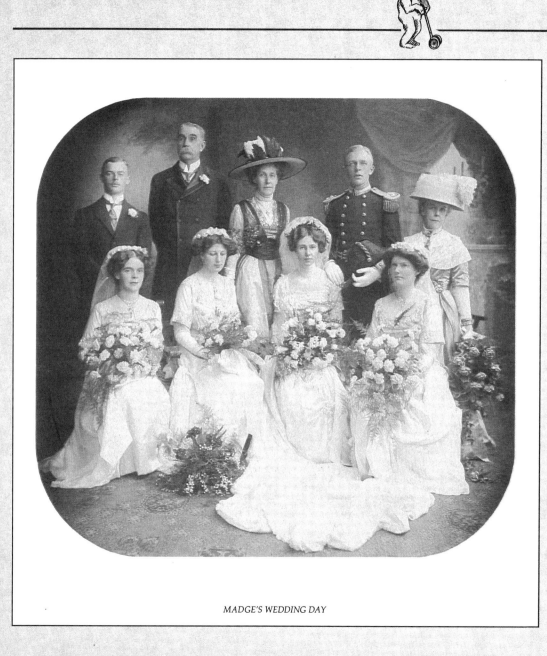

MADGE'S WEDDING DAY

gunnery officer who had been invalided out of the Service with severe gun-deafness and subsequently joined the Indian Audit and Accounts branch. The following year Sir Henry retired and took a prolonged holiday in Kashmir, in those days a region unknown to tourists. It was in Srinagar, on 30 July 1912, that his first grandchild, Teddy, was born. Shortly after, while staying at Chakrata, a hill-station lying between Simla and Mussoorie, baby Teddy's attempts to say 'grandpa' resulted in Sir Henry's nickname of 'Kaka'.

On the face of it, a distinguished old India hand seems an unlikely correspondent for four small children. Yet it is clear that Sir Henry had exceptional qualities, not to say a streak of eccentricity, which marked him out from the average soldier-sahib. Physically, he literally towered head and shoulders above most people, standing 6'8" in his socks. Even in old age one of his favourite party tricks was to swing his leg over high-backed chairs, to the amusement of children. Motor-cars presented him with more of a problem. In order to drive the Woods' tiny Austin Seven in the 1920s, he had to take out the front seat and steer from the back. He learned to drive when he was well over sixty, but enjoyed it immensely, taking a delight in just missing obstacles in his path and alarming everyone by going too fast.

CHARLIE, TEDDY, SIR HENRY AND CUD

His father Cudbert had been an accomplished water-colourist and Sir Henry seems always to have sketched and doodled. His early notebooks in the India Office Library are full of drawings of military life. Later sketches show that his expert knowledge of Indian languages and customs was in part learned by making detailed drawings of everything that he came across, from tools and artefacts to people and animals.

He was an ardent amateur naturalist with a remarkable knowledge of Indian birds. 'There was not one he could not tell you all about,' wrote a colleague, 'its ways, plumage, call, nesting habits.' He could even imitate the calls of birds. But all animal life fascinated him and he was rarely without a small menagerie of pets. At Bareilly he had a red monkey called Koko, which he had trained to fetch snipe on shooting expeditions. At one time he owned ten dogs. Another passionate interest was trees. 'I am mad on trees,' he once confessed, 'I have collected every sort of seed I came across for years.' During his posting to the Andamans he introduced new species of trees which subsequently became the islands' principal export in the form of commercial timber.

Sir Henry's wide knowledge of the Indian habitat had largely been acquired through numerous forays up-country in

pursuit of another favourite hobby, small-game shooting. He had a legendary reputation as a crack shot, especially with small-bore guns. 'To see [him] bringing down snipe and mallard in a high wind at incredible range, with his twenty-eight-bore, was something worth watching,' observed a contemporary, himself no slouch with a gun. In fact, Sir Henry could shoot with anything. At one time he took up a *gulel*, a two-stringed bow that fired round clay pellets. With this catapult-like weapon he became so accurate that he could down birds on the wing, even swifts – though he did not regard the latter as a legitimate target for hunters.

This good eye enabled him to excel at most sports. As a young man he had played cricket at Lord's for the M.C.C. and earned a reputation at Indian grounds for hitting sixes. Because of his height his cricket bats were specially made for him, with extra length and weight. At tennis he demonstrated he could beat top Wimbledon players. He was once considered good enough to play for England in both sports, and would probably have done so had he not pursued a career in India. In his retirement he became a skilful billiards player.

An old family story has it that, when his sister Ellen was dying of consumption,

Sir Henry (then 19) was the only person who could distract the attention of her two toddlers – by pretending to talk to them in Hindustani. There is no doubt he had a natural way with children. He knew instinctively what interested them and, as this book shows, went to enormous lengths to satisfy their curiosity and vitality. Children in distress always profoundly affected him and in

'KAKA' AND TEDDY

his retirement he undertook, in a quiet way, a good deal of charitable work on their behalf. The letters to his grandchildren frequently tell of small kindnesses dispensed to other children – sick children, blind or crippled children,

and orphans such as Barnardo's boys. A firm in Scotland manufactured specially for him little tins of chocolate balls. These tins were shaped and coloured like butterflies and Sir Henry always carried several in his pockets in case he should meet a deserving child.

Such philanthropy formed part of a family tradition, for a Beaufoy ancestor had endowed a Ragged School and his cousin Minnie carried out good works among the poor of Lambeth. But Sir Henry seems to have had a natural sweetness of disposition, a Peter Pan-like amiability which both attracted him to 'babas', as he liked to call small children (using the Anglo-Indian word), and drew them to him. These letters to his grandchildren, particularly the pictures of bird and animal characters, take their place in a very English tradition of whimsy created by adults for children. If Kaka lacks the brilliance of a Lewis Carroll or a J. M. Barrie, his style is nonetheless wholly original, possessing a charm all its own.

CHRONOLOGY OF THE LETTERS

1912 Lieutenant-Colonel *Sir Henry Thornhill* retires.
Teddy Westmorland Wood born in Srinagar, Kashmir (30 July).

1914 *Kaka* sends his first picture cards to *Teddy* (March).
Sir Henry and the *Westmorland Woods* leave India and return to England (May).
First World War breaks out (August).
Margaret Westmorland Wood born at The Holt, Camberley (8 November).

1917 *Sir Henry's* wife, Maggie, dies of cancer.
Sir Henry moves into 'bachelor' rooms in the Wellington Club, Knightsbridge.

1918 First World War ends (November).
Sir Henry and his elder son *Cud* are awarded the C.M.G.

1919 *Elizabeth Westmorland Wood* born in Finchley (27 January).
Sir Henry's younger son, *Charlie*, dies in Lahore.

1920 The *Westmorland Woods* return to India.
Kaka starts to send illustrated letters to *Teddy* and *Margaret*, picture cards to *Elizabeth*.

1921 *Ann Westmorland Wood* born in Simla (20 July).

1922 *Teddy* returns to England on the S.S. *Caledonia* to attend boarding school (February).
Teddy starts his first term at St Michael's College, Tenbury Wells (April).
Kaka sends his first picture cards to *Ann*.

1923 The *Westmorland Woods* return to England (February).
The family reunited.

Chapter One

Hathi And Mr Hare

1914 – 1918

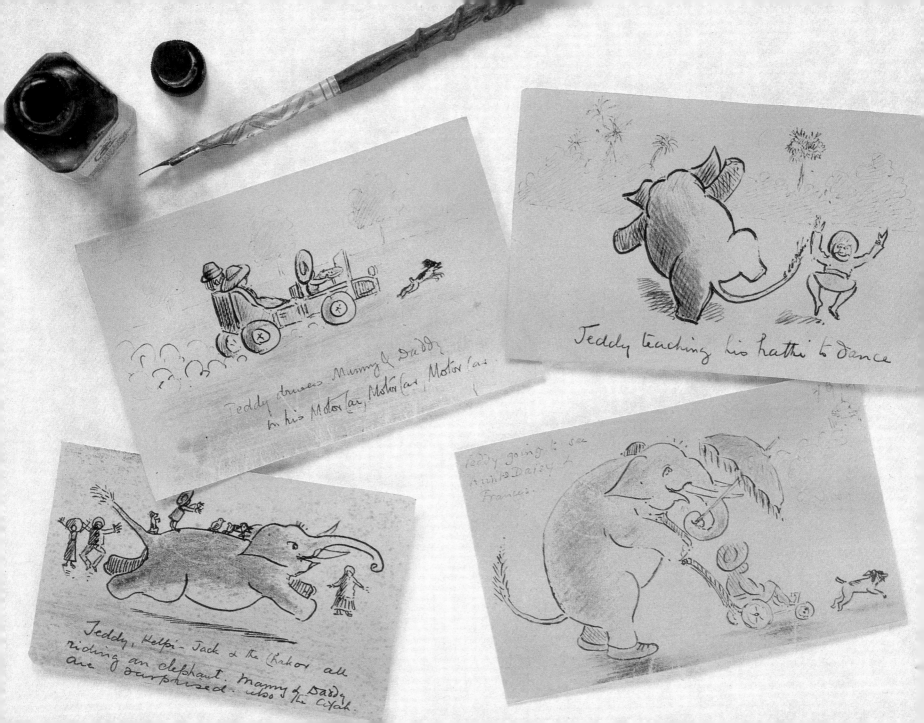

Teddy drives Mummy & Daddy
in his Motor Car, Motor Car, Motor Car.

Teddy teaching his hathi to dance

Teddy, Helpi~ Jack & the Chakor all
riding an elephant. Mummy & Daddy
are surprised. also the Citah.

Teddy going to see
his Daisy &
Frances.

Kaka's correspondence starts with illustrated postcards sent to Teddy from the age of one and a half onwards during the Great War years, 1914–18. These cards first appear in India, before the war began and when the Westmorland Woods were stationed at Lucknow. At the time Kaka was moving about the country, enjoying his retirement hunting and shooting in the company of his grown-up sons Cud and Charlie. But he could see the European war coming and safely got his family and the Woods back home to England just weeks before the outbreak of hostilities on 4 August 1914.

The war quickly separated Kaka and his grandson – inspiring more postcards. Arthur Wood, promoted to lieutenant-commander, was posted to the naval barracks at Chatham to help supervise gunnery training. Kaka, meanwhile, remained in London, having offered his services in any capacity and been given the responsible job of protecting all public buildings in the metropolitan area with a special force of twenty thousand policemen under his command. 'Voluntary, no pay, alas,' he wrote to his

elder sister Henriette, adding cheerfully: 'I shall have a very slim figure by the time I have won through.'

Henriette Thornhill, who was known as Aunt Tal in the family, lived at a large house in Camberley, Surrey, called The Holt, which became a home-from-home for the Woods. In the autumn of 1914 Teddy and his mother spent several months there, for Madge was heavily pregnant with her second child, Margaret, who was born in the house on 8 November. Aunt Tal suffered severely from arthritis and Teddy, the only grandchild still alive today, remembers pulling her round the garden in a bath chair – a contraption that soon found its way into Kaka's drawings. The Holt was effectively run by Alice the housekeeper and the elderly gardener, Reeves, both of whom were to become great favourites with all the Wood children. When Armistice Day finally arrived in 1918 it was under Aunt Tal's roof that Woods and Thornhills gathered for their celebrations.

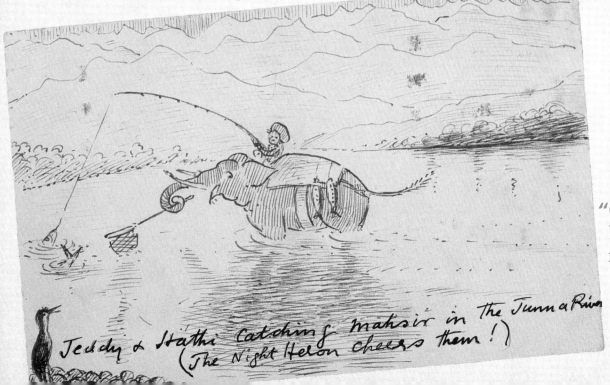

Teddy & Hathi catching Mahsir in the Junna River (The Night Heron cheers them!)

"Go on Teddy Bear, it's not cold!"

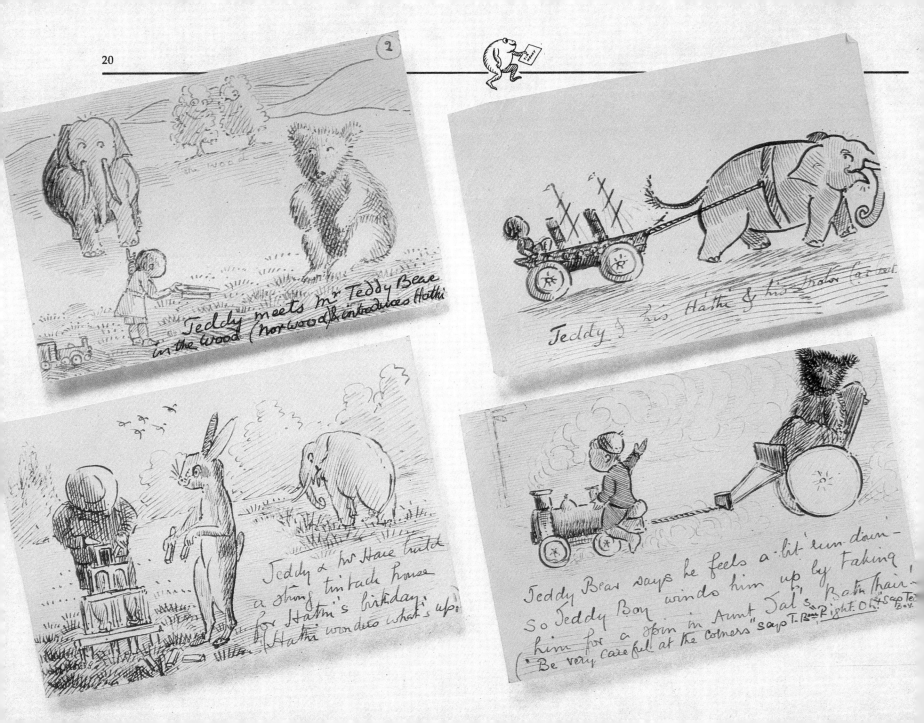

Teddy meets Mr Teddy Bear in the wood (Norwood) & introduces Hathi

Teddy & his Hathi & his Motor Car

Teddy & Mr Hare build a strong tin tack house for Hathi's birthday. Hathi wonders what's up!

Teddy Bear says he feels a bit run down - So Teddy Boy winds him up by taking him for a spin in Aunt Sal's Bath chair - "Be very careful at the corners" says T.B.

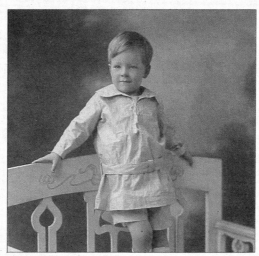

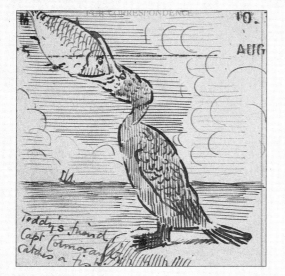

Teddy's friend Capt Cormorant catches a fish

TEDDY, AGED 4

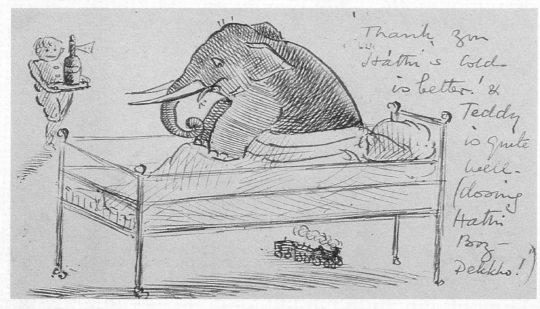

Thank you 'Hathi's cold is better.' & Teddy is quite well. (closing Hathi Boz — Dekkho!)

From the spring of 1915 Arthur Wood took up intelligence duties at the Admiralty and for the remainder of the war the family moved to a variety of rented addresses in London – principally an apartment in Prince of Wales Drive overlooking Battersea Park and, latterly, a house in East Sheen called The Halsteads. Sir Henry and his wife had a house in Ealing, but by the time the Woods returned to London Kaka was busy touring the country as the government's inspector of prisoner-of-war camps. Teddy recalls 'going with him on more than one occasion and being made to wait in the staff car outside the camp gate'. More usually, however, Kaka would be away in Edinburgh, Liverpool or Southampton and it was from such places that in his spare moments he penned his cards to Teddy.

"Teddy bandaging a poor little bird who has been hurt"

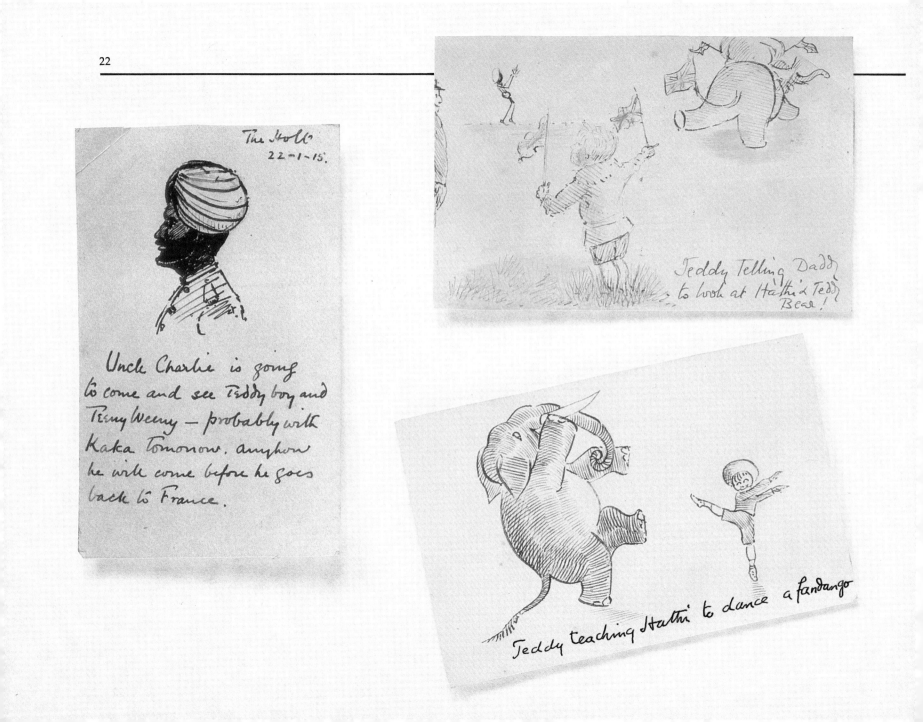

The Holt
22-1-15.

Uncle Charlie is going
to come and see Teddy boy and
Teeny Weeny — probably with
Kaka Tomonow. anyhow
he will come before he goes
back to France.

Teddy Telling Daddy
to look at Hathi & Teddy
Bear!

Teddy teaching Hathi to dance a fandango

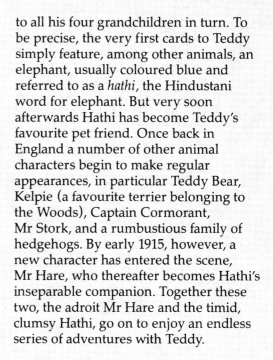

Teddy & Hathi go recruiting

Many of the early illustrations in this correspondence are drawn in pen and ink only, perhaps because coloured crayons were difficult to find in the first months of the war or because Kaka was too busy to colour them. From 1915 onwards, however, he regularly adds colour. Right from the start, while the Woods are still in India, Kaka introduces us to Hathi the elephant, the animal character who will dominate the letters to all his four grandchildren in turn. To be precise, the very first cards to Teddy simply feature, among other animals, an elephant, usually coloured blue and referred to as a *hathi*, the Hindustani word for elephant. But very soon afterwards Hathi has become Teddy's favourite pet friend. Once back in England a number of other animal characters begin to make regular appearances, in particular Teddy Bear, Kelpie (a favourite terrier belonging to the Woods), Captain Cormorant, Mr Stork, and a rumbustious family of hedgehogs. By early 1915, however, a new character has entered the scene, Mr Hare, who thereafter becomes Hathi's inseparable companion. Together these two, the adroit Mr Hare and the timid, clumsy Hathi, go on to enjoy an endless series of adventures with Teddy.

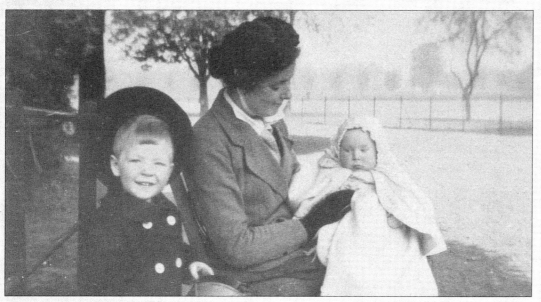

TEDDY, NANNY VERA AND MARGARET ('Teeny-Weeny')

"Hathi and Mr Hare kicking up their heels"

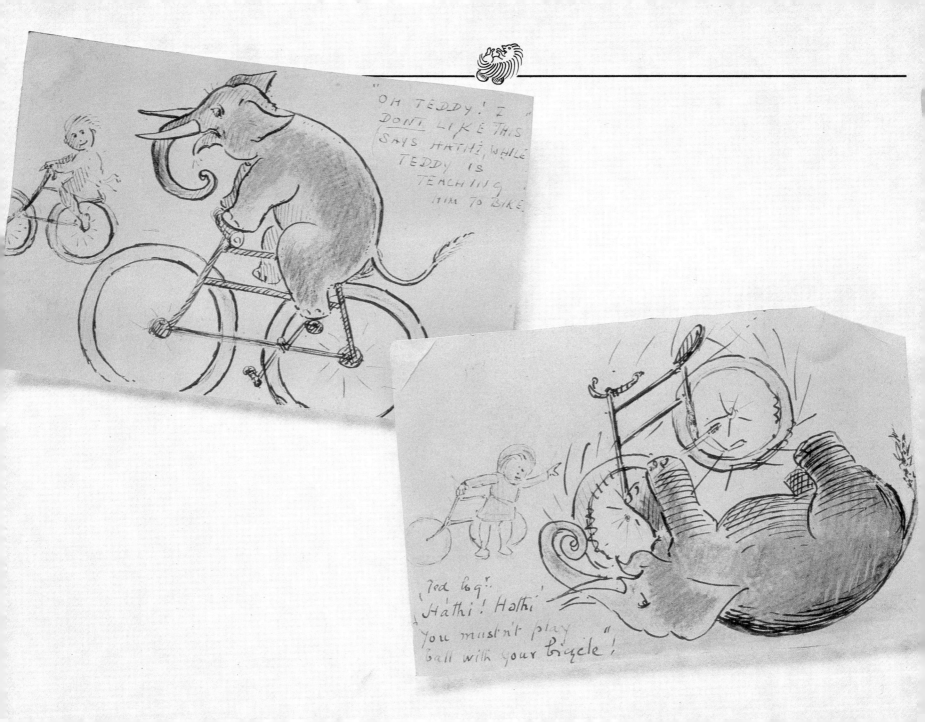

Teddy & his Hàthi at tea.

Teddy speaks:—
"I told you Hàthi — not to try to drink your tea so hot. Now, look what you've done !"

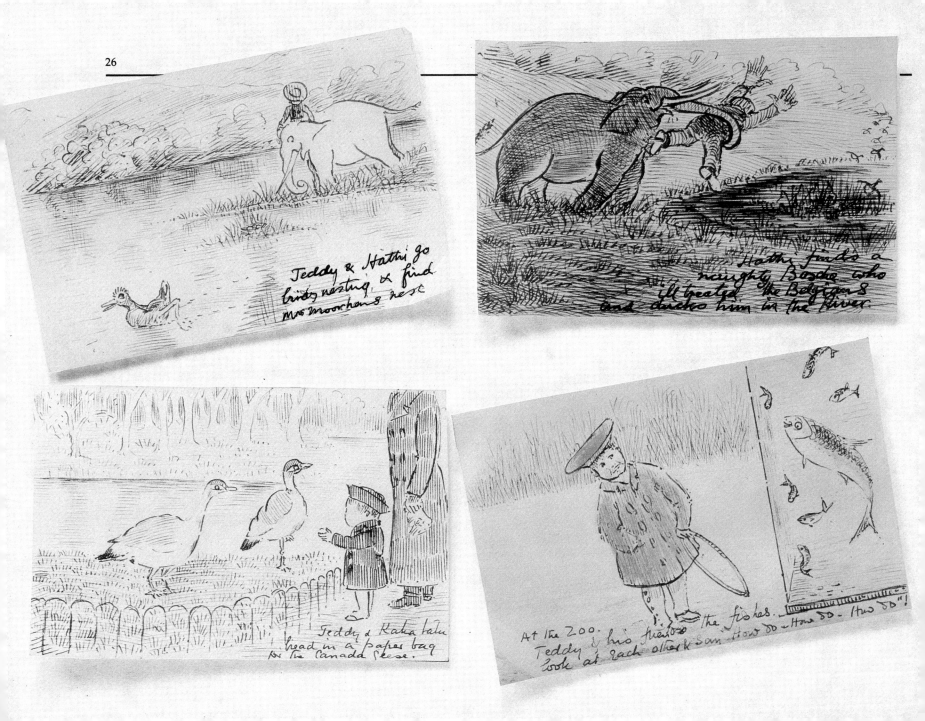

Teddy & Hathi go birds nesting & find Mrs Moorhens nest

Hathi finds a naughty Bosche who ill treated the Belgians and ducks him in the River.

Teddy & Kaka take bread in a paper bag for the Canada geese.

At the Zoo. Teddy & his friends look at each other & say How DO — How DO — How DD"!

KAKA IN UNIFORM, 1915

If the Hathi – Mr Hare double act is the most visible, and most appealing, feature of the postcards, it is only part of a wider fascination with nature and the animal world. Kaka obviously had a fellow-feeling for animals which he was concerned to encourage in his grandson. Thus Teddy is frequently portrayed in the drawings as the benefactor of creatures in distress, a special friend to birds, such as the ducks and geese he and Kaka often visited at the pond in Battersea Park. Another place frequented by the two of them was London Zoo.

Kaka was a Fellow of the Royal Zoological Society, which meant he could visit the zoo on Sundays when it was closed to the general public.

Several of the cards contain portraits of Kaka himself, a tall, protective figure in military khaki sporting a Kitchener moustache. The war, of course, provided the context in which Kaka was writing to Teddy and the pictures give fleeting glimpses of the conflict as experienced on the civilian front. Boisterously assisted by Hathi and Mr Hare, Teddy waves flags, dons uniforms, marches and salutes, and lends his services on behalf of the recruiting campaign.

2 Ap. 1915. Daddy & Mummy & Teddy go to the Zoo. (Teddy likes the Lion, & the Lion is pleased with Teddy.)

"Mr Hare gets a big drum to bang"

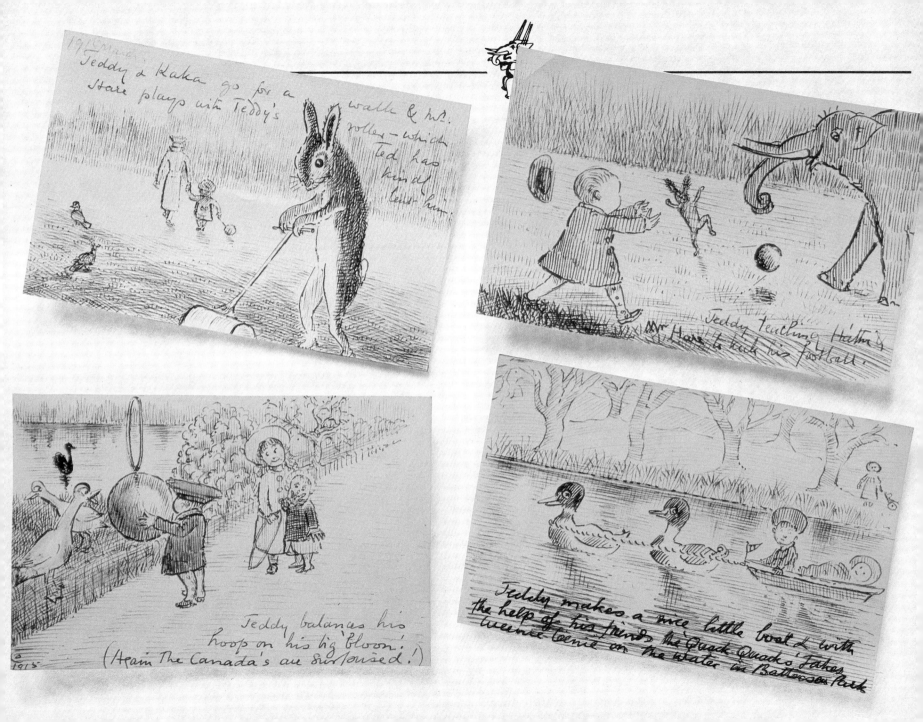

1915 [...]
Teddy & Kaka go for a walk & Mr. Hare plays with Teddy's roller – which Ted has kind lent him.

Teddy teaching Hathi's Mr Hare to kick his football.

Teddy balances his hoop on his big 'bloom'!
(Again The Canada's are surprised!)

Teddy makes a nice little boat & with the help of his friends the 'Quack Quacks' takes winnie [...] on the water in Battersea Park

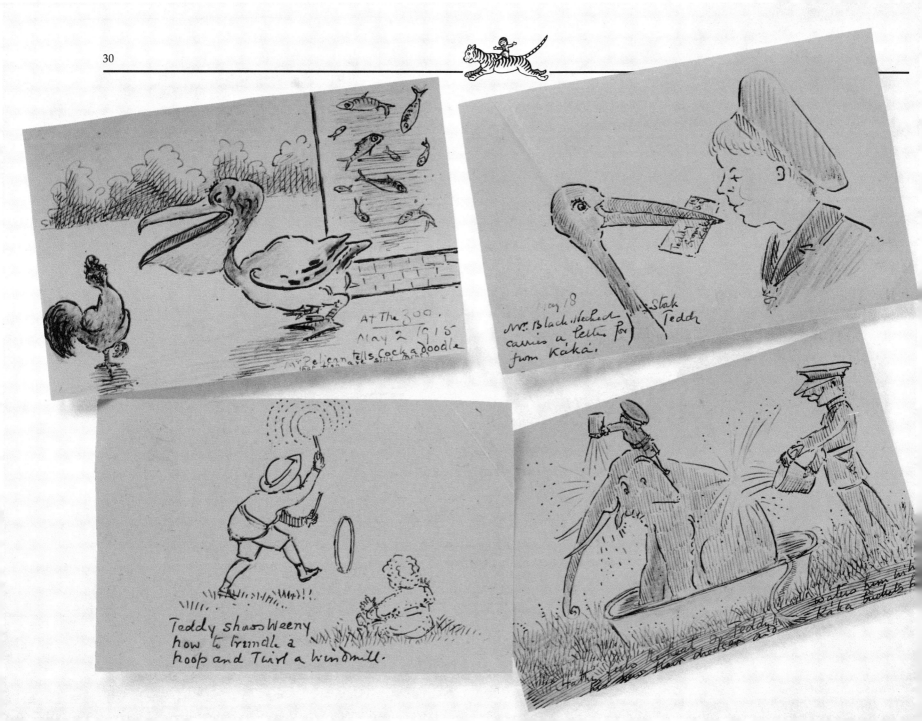

At The Zoo.
May 2 1915
Mr Pelican tells Cock a doodle
that fish are silly things

May 18
Mr. Black Necked
carries a letter Box
from Kaka.

Stork
Teddy

Teddy shows Weeny
how to Trundle a
hoop and Twirl a windmill.

Kaka's general tone is patriotic but exuberant and fanciful, with no reference to casualties and other horrors, a playing at war fit for a child rather than the real thing. In fact, at the beginning such sentiments were not altogether untypical of the country as a whole, for few people had any inkling of what was to come. A feeling of 'business as usual' prevailed in the early weeks, based on the assumption that soon it would all be over. County cricket matches continued to be played until the end of August 1914 and the government made few plans to

marshal its resources. But by late autumn the war had reached stalemate, with an unbroken line of trenches stretching across France from the Swiss frontier to the sea. Ignominious failure for the Allies followed at Gallipoli in early 1915, then came the first German gas attacks at Ypres resulting in serious British losses. Lord Kitchener, the Secretary for War, initiated a voluntary recruiting campaign with the famous slogan beneath his piercing gaze: 'Your Country Needs YOU.' Men flocked to the colours in their thousands (750,000 in September 1915

alone), responding to a burst of anti-German enthusiasm that was inflamed by spy scares and the stories of 'Boche' atrocities brought by Belgian refugees. Despite the fact that the Army soon had more men than it could equip, there was a general belief that 'slackers' were everywhere evading their country's call. The appalling British casualty rate at the front (50,000 dead or wounded at Loos in September–October 1915) further increased the pressure for conscription. It finally came in 1916, initially for single men up to the age of forty-one, then for all men. Ironically, recruitment immediately declined, at times dropping to less than half the rate under the voluntary system.

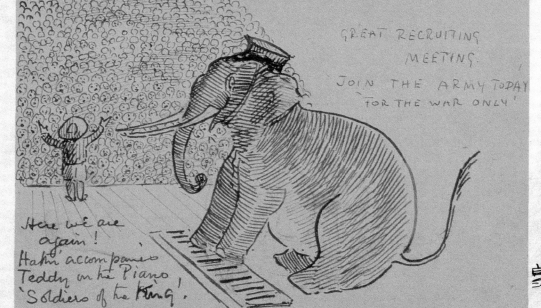

"Weeny tries to catch butterflies"

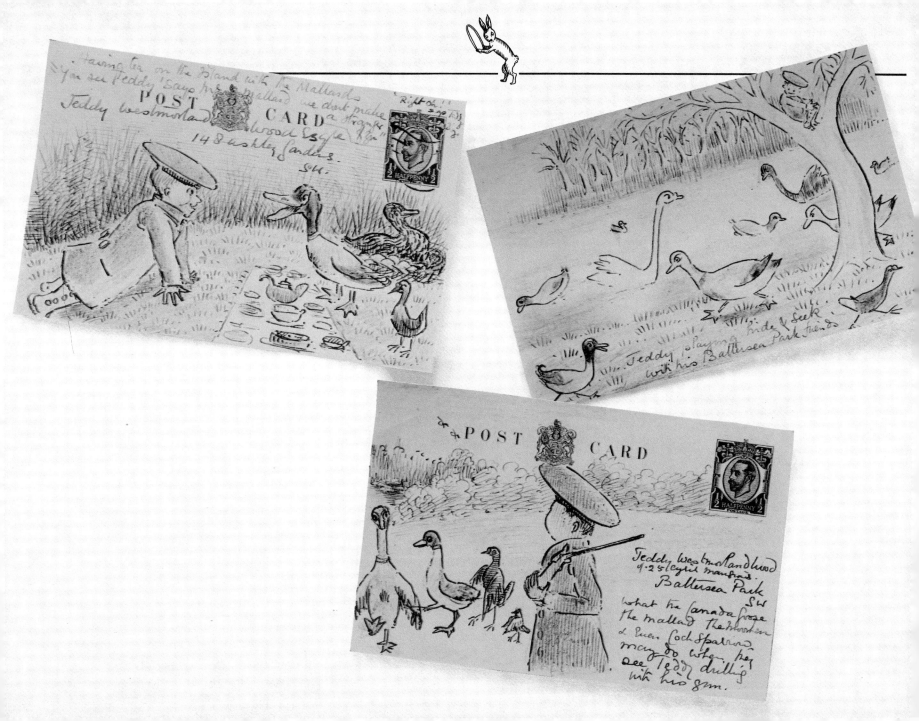

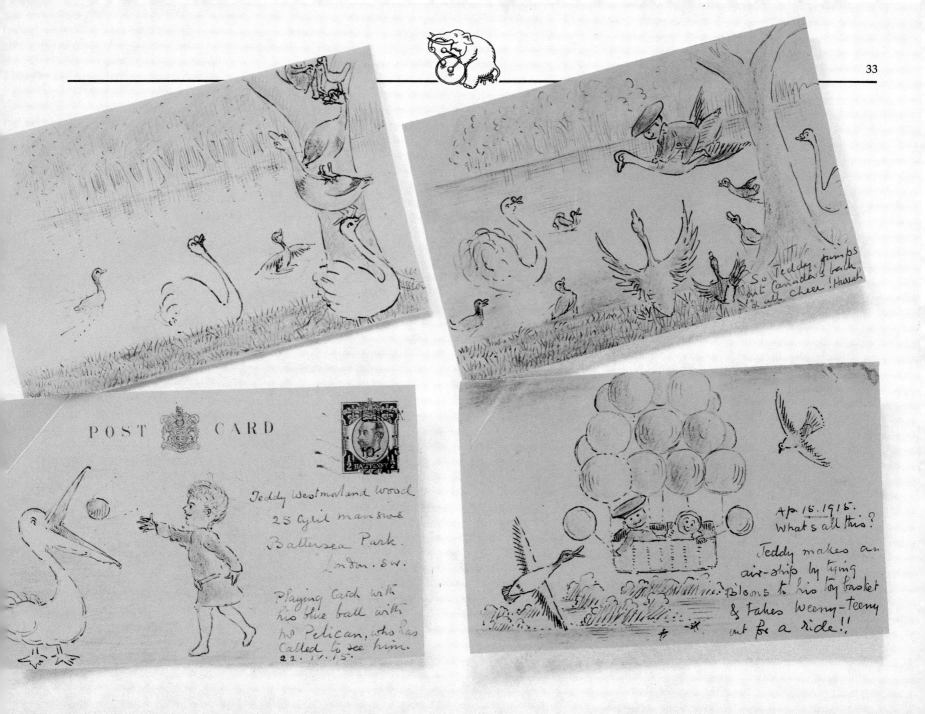

So Teddy jumps out Canada's back & all cheer! Hurrah

POST CARD

HALFPENNY 2

Teddy Westmoland wood
25 Cyril mansions
Battersea Park.
London. S.W.

Playing catch with
his blue ball with
his Pelican, who has
called to see him.
22. IV. 15.

Ap. 15. 1915.
What's all this?

Teddy makes an
air-ship by tying
Bloons to his toy basket
& takes weeny-teeny
out for a ride!!

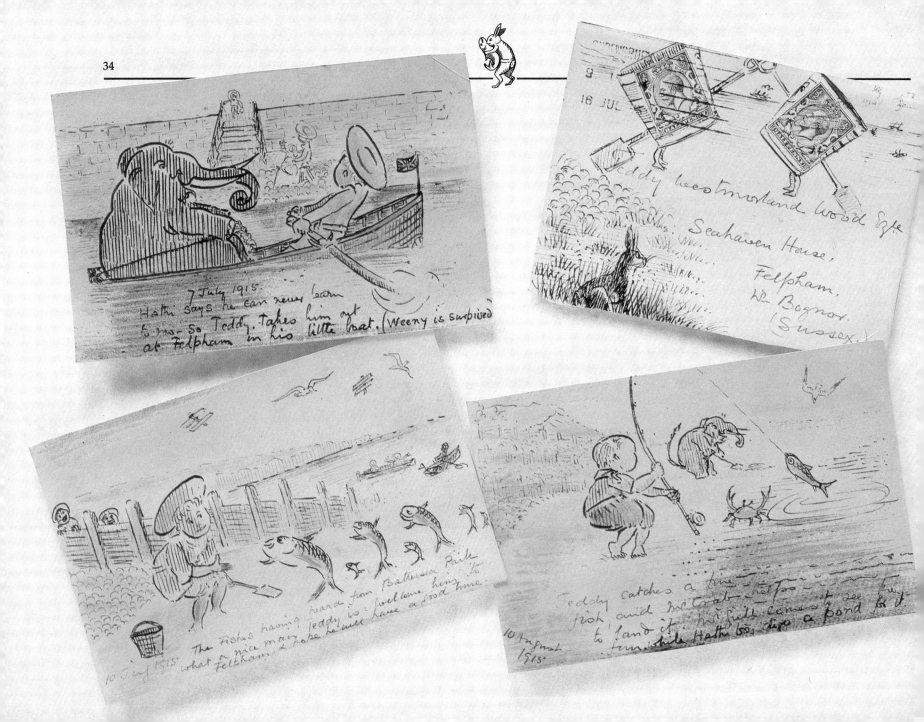

7 July 1915.
Hathi says he can never learn
to row—so Teddy takes him out
at Felpham in his little boat. (Weeny is surprised)

Teddy Westmorland Wood Esqr
Seahaven House,
Felpham,
Nr Bognor.
(Sussex.)

The fishes having heard from Battersea Park
what a nice man Teddy is, fool some him to
Felpham & hope he will have a good time.
10 July 1915.

Teddy catches a fine
fish and Mr Crab helps
to land it. What fun it causes to see the
fun while Hathi tries a pond for it.
10 August
1915.

MARGARET AND TEDDY

given the remorseless rise in British casualties during the first three years. The Somme campaign of 1916, in which the British alone sustained losses of 420,000 men in the months of July to November, finally exhausted any surviving idealism for the struggle. Instead, Kaka produces pictures of Teddy at the seaside (the Woods regularly spent their summer holidays at Felpham, near Bognor Regis, and at Instow, north Devon), Teddy at the zoo, Teddy befriending birds and animals, Teddy with his toys, Teddy with Teeny Weeny (baby Margaret's nickname) and his best friend Paul – projecting a world of innocent fun that is often all the more removed from reality by the presence of Hathi and Mr Hare.

"Hurrah! A Race! A Race!"

Life for civilians grew increasingly drab and regimented. The news was censored. Prices rose steadily and income tax almost doubled. Clothes, shoes and furniture became scarce. Coal sometimes ran short. Trains were slow and overcrowded, queuing was common. Food remained generally plentiful, especially bread and meat, and rationing in 1918 did more to ensure supplies than decrease consumption. However, beer was watered down and drinking restricted (to reduce absenteeism at work), introducing the afternoon gap in pub opening hours that has remained in force ever since. People's freedom of movement was controlled and their conditions of work prescribed. From 1916 they even had to get up one hour earlier in the summer when the clocks were put back by Act of Parliament.

None of this austerity is apparent from Kaka's correspondence to Teddy. Indeed, from the middle of 1915 onwards his postcards even steer clear of the patriotic flag-waving with which they had first greeted the war. This is hardly surprising

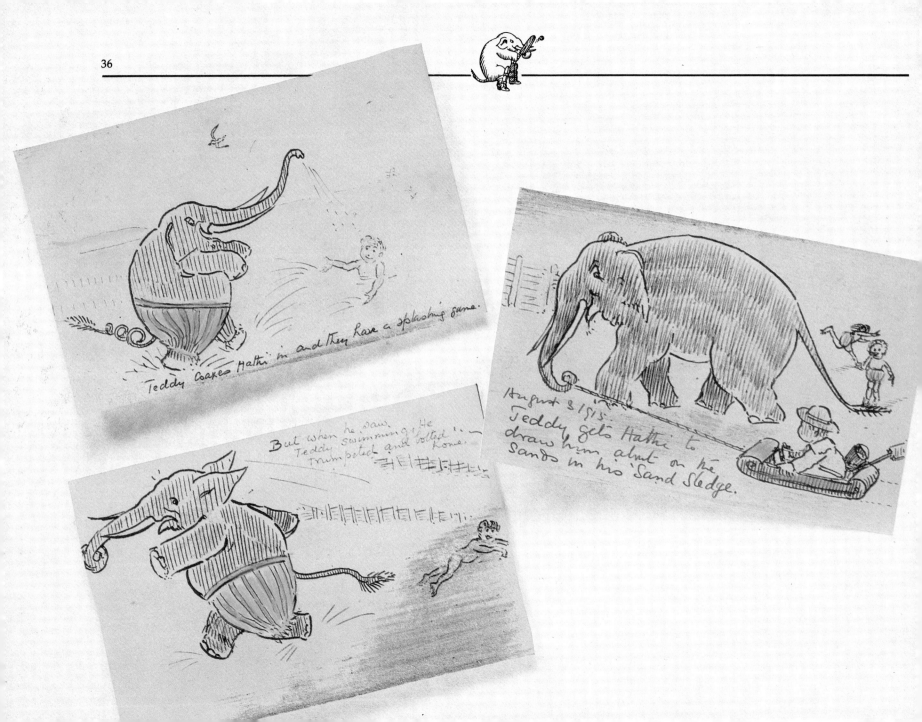

Teddy coaxes Hathi in and then have a splashing game.

But when he saw. Teddy swimming, He Trumpeted and bolted home.

August 3/15.
Teddy gets Hathi to draw him about on the Sands in his 'Sand Sledge.

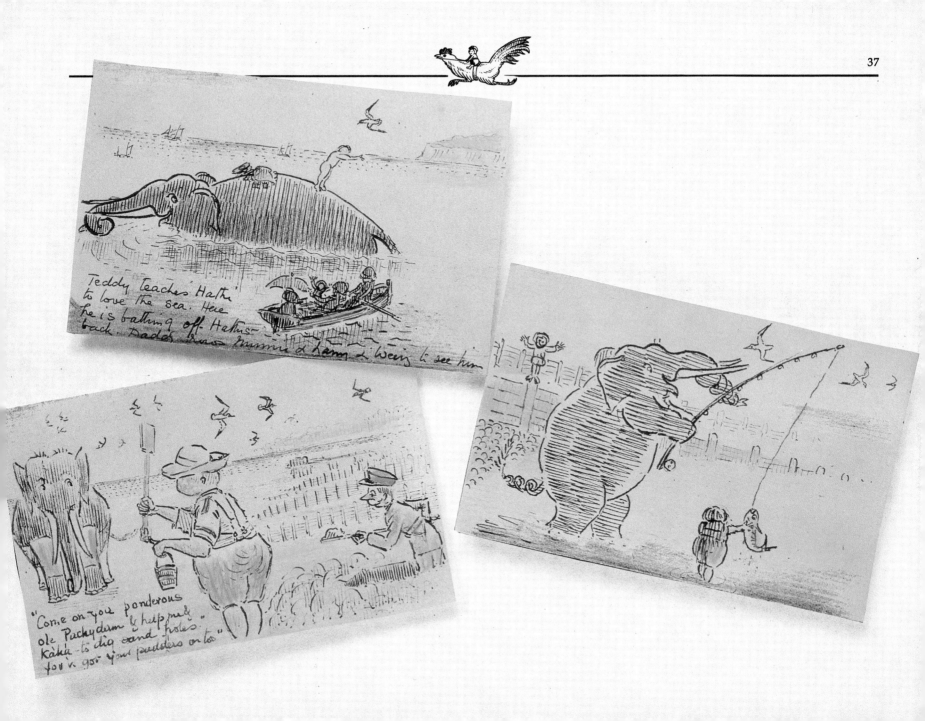

Teddy teaches Hathi
to love the sea. Here
he is bathing off Hathi's
back. Daddie & Mummie & Larry & Weeg to see him

"Come on you ponderous
ole Pachyderm & help me &
Kaka to dig sand holes.
You've got your paddlers on too"

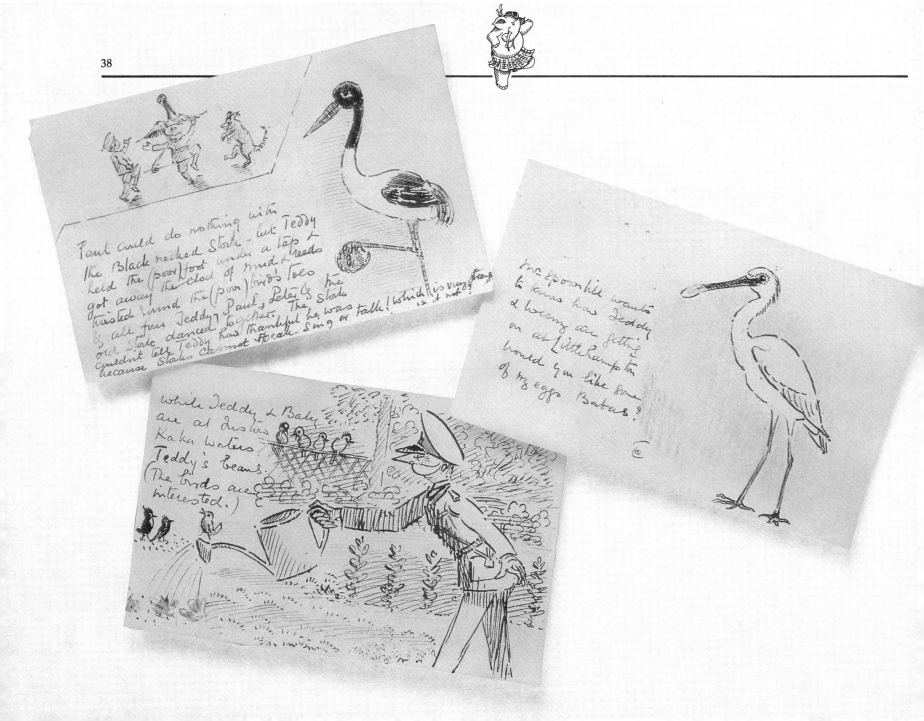

Paul could do nothing with
the Black necked Stork – but Teddy
held the (poor) foot under a tap &
got away the clod of mud & reeds
twisted round the (poor) bird's toes
& all four Teddy, Paul, Peter & the Stork
old Stork danced together. The Stork
couldn't tell Teddy how thankful he was
because Storks cannot speak – sing or talk! Which is very strange
is it not?

Mr Spoonbill wants
to know how Teddy
& Vicky are getting
on at Littlehampton
Would you like some
of my eggs Babas?

While Teddy & Baby
are at Justin
Kaku waters?
Teddy's beans.
(The birds are
interested.)

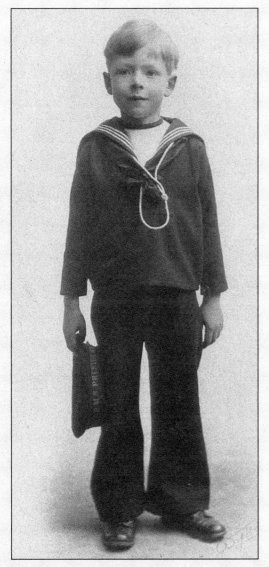

TEDDY

In fact, for Teddy this probably *was* quite an authentic picture of how he spent the war. For example, one of the few incidents he can still recall vividly from those far-off years has nothing to do with the war but concerns a favourite toy, a large red wooden railway engine pulled by a rope. When his sister Margaret was christened at Felpham in 1915, he was most upset not to be allowed to take this engine into the church during the service. As Teddy comments: 'One's memory is a strange thing!'

MARGARET IN PATRIOTIC COLOURS

Only the odd drawing of Zeppelins shows us that the war is still going on, but these air-raids proved more dramatic than dangerous. They began over London in the spring of 1915, subjecting British civilians to their first direct taste of combat. The psychological impact was considerable, especially as lighting restrictions were imposed in the streets and factories shut down at the slightest hint of an attack. Yet the real damage the 'Zeps' inflicted was insignificant and the casualties negligible. Teddy was roused from his bed one night to watch a German airship being shot down in flames over Potters Bar. He also recalls that sometimes after raids Kaka – and also his nanny Vera – would take him to the latest bomb craters to hunt for pieces of shrapnel.

"Kaka brings Teddy a hawk kite & when Teddy flies it on the sands the gulls come to look at it!"

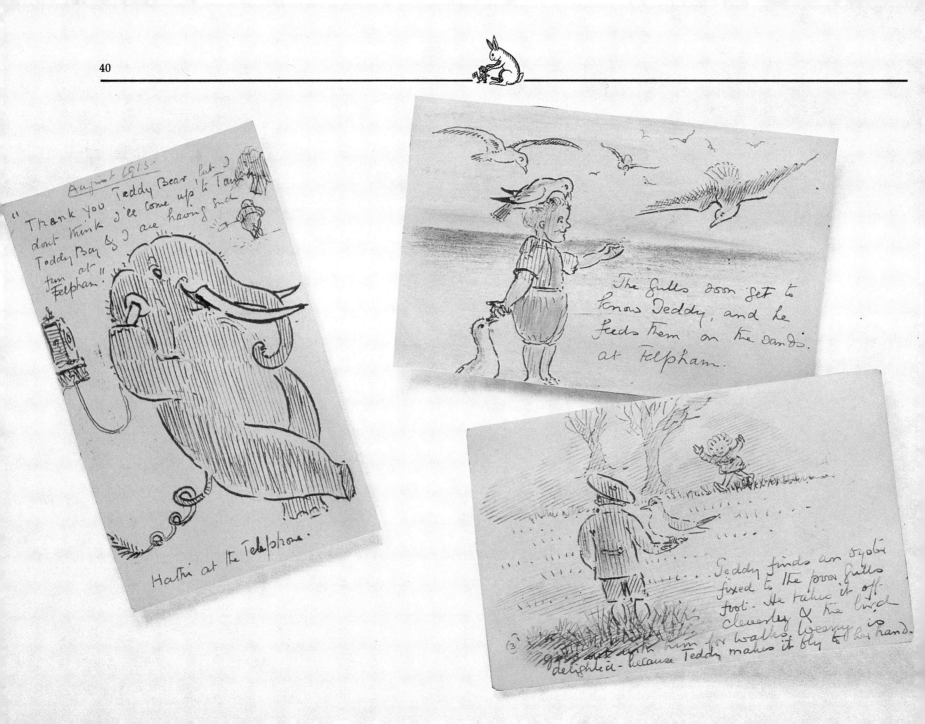

August 1915

" Thank you Teddy Bear but I
don't think I'll come up to Town.
Teddy Boy & I are having such
fun at
Felpham."

Hathi at the Telephone.

The Gulls soon get to
know Teddy, and he
feeds them on the sands
at Felpham.

Teddy finds an oyster
fixed to the poor Gulls
foot. He takes it off
cleverly & the bird
goes out with him for walks. Weeny is
delighted—because Teddy makes it fly to his hand.

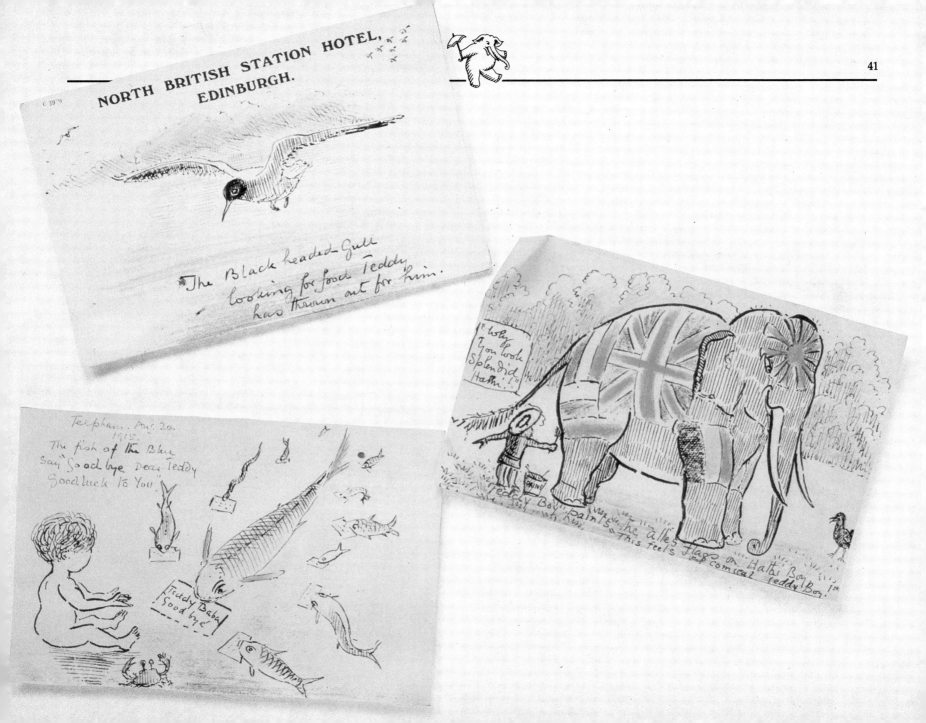

NORTH BRITISH STATION HOTEL,
EDINBURGH.

The Black headed Gull
looking for food Teddy
has thrown out for him.

Felpham. Aug. 20.
1915.
The fish of the Blue
Sea "Good bye Dear Teddy
Good luck to You"

Teddy Baby
Good bye

"Why you look
Splendid
Hathi!"

Teddy Boy paints the Allies' flag on Hathi Boy
with "This feels most comical Teddy Boy"

June 1916.

"You look seedy old Cock - You should go and Consult Teddy Westmorland Wood in Westbury Road. Come along wif me - He is very kind to poor little Sick birds"

'Oh - I feel so bad!'

"Teddy.
"Halt! Who Comes There?"
a voice. "Kaka." -
Teddy.
"Pass Kaka & all's well!"

POST CARD
10.— PM
19 JUN 16

½ HALFPENNY

Master Teddy Westmorland Wood
Go Lady Thornhill
2 Westbury Road
Ealing. Ⓦ

Teddy teaching Hathi his Celebrated Eastern Stroke at Lawn Tennis. Weeny Teeny is pleased.

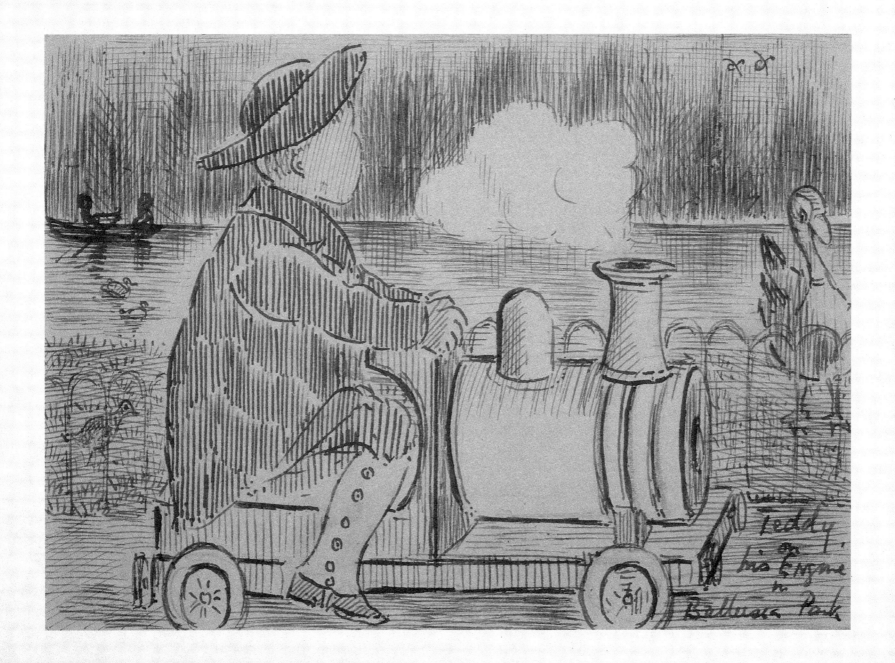

Teddy on his Engine in Battersea Park

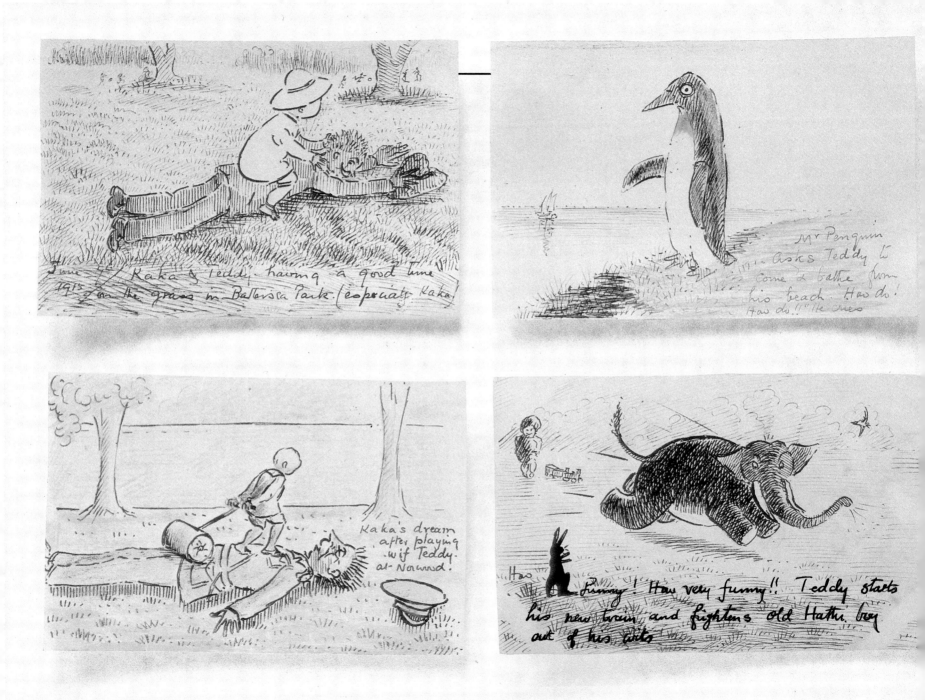

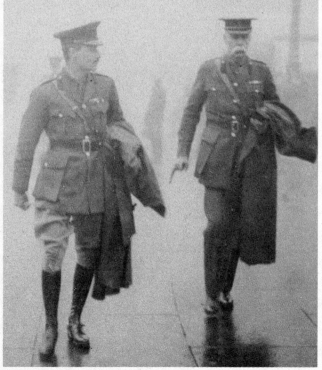

Soon Mr & Mrs Rook will begin to mend their nest – Look out for them in tall elm trees. ©
21.1.18

After 1916 the cards from Kaka to Teddy dwindle to a mere handful. It's possible that many have been lost or mislaid, but more likely that Kaka simply wrote less. 1917 proved a difficult year for him, for his wife Maggie succumbed to cancer. Madge Wood helped to look after her and it was at The Halsteads in East Sheen that Lady Thornhill died – so no doubt Kaka saw more of Teddy than usual.

From 1918 only a single card exists. Postmarked January, it is vintage Kaka, showing a pen-and-ink drawing of a rook standing guard over its nest. The caption reads: 'Soon Mr and Mrs Rook will begin to mend their nest – Look out for them in tall elm trees.' The war dragged on until November but one feels that Kaka, whose instincts were so often right, already sensed the end and was here expressing a renewed faith in the future.

CUD AND KAKA GO TO BUCKINGHAM PALACE TO RECEIVE THEIR C.M.G.s

"Teddy showing Weeny how to tame little birds"

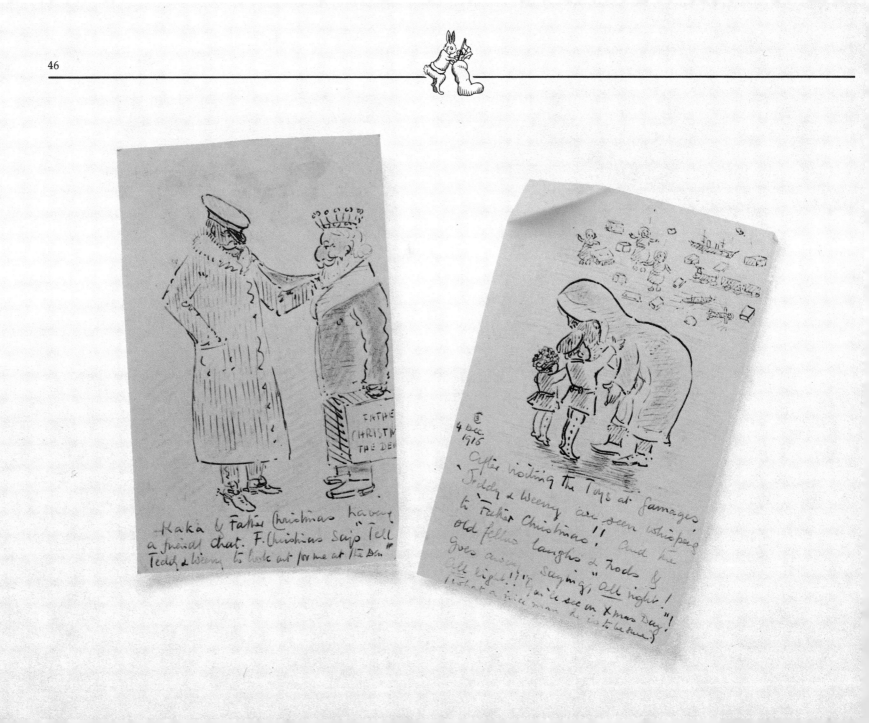

Kaka & Father Christmas having
a friendl chat. F. Christmas says "Tell
Teddy & Weeny to look out for me at the Den "

"After visiting the Toys at Gamages
Teddy & Weeny are seen whispers
to "Father Christmas". And he
old fellow laughs & nods &
goes away saying "All right!
All right!" "You'll see on Xmas Day."
(What a nice man he is to be sure)

4 Dec.
1916

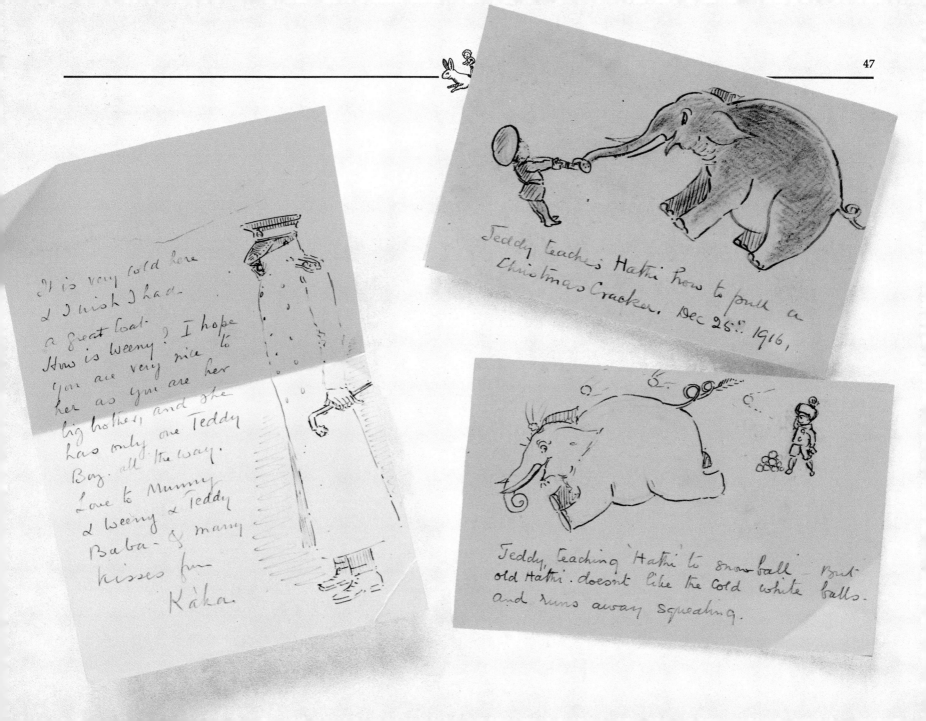

It is very cold here
& I wish I had
a great Coat.
How is Weeny? I hope
you are very nice to
her as you are her
big brother, and she
has only one Teddy
Boy. all the way.
Love to Mummy
& Weeny & Teddy
Baba & many
kisses from
Kaka

Teddy teaches Hathi how to pull a
Christmas Cracker. Dec 25th 1916,

Teddy teaching Hathi to snow ball — But
old Hathi. doesn't like the cold white balls.
and runs away squeaking.

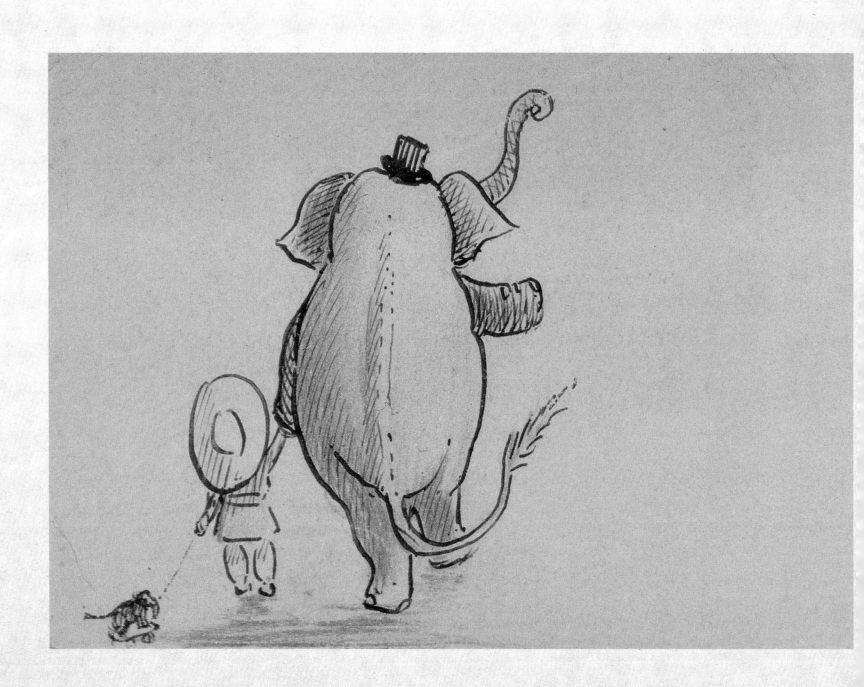

CHAPTER TWO

MASTER TEDDY AND YE MISSES WESTMORLAND WOOD

1920 – 1921

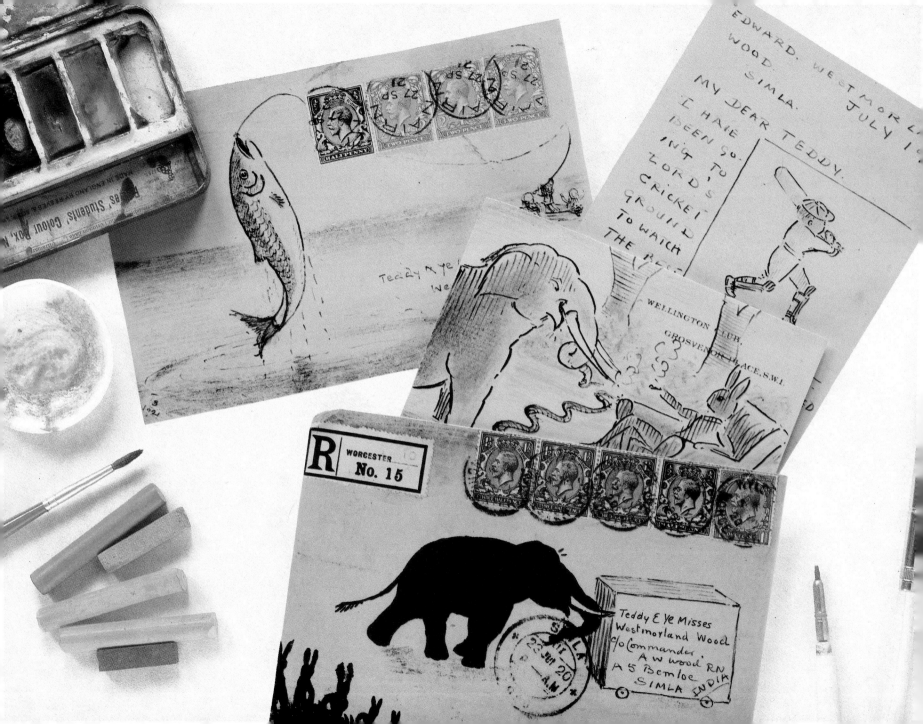

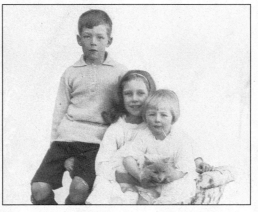

After 1918 there is a gap in Kaka's correspondence until May 1920. From this date onwards, however, we find him suddenly writing to three children at once: illustrated letters to Teddy and Margaret, now seven and five respectively, and picture cards to one-and-a-half-year-old Elizabeth – the new addition to the Wood family born in London on 27 January 1919.

Until 1922 all this correspondence is directed to India, either to Delhi or Simla, each posting addressed quaintly to 'Master Teddy & Ye Misses Westmorland Wood'. After the war Arthur Wood decided to return to his old job in the Indian Audit and Accounts Service and was posted to the government secretariat at Delhi. As soon as baby Elizabeth was able to travel, Madge and the children went out to join him, sailing from Liverpool on the S.S. *City of Karachi* in early 1920.

> " The orchards are so lovely. The sloe flowers will soon be over and then the hawthorn will come into flower and you and Teddy must teach Elizabeth to sing 'O that we two were Maying!'" *TO MARGARET – APRIL 1920*

The removal of the Woods to India left Kaka particularly isolated. Not only was he now retired and widowed, but in 1919 he had lost his younger son, Charlie, who died from unsuspected heart trouble while with his regiment in Lahore. Charlie had come through the war with distinction, winning the D.S.O., M.C. and *Croix de Guerre*, and his death so soon after the peace must have seemed a bitter twist of fate. India had

TEDDY, MARGARET AND ELIZABETH

claimed yet another Thornhill. Cud, Kaka's elder son (and the 'Uncle Cud' of the letters), was now absent abroad, serving as a British military attaché in the Soviet Union. He too had received the *Croix de Guerre* during the war, adding a D.S.O. for his part in secret operations around Archangel during the civil war that followed the Bolshevik revolution of 1917. In 1918 he was awarded the C.M.G.,

collecting it from Buckingham Palace on the very day Kaka received his – a 'first' for a father and son. The only time Kaka could count on seeing Cud, as the letters demonstrate, was when he came home on leave for the annual grouse-shooting season.

Separated from his closest family, Kaka moved into 'bachelor' rooms at the Wellington Club in Grosvenor Place, Knightsbridge. He spent a good deal of time in Brighton, where he had close friends, and he also stayed at intervals with Aunt Tal at The Holt. But after such an active career Kaka in retirement must have felt keenly the lonely gap in his life. He would probably have kept in touch with his grandchildren in any case, but the sheer volume of the correspondence, the care with which it was prepared and despatched across the Empire, suggests that it served as much for his own comfort as theirs.

"A letter for Margaret"

BRIGHTON
MAY. 1920

MY DEAR MARGARET.

SUCH LOVELY WEATHER.
I WISHED FOR YOU ALL
TO 'PADDLE AND PLAY ON
THE BEACH. AND
SUCH LOTS
OF BABAS,
BUT THEY-
POOR DEARS-
DONT HAVE
LOVELY MAN-
-GOES, TIPPARI
JAM, AND THE WONDERFUL
MOUNTAIN SCENERY YOU
AND TEDDY.
AND ELIZA-
BETH
ENJO

I HOPE LAST
WEEK'S LETTER
REACHED YOU
WITH PICTURES
OF BLUE PERSIAN
CAT AND OTHER "Climbing Perch"
THINGS. ARE YOU
GOING TO JOIN 'THE' BLUE-
BIRDS' - WHAT FUN FOR
YOU! - ONLY
DONT TRY
TO EAT GRAIN
AND INSECTS
DEAR, WILL YOU!
TELL ME WHAT THE UNIFORM
IS, AND WHAT
YOU HAVE TO DO,
IT WILL BE SO
INTERESTING.
[WHATEVER
WILL AUNT TAL, ALICE, AND

A FISH WHO
CAN GET UP
LOCK GATES, ETC!

Blackbird
a blot!

Bluebird.

REEVES SAY!
I GO TO THE
MUSEUM AND
ADMIRE ALL THE
WONDERFUL BIRDS,
BEASTS, AND FISHES
THERE, AND MAKE
ROUGH SKETCHES FOR YOU ALL
I WANT YOU
TO DRAW THINGS
FOR ME AS
SOON AS EVER
YOU CAN! I HAVE
SOME OF YOUR
PICTURES CAREFULLY
PUT AWAY.
THE BLUE CAT CAUGHT A
YOUNG SPARROW TODAY-
I RESCUED IT BUT IT DI
NOT LIVE LONG. POOR M
POOS FANCY! A SPARRO

margaret & her Zebra

"You remember seeing porpoises on the voyage out? Well, when you go to a museum have a good look at one. You will notice that the tail is edgeways not broadside on, as in other ordinary fishes. This arrangement, don't you think, helps Mr Porpoise to do such fine leaps and jumps out of the water!" TO TEDDY – MAY 1920

LITTLE HEART BEATS 800 TIMES A MINUTE - A CANARY'S 1000 TIMES EVERY MINUTE OUR HEARTS BEAT, AS YOU KNOW, ONLY ABT 80 TIMES A MINUTE. MR MOUSE'S HEART GOES 700 PUMPS IN A MINUTE.]

I HOPE YOU ARE ALL VERY WELL, AND THAT ALL THE PETS ARE GOOD & HAPPY. DO YOU LIKE LETTERS LIKE THIS, OR DO YOU PREFER PICTURE POSTCARDS? MUCH LOVE, DEAR.

FROM KAKA.

PLEASE ALWAYS GIVE ELIZABETH A KISS FROM ME WHEN YOU GIVE HER THE PICTURE.

Kaka normally wrote once a week to the three children in India. The letters went by registered post and cost on average 5d each, expensive for those days, no doubt because each envelope contained two letters and a card (in 1920 letters to India cost 2d for the first ounce, 1d for each further ounce).

A letter sent from London to Simla in 1920 would have taken well over a fortnight to arrive at A5 Bemloe, the Woods' address. Mails to India started their long journey on a special train which left Charing Cross every Thursday evening and went via Calais to Marseilles. Coloured labels differentiated the destinations of the hundreds of mail bags: grey for Port Said and the Middle East, pink for Aden and East Africa, buff for Bombay, red and white for Ceylon. At Marseilles the train drew up on the quay

"Margaret driving"

alongside a P.&O. ship that had left London with passengers and cargo five days earlier (the Peninsular and Orient Line held a monopoly on the India run). The overland London–Marseilles leg officially took thirty hours, but by the time loading had been completed and the boat had actually departed from Marseilles it could be more like two days. The next port of call was Port Said, followed by Suez, then Aden, and finally Bombay, a voyage lasting some twelve or thirteen days, though often longer in the monsoon season. The Indian mails always formed the largest single consignment. From Bombay special postal trains left for Calcutta, Madras, Lucknow and the Punjab. The Bombay postal authorities boasted that letters for the city itself arrived within two hours of the mail steamer rounding the lighthouse in the bay, but to Simla (some 1500 kilometres to the north) the journey probably took another couple of days at least.

Writing letters with such a time-lag demanded forethought. Kaka always posted birthday letters and parcels for the children well in advance to be sure they would be received on the right day. Parcels from Kaka were always a great event, for instead of string and brown paper he wrapped them in cloth and sewed them up.

"Elizabeth goes for a ride – on a fish! Along the Simla Mall!!!"

Envelope 1 address:
Master Teddy & ye Missco. WESTMORLAND WOOD. A.S. Bemloe. SIMLA. INDIA

Envelope 2 address:
TEDDY WESTMORLAND & YE MISSES WESTMORLAND A.S. BEMLOE. INDIA. SIMLA

AN EN-
GINEERING
SHOP SOME
LITTLE UN-
MOUNTED GUNS
WHICH DADDY WILL
SHOW YOU HOW TO MOUNT. ON
LITTLE BLOCKS OF WOOD
— SOMETHING IN THIS
STYLE.

A NEW AND COMIC
MOTOR CRAFT
ON THE RIVER
THAMES

ISN'T IT INTERESTING·
SOME MONITOR LIZARDS ARE
SO FOND OF EATING EGGS
THAT THEY ACTUALLY—
IN AFRICA — DIG UP

CROCODILES EGGS AND EAT
THEM — THEY ALSO FIND
YOUNG CROCODILES VERY
NICE EATING !!
THE INDIAN MONITORS
ARE CALLED "GOAS"—

JUST THE
OTHER
DAY IN
AN ISLAND
NEAR SU-
MATRA
THEY DIS-
COVERED
A MONITOR
TWENTY
THREE
FEET LONG.
NO OTHER
LIZARD
IS LONGER
THAN 4
FOUR FEET!

THIS IS SOMETHING LIKE
YOUR HIMALAYAN JAY
AT SIMLA. 'SALAAM MR JAY.'

"The birds in India in the hot weather go about with their beaks open, wide open, and I feel inclined to do the same! Wouldn't it look odd!!"

TO MARGARET – MAY 1920

Compared to the earlier postcard correspondence with Teddy, the most striking difference about the India letters is the improvement in the illustrations. Kaka still mainly uses pen and ink but the draughtsmanship is infinitely superior and he has introduced widespread colour with both crayons and inks. This is seen most spectacularly on his envelopes where the address is invariably, and inventively, incorporated into a highly finished picture.

> **"You must look on every word in my letters as a kiss from Kaka."**
> *TO MARGARET – JUNE 1920*

Now that Teddy and Margaret are no longer babes-in-arms, the text of the letters has become more important and more substantial. Kaka writes in bold, clear capitals throughout, which suggests that he hoped his correspondence would not just be read out to the children but would help them learn to read as well. Teddy, in fact, could read from a very young age, having been coached by Vera, the beloved nanny who joined the Woods shortly after Margaret's birth and stayed for many years.

The adventurous animal characters of the postcards, principally Hathi and Mr Hare, have now given way to a less

> **"Isn't it clever of the Marconi Wireless Company who have now invented a machine which will enable a vessel in distress to ring alarm bells on every ship within a radius (ask Daddy what radius is) of 80 miles!"**
> *TO TEDDY – JUNE 1920*

whimsical and more 'educational' subject matter. Drawing on his own interest in animal life and ornithology, Kaka imparts a veritable encyclopaedia of natural lore and general knowledge. He obviously spent a good deal of time browsing in books and museums on the children's behalf. The British Museum, the Natural History Museum in South Kensington, where the curator was a friend, and the Brighton Aquarium were among his favourite stamping grounds. Kaka knows exactly what best arouses a young child's curiosity. He concentrates upon the most striking titbits of information and backs them up with vivid illustrations that are

drawn with particular care for the accuracy of colour and markings.

He also tells a good story. Among other examples, one letter is devoted entirely to his rescue of a guillemot he discovered on Brighton beach which had been contaminated by oil tar:

As he squatted on the pebbles, preening his feathers, I very slowly advanced towards him, stopping when he looked up. In half an hour I was within two yards of him. Then he stopped cleaning his feathers, and it was ten minutes before I was close enough to stoop and catch him. He was surprised! Twisted his funny old head about and tried to bite me. I stopped that by rubbing his head with my right hand, but he pinched my chin, which no doubt pleased him! I put him in a waste paper basket and he went to sleep. In the afternoon I carried him to the aquarium and he joined two other guillemots and a razor-bill in a big tank, and will, I hope, be happy and good!

> **"Going to fish at Hove."**

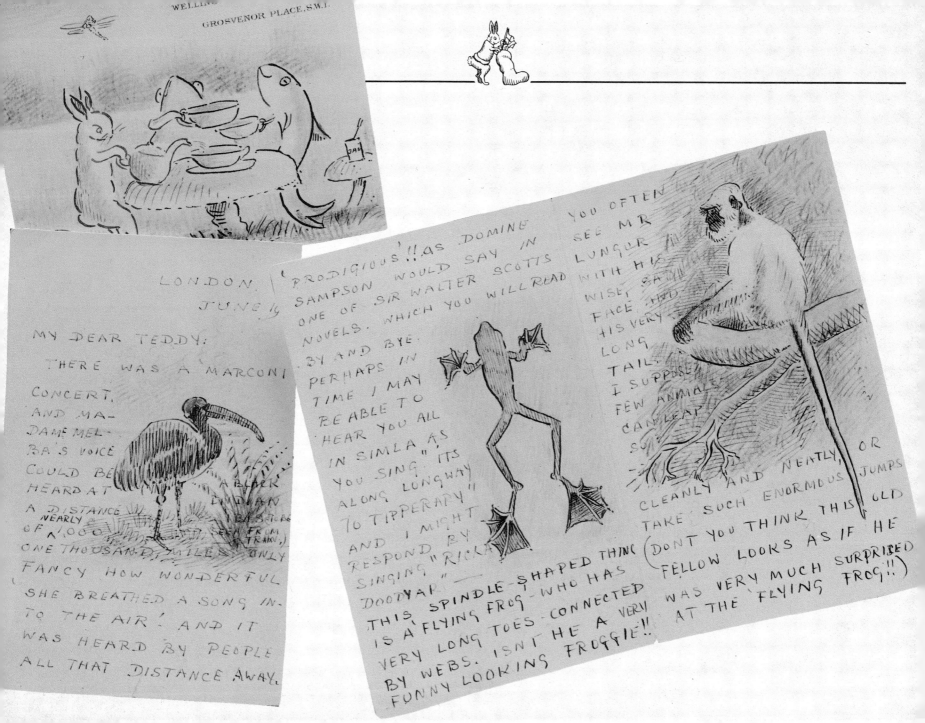

LONDON.
JUNE 19

MY DEAR TEDDY:

THERE WAS A MARCONI

CONCERT, AND MA-
DAME MEL-
BA'S VOICE
COULD BE
HEARD AT
A BLACK
A DISTANCE LYNDIAN
NEARLY IBIS.(ALSO
OF 1,000 SEEN FROM
ONE THOUSAND MILES. ONLY TRAIN.)
FANCY HOW WONDERFUL
SHE BREATHED A SONG IN-
TO THE AIR! AND IT
WAS HEARD BY PEOPLE
ALL THAT DISTANCE AWAY.

"PRODIGIOUS!! AS DOMINE
SAMPSON WOULD SAY IN
ONE OF SIR WALTER SCOTTS
NOVELS. WHICH YOU WILL READ
BY AND BYE.
PERHAPS IN
TIME I MAY
BE ABLE TO
HEAR YOU ALL
IN SIMLA AS
YOU SING. ITS
A LONG LONG WAY
TO TIPPERARY"
AND I MIGHT
RESPOND BY
SINGING "RICKA-
DOODYAR" —

THIS SPINDLE-SHAPED THING
IS A FLYING FROG - WHO HAS
VERY LONG TOES - CONNECTED
BY WEBS. ISN'T HE A VERY
FUNNY LOOKING FROGGIE!!

YOU OFTEN
SEE MR
LUNGOR
WITH HIS
WISE SAD
FACE AND
HIS VERY
LONG
TAIL.
I SUPPOSE
FEW ANIMALS
CAN LEAP
SO

CLEANLY AND NEATLY, OR
TAKE SUCH ENORMOUS JUMPS
(DON'T YOU THINK THIS OLD
FELLOW LOOKS AS IF HE
WAS VERY MUCH SURPRISED
AT THE FLYING FROG!!)

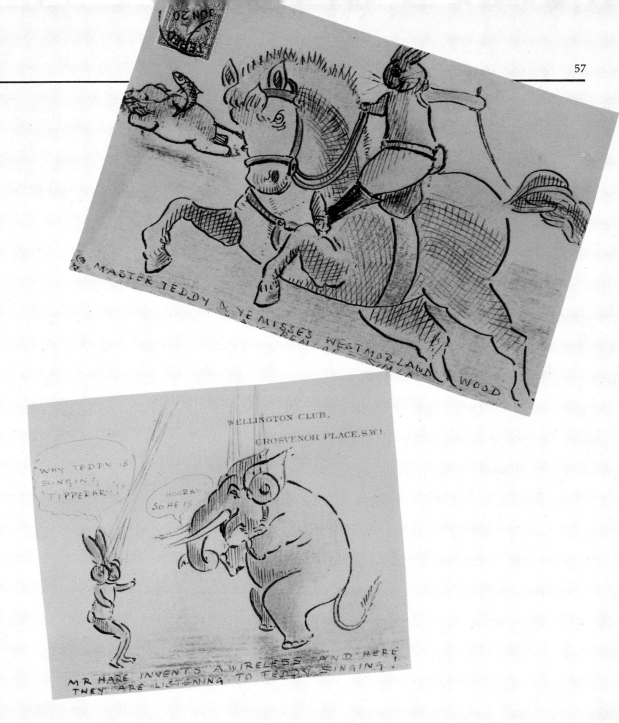

LYING FISH - THERE ARE
ER 40 DIFFERENT KINDS
D SOME CAN FLY 300
RDS! (WELL DONE, SIR!!)
HAT A LIFE THEY MUST
EAD! - PURSUED BY GREEDY
MONSTER-FISH THEY FLASH
UT OF THE WATER - LITTLE
ARS OF SILVER - AND FIND
EA-BIRDS AFTER THEM IN
HE AIR! INTO THE SEA
THEY DIVE - PERHAPS TO HAVE
TO DASH OFF ON ANOTHER
PERILOUS FLIGHT TO ESCAPE
BEING SWALLOWED BY
SOME OTHER HUNGRY FELLOW.
FISH! MUCH LOVE - DEAR -
FROM KAKA.

A LITTLE JOKE ON THE PEOPLE COMING FROM CHURCH BY SETTING BEHIND THE LAURELS AND WITH HIS HANDS TO HIS MOUTH IMITATED THE CUCKOO. GENERAL MONEY SAW SEVERAL PEOPLE STOP AND SAY "DID YOU HEAR THE CUCKOO?" "HOW EARLY TO HEAR THE CUCKOO"!

(SOMETHING LIKE A HORN-BILL)

THE DEAR WEE CHINCHILLA.

AS IT WAS IN MARCH – NEARLY A MONTH BEFORE THE CUCKOO ARRIVES IN ENGLAND. IT WAS TOO BAD OF UNCLE CUD TO TAKE THEM IN! HE CAN IMITATE THE CALL – AND CRY OF THOSE CHEERFUL SONGSTERS OF THE NIGHT – THE JACKALS! AND WHEN HE WAS A SMALL BOY HE CALLED

THE SO CALLED FOUR-EYED FISH.

JACKAL RACING UP TO UNCLE CUD'S CALL.

Westmorland

SIMLA INDIA

A.5. BEMLOE. SIMLA. INDIA.

"All snakes used to go on four legs, but only in one Indian snake the python, which sometimes grows to a length of ten yards – thirty feet! – can we trace any remains of the limbs, and the hind legs can be plainly seen – or rather what is left of them. The universal rule is – that when any organ – or part of the body – is not used, it slowly but surely gets smaller and smaller and at last – after a long long time – it disappears altogether. The whale who used to be a land animal has only faint marks now to show where his hind legs used to be. What a wonderful world this is!"

TO TEDDY – JUNE 1920

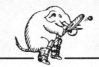

Indian birds and animals were his speciality and he encourages the children to take an interest in the Indian habitat by asking them to look out for different species and report back to him. As he writes to Teddy: 'What curious things we can find out by watching animals, birds, insects, and fishes.'

The letters must have stirred fond memories of India for Kaka. Throughout there are references to Anglo-Indian terms and rituals which would still have been familiar to post-war British families living under the Raj. The occasional drawing of an Indian scene or landscape is lovingly done. And at times he is unequivocally nostalgic for the old days and the old places: 'I hope you will find

" Snapshot of Capt. Woodcock by Teddy who notices that his ear is underneath his big eye, and that the eye is very far back in his head and he guesses the reason is that this fine bird loves probing wet ground for worms."

TO TEDDY – JUNE 1920

nice nests and pretty flowers in Simla. Give Kaka's love to the snows – the birds – the butterflies and the dear trees and tell them I don't forget them and love them very much.'

" I like your letters dear, very much. But send me a drawing when you are not inclined to write. You know one often feels like that! Perhaps Nannie will write down what you want to say sometimes. The way to fix pencil drawings, they say, is to breathe on them. So, please breathe."

" O! Well jumped Margaret!"

TO MARGARET – JULY 1920

Simla was the grandest of the European hill-stations in India and Kaka knew it well. The retreat to the hills in March for the duration of the hot season was part

THE MALL AT SIMLA

of an old tradition in British India. At considerable cost, the whole seat of government moved from the plains into the Himalayan foothills and stayed there until the coming of the cool weather in September or October. North and south India had separate hill-stations to receive this annual exodus, but Simla had a special position as the summer headquarters of the Viceroy. It was also where the Delhi and Punjab secretariats brought their families, the Westmorland Woods among them.

"I saw this swell somewhere"

> " Teddy bowled – after a good innings, because he – for a wonder – didn't play with a straight bat! Never mind, remember next time and you will keep your wicket up."

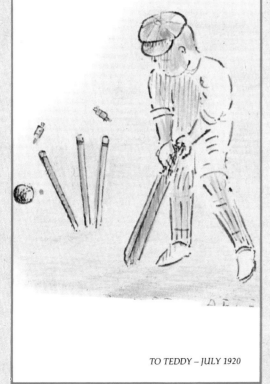

TO TEDDY – JULY 1920

Perched on a ridge over 2000 metres up, Simla looked like something out of suburban Surrey. Houses and bungalows of eminently English design swept down from the Gothic church along a broad avenue called The Mall – where the

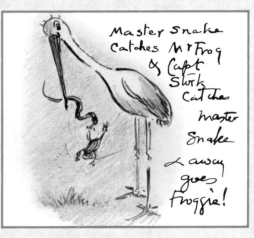

Master snake catches Mr Frog & Capt Stork catches master Snake & away goes Froggie!

European residents would take the air punctually at five every evening, congregating at hotels like fashionable Peliti's for tea and gossip. Even in 1920 Simla still had a Victorian feel. Motorcars were not allowed, only horses, carriages and rickshaws. Scenically, the place provided a refreshing contrast to the hot, flat plains. Northward lay tantalising glimpses of snow-capped Himalayan peaks. The surrounding valleys offered pleasant forest walks and sites for picnics. The calls of doves, barbets and cuckoos mingled with the distant rush of streams and waterfalls.

At nearby Annandale a race-course lying in a shaded valley of pines and deodar cedars formed the setting for pony races, polo, gymkhanas, archery and fêtes. By the Woods' time tennis courts had been added, which were flooded for skating during the winter months. Seven miles away lay Mashobra where Lord Curzon (Viceroy 1899–1905) had used a house called The Retreat as a bolt-hole from the hectic social round of Simla. The Woods, too, sometimes got away from it all to Mashobra, putting up in the local *dak* bungalow that served as a rest-house. In the neighbourhood stood a large mansion called Wildflower Hall, which had been Lord Kitchener's residence during his time as Indian Commander-in-Chief. Teddy recalls that 'it had a huge swing strung between two quite tall pine trees, and you went up steps to a platform, pulled the swing up, and then set off into what seemed like miles into the air!'

"A very pretty puss"

BRIGHTON 2
No. 482

Master Teddy & ye Misses

...morland Wood
.W...

IT WAS VERY WET. HERE
A VALUABLE
TIP FOR YOU—
IF YOU WANT
TO CLEAN YOUR
KNITTING NEED-
LES— RUB WITH
EMERY PAPER.
AWAY WILL GO
THE RUST AND
THEY WILL SHINE LIKE NEW ONES!

Nest of Fan-tailed Fly-catcher on Trians (INDIA)

HIMALAYAN WANDERING PIE

Miss Margaret Westmorland Wood.
Simla —

August 1920

MY DEAR LITTLE MARGARET.

SUCH FUN WITH THE KITTEN—
OR RATHER I SHOULD SAY FOR ...
THE KIT-
TEN, WHO
RUNS UP
AND DOWN
MY LEGS
WHILE I
AM TRY-
ING TO DO
MY WRITING,
AND I AM
FULL OF LIT-
TLE HOLES
AND SCRATCHES! A MERRY GAME
FOR HER, BUT WHEN MR NASH ...
OR I SUDDENLY SCREECH 'OW!
IT MEANS THE KITTEN HAS ...

MARGARET IN HER CANOE.

CLIMBED UP ONE'S LEG—
AND IS
HOLDING
ON WITH
ALL ITS
CLAWS!
THE OLD
CAT, I AM
SORRY TO
SAY, CATCHES
BIRDS AND
YOUNG RABBITS. I SEE HER OF-
TEN WAIT-
ING VERY
PATIENTLY
IN THE GAR-
DEN FOR
LITTLE, WEE
BIRDS, WHO
CANNOT FLY
VERY FAR.
A NUMBER
OF LITTLE

MARGARET SEES A STAG.

THE ADJUTANT (A STORK)

CHILDREN CAME TO TEA,
AND ELEVEN
OF US PLAYED
GAMES IN THE
GARDEN. THE
YOUNGEST WERE
FIVE AND THE
ELDEST NINE
YEARS OLD. THEY
HAD A LOVELY
TIME, AND WERE
VERY GOOD IN-
DEED. THEY ALL
SANG THEIR GRACE SO NICELY,
I WISHED
YOU THREE
COULD HA-
VE HEARD
THEM. THE
BIGGER ONES
WENT BY
MOTOR TO
CLACTON
ON THE
SEA, AND

A GOLDEN-CRESTED WREN.

"COME AND DANCE KAKA"

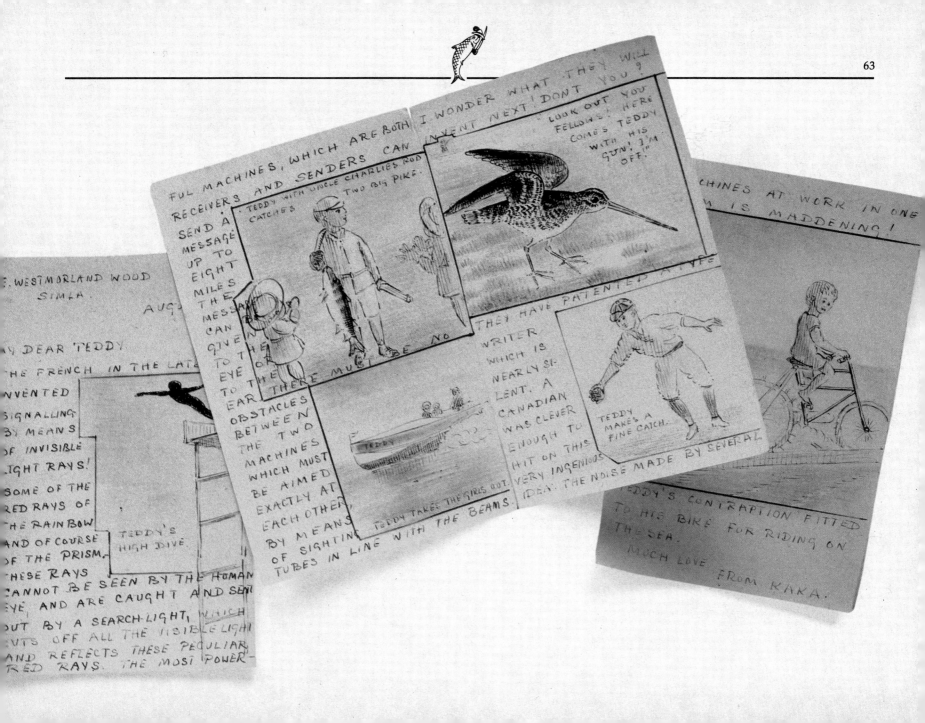

WELLINGTON CLUB, SEP. 1920

GROSVENOR PLACE, S.W.1.

MR PURPLE
HERON
BRINGS ANOTHER
INVITATION
FOR
ELIZABETH.

FOR
TEDDY WESTMORLAND WOOD.
SIMLA.

AUGUST 1920

MY DEAR OLD TEDDY.

I KEPT YOUR BIRTHDAY ON 30ᵗʰ JULY AND WONDER IF I WAS RIGHT! ANYHOW I SENT YOU ALL SORTS OF GOOD WISHES ACROSS THE DEEP BLUE SEA, AND HOPE YOU HAD A VERY HAPPY BIRTHDAY — UP IN THE HIMALAYAS — THOSE SPLENDID MOUNTAINS WHICH WE ALL LOVE SO MUCH.

JERBOAS, OR JUMPING RATS.

YOU MAY SEE THE 'JERBOA' OR JUMPING RAT — SUCH A JOLLY LITTLE FELLOW WITH VERY LONG HIND LEGS, & SUCH VERY TINY FORE-LEGS. I AM AFRAID THEY EAT A LOT OF WHEAT, AND MAKE THE GROUND VERY DANGEROUS FOR PEOPLE WHO ARE ON HORSEBACK! BECAUSE THEY TUNNEL UNDER THE SURFACE — AND ALSO STORE GRAIN IN

FLYING SQUIRREL.

THEIR UNDERGROUND BURROWS. THEY ARE VERY PLENTIFUL IN THE PUNJAB, BUT I NEVER SAW THEM IN THE HILLS. I LIKE TO HEAR WHEN YOU SEE NEW BIRDS, LIKE THE HOOPOE YOU TOLD ME ABOUT.

THE SKIMMER TERN, OR SCISSOR-BILL FLIES LIKE THIS WITH HIS BILL IN THE WATER

THE HOOPOE BUILDS IN HOLES, AND HAS (PHEW!) SUCH A VERY SMELLY NEST — NEARLY AS BAD AS THE BEAUTIFUL LITTLE KINGFISHER

Kite balloon and observer in his car.

HEAD OF SKIMMER TERN.

In Simla the Woods lived at A5 Bemloe. Bemloe was a sort of housing estate reserved for government officials. Houses were graded from A to D according to rank and seniority. A5 had five bedrooms and a nursery upstairs, a drawing-room, dining-room, study, day-nursery, kitchen, and utility room (where a full-time *derzi* darned and sewed).

Some fifty yards behind the house lay the servants' quarters. The Woods employed five male servants and an ayah who helped with the children. The faithful Vera had accompanied the family to India – and subsequently married a British military bandsman who played at Peliti's.

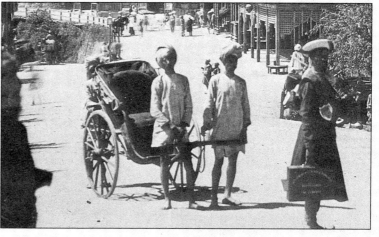

JAMPANEES AT SIMLA

In addition, A5 Bemloe engaged the services of four *jampanees* or rickshaw pullers – who wore a livery of blue tunics, yellow turbans and yellow puttees. Well-trained *jampanees* could run or walk exactly in step, ensuring a smooth ride.

In keeping with Thornhill tradition, numerous pets completed the Wood household in Simla. There were several dogs, including Kelpie the terrier and Charlie's old dog Gipsy, a number of white rabbits, some cats, and usually a tame bird or two. For a time Margaret had a pet crow, which had been injured and which she nursed back to health.

" **Have you ever heard of a parrot fish? So called because it has a very horny sort of a beak in his ugly old mouth. A naval officer I once knew put his finger into a large parrot fish's mouth! Result – the fish promptly bit off the top joint of the naval officer's first finger!!**"

TO MARGARET – AUGUST 1920

" **Do you know that stockings always ought to be washed before they are worn? By this, thin parts in the weaving get thicker and are strengthened. And that's worth knowing.**"

TO MARGARET – AUGUST 1920

" **Margaret and Elizabeth go riding**"

MISS MARGARET WESTMORLAND
WOOD.
 SIMLA'.
 SEPTEMBER 1910.

MY DEAR LITTLE MARGARET
 THERE ARE A LOT OF BUNNIES
HERE AND WHEN THEY GET
INTO THE GARDEN THERE
IS A FEARFUL TO DO! SWEEP

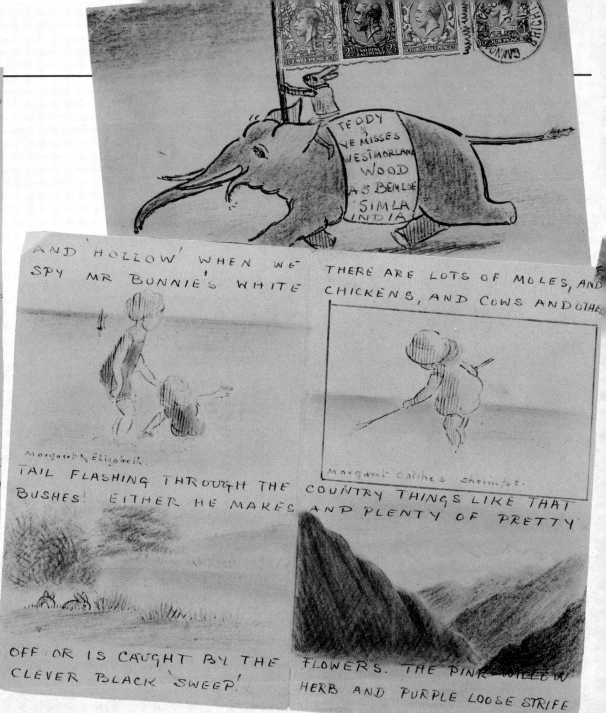

THE BLACK DOG TEARS ABOUT—
—AWAY DASHES THE RABBIT!
WE ALL RUN TOO AND SHOUT

AND HOLLOW' WHEN WE
SPY MR BUNNIE'S WHITE

Margaret & Elizabeth.

TAIL FLASHING THROUGH THE
BUSHES! EITHER HE MAKES

OFF. OR IS CAUGHT BY THE
CLEVER BLACK 'SWEEP!

THERE ARE LOTS OF MOLES, AND
CHICKENS, AND COWS AND OTHER

Margaret catches shrimps.

COUNTRY THINGS LIKE THAT
AND PLENTY OF PRETTY

FLOWERS. THE PINK WILLOW
HERB AND PURPLE LOOSE STRIFE

TEDDY
&
YE MISSES
WESTMORLAND
WOOD
A 5 BEMLOE
SIMLA
INDIA

TWO PENCE 2½ TWO PENCE HALFPENNY THREE HALFPENCE FOUR PENCE

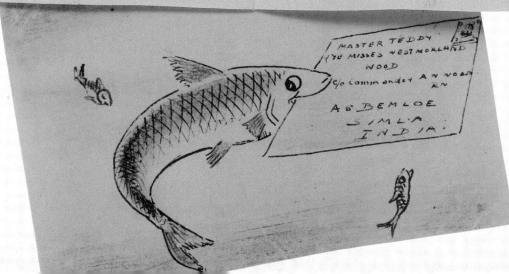

DONT BE A CRY-BABY HATH.!
YOU'VE BROKEN MY BOAT
AND OF COURSE YOUR
BILLY OLD TAIL HAS
GOT WET!"

MASTER AND YE MISSES WESTMORLAND WOOD.
C/o COMMANDER A. WESTMORLAND WOOD.
A.S. BEMLOE, R.N.
SIMLA INDIA.

TEDDY WESTMO... SIMLA. Oct. 1920

MY DEAR TEDDY

ISNT THIS INTERESTING! HERE
IS A MOTOR (TRACTOR) GOING UP
A STEEP BANK. THE DRIVER
HAS GOT OFF AND IS GUIDING
... FOOT. A

I HAVENT LEFT ANY ROOM
FOR WRITING SO WONT SAY
MUCH THIS WEEK. WHAT

HAVE CAUGHT AT THE SEA-
SIDE! I WONDER WHAT
MUMMIE, DADDY AND NANNIE

A SPLENDID LOT OF FINE WILL SAY! MUCH LOVE
FISH YOU AND THE GIRLS FROM KAKA.

MASTER TEDDY
PYE MISSES WESTMORLAND
WOOD
C/o Commander A.W. WOOD
R.N.
A.S. BEMLOE
SIMLA
INDIA.

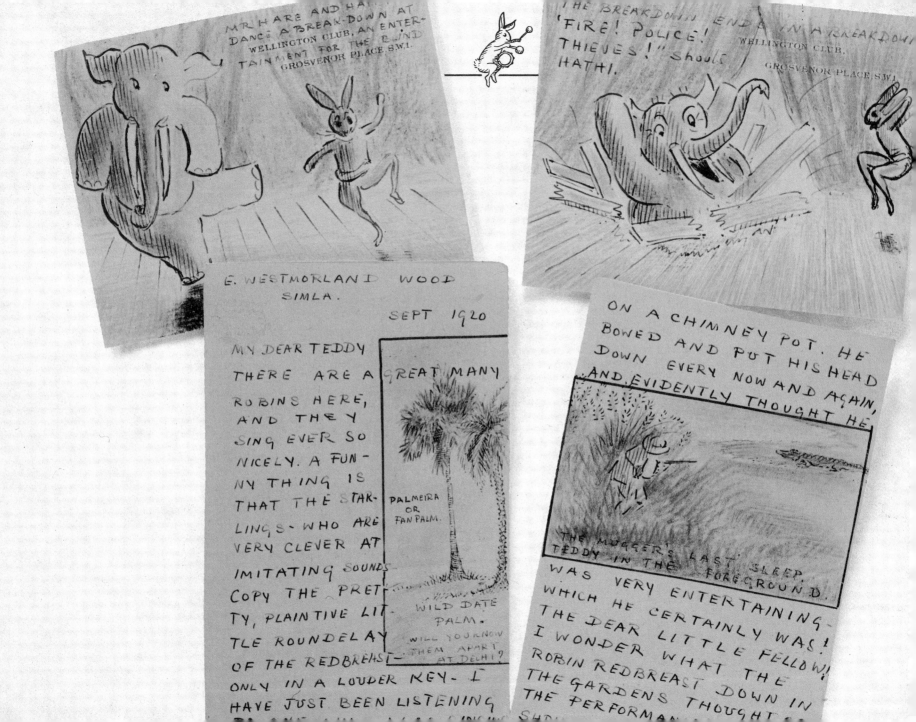

MR HARE AND HA...
DANCE A BREAK-DOWN AT
WELLINGTON CLUB, AN ENTER-
TAINMENT FOR THE BLIND
GROSVENOR PLACE, S.W.1.

THE BREAKDOWN ENDS IN A BREAKDOWN
"FIRE! POLICE!
THIEVES!" SHOUTS WELLINGTON CLUB,
HATHI. GROSVENOR PLACE, S.W.1.

E. WESTMORLAND WOOD
SIMLA.

SEPT 1920

MY DEAR TEDDY
THERE ARE A GREAT MANY
ROBINS HERE,
AND THEY
SING EVER SO
NICELY. A FUN-
NY THING IS
THAT THE STAR-
LINGS - WHO ARE
VERY CLEVER AT
IMITATING SOUNDS
COPY THE PRET-
TY, PLAINTIVE LIT-
TLE ROUNDELAY
OF THE REDBREAST-
ONLY IN A LOUDER KEY- I
HAVE JUST BEEN LISTENING

PALMEIRA
OR
FAN PALM.

WILD DATE
PALM.
WILL YOU KNOW
THEM APART
AT DELHI?

ON A CHIMNEY POT. HE
BOWED AND PUT HIS HEAD
DOWN EVERY NOW AND AGAIN,
AND EVIDENTLY THOUGHT HE

THE MUGGER'S LAST SLEEP.
TEDDY IN THE FOREGROUND.

WAS VERY ENTERTAINING -
WHICH HE CERTAINLY WAS!
THE DEAR LITTLE FELLOW!
I WONDER WHAT THE
ROBIN REDBREAST DOWN IN
THE GARDENS THOUGHT OF
THE PERFORMAN...

Not all government servants returned to Delhi at the end of the hot season. In the winter of 1921–2 the Woods stayed in Simla and Teddy remembers heavy snowfalls there – as well as dressing up in goat skins as Robinson Crusoe for a Christmas fancy-dress party (the skins were later made into a coat for Margaret).

" Teddy snapped by Margaret before the big lawn tennis tournament, which he won because he practised against a wall for an hour every day."

TO TEDDY – SEPTEMBER 1920

The British in India cheerfully tried to make Christmas as English as possible. In the weeks leading up to it most European stations laid on parties, dances and amateur theatricals but somehow the season retained a distinctively Indian flavour. If Christmas cake was a must, pea-fowl frequently took the place of

" A book which I like very much indeed is called 'Opal Whiteley's Diary', and was written by a little girl of between six and seven, who hadn't a very nice home with foster parents but had such a lovely disposition that she was ever so happy with dogs, trees, pigs, cows and rats as her friends. You will love her, as we all must."

TO MARGARET – OCTOBER 1920

turkey. Father Christmas arrived on a camel, an elephant or, in the railway communities, a steam engine. Picnics, polo and pig-sticking would be organised, while in remote up-country stations families might spend Christmas under canvas, shooting, fishing and cooking round the camp fire.

By 1920 Teddy was going to school. In Simla he first received private tuition at Viceregal Lodge in the select company of the Viceroy's daughter and a few other children. Later he attended Bishop Cotton School in Simla. This lay three miles from the Woods' house and Teddy rode there every morning accompanied by the family's *syce* or groom. He recalls the school as a 'fairly rough place', attended mainly by Eurasian children. 'I don't remember learning much except playing marbles and flying fighting paper kites. You got your line (with a sort of sand solution on it) over your opponent's line and then sawed like mad to try and cut his line before he cut yours!'

"The merry 'oont'. Don't trust him – he's a biter!"

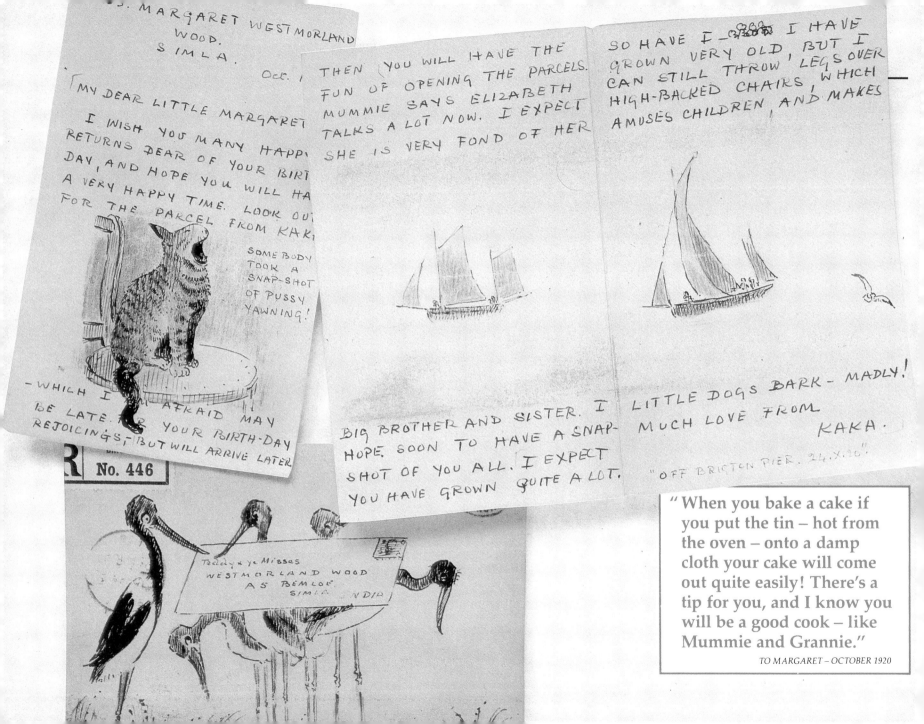

S. MARGARET WESTMORLAND
WOOD.
SIMLA.
Oct.

MY DEAR LITTLE MARGARET

I WISH YOU MANY HAPPY
RETURNS DEAR OF YOUR BIRTH-
DAY, AND HOPE YOU WILL HAVE
A VERY HAPPY TIME. LOOK OUT
FOR THE PARCEL FROM KAKA

SOME BODY
TOOK A
SNAP-SHOT
OF PUSSY
YAWNING!

—WHICH I AM AFRAID MAY
BE LATE FOR YOUR BIRTH-DAY
REJOICINGS—BUT WILL ARRIVE LATER.

R No. 446

Today & ye Misses
WESTMORLAND WOOD
AS BEMLOE
SIMLA INDIA

THEN YOU WILL HAVE THE
FUN OF OPENING THE PARCELS.
MUMMIE SAYS ELIZABETH
TALKS A LOT NOW. I EXPECT
SHE IS VERY FOND OF HER

BIG BROTHER AND SISTER. I
HOPE SOON TO HAVE A SNAP-
SHOT OF YOU ALL. I EXPECT
YOU HAVE GROWN QUITE A LOT.

SO HAVE I — I HAVE
GROWN VERY OLD, BUT I
CAN STILL THROW LEGS OVER
HIGH-BACKED CHAIRS, WHICH
AMUSES CHILDREN, AND MAKES

LITTLE DOGS BARK — MADLY!
MUCH LOVE FROM
KAKA.

"OFF BRIGHTON PIER. 24.X.20"

> "When you bake a cake if
> you put the tin – hot from
> the oven – onto a damp
> cloth your cake will come
> out quite easily! There's a
> tip for you, and I know you
> will be a good cook – like
> Mummie and Grannie."
>
> TO MARGARET – OCTOBER 1920

Kaka's letters to Teddy display a great interest in inventions and new technology. Today the telephone, radio, powered flight and X-rays are taken for granted, but in 1920 these things were still being pioneered and aroused widespread interest. Wireless broadcasting, of the most rudimentary kind, began only in 1919, the same year that Alcock and Brown flew the Atlantic and the world's first commercial air service (between London and Paris) was inaugurated. Kaka read *Wireless World*, the bible of radio enthusiasts, and took pains to search out items which he thought would interest his grandson.

" This motor car was driven up and down the steps at the Crystal Palace to show how wonderfully some new springs acted! (They must be very wonderful springs!)." *TO TEDDY – OCTOBER 1920*

"Here's a funny globe-fish for you. He is long and graceful, but can take in air and blow himself out in a very balloon-like way."

TO TEDDY – NOVEMBER 1920

Some of these items concern quite complex technological processes, but Kaka has a knack of making them sound both simple and exciting. A typical letter relates the discovery of 'wireless photographs' – that is, the telegraphic transmission of pictures. This was a process really invented by a German scientist, Professor Korn, but it became a practical proposition only when a Danish watchmaker called Anderson succeeded in 1920 in transmitting a picture of a young woman from one wireless station to another. 'So we could exchange greetings on your birthday', Kaka tells Teddy, 'and see one another's photograph!' This must indeed have seemed a miraculous device to contemporaries and Kaka's effusive catch-phrase – 'What will they do next!' – shows him thoroughly in tune with the youthful optimism of the 1920s generation.

"Worn by a newsboy to keep off the rain"

Master & ye
Misses Westmorland
WOOD
Commander A.W. WOOD
RN
A.S. Bembe
SIMLA
INDIA.

FOUR PENCE
4 4

...ng Mashi...
...iki Boy as clown in
WELLINGTON CLUB. the Royal
Bembe Circus.
GROSVENOR PLACE, S.W.1.

TEDDY WESTMORLAND WOOD
SIMLA,
OCT. 1920

MY DEAR TEDDY.
I AM. VERY GLAD YOU ARE
AT MASHOBRA. ITS LOVELY
IN THE HILLS IN AUTUMN.

AND ALL THE BIRDS WHICH
CROSSED THE SNOWS AND FLEW
FAR NORTH TO BREED, ARE
COMING BACK FOR THE
LOVELY COLD WEATHER.

WE OFTEN SEE AND
HEAR DUCKS, GEESE AND
CRANES, AND SOMETIMES
SEE GREAT FLOCKS HIGH IN
THE AIR. WINGING SOUTH,
AND KNOW THE SUMMER

COVERED WITH LIGHT BLU
AND DARK BLUE FEATHER
ON HIS LOVELY WINGS. H
NESTS IN HOLES, AND HAS
A VERY HARSH VOICE. BUT
WE ALL LOVE TO WATCH HIM

THUMB-NAIL SKETCH OF A PICTURE SHOWING WHALERS ATTACKING SPERM-WHAL

HEATS ARE OVER AND PAST.

LOOK OUT FOR THE 'ROLLER'
[BECAUSE HE ROLLS ABOUT IN
THE AIR] WE CALL HIM 'THE
BLUE JAY' - BECAUSE HE IS

I HAVEN'T MUCH TIME FOR
WRITING IN LONDON AND
NO TABLE TO WRITE AT IN MY
BEDROOM. MUCH LOVE
FROM KAKA

MISS MARGARET WESTMORLAND
WOOD - DELHI!

NOV. 19 20.
Brighton.

DEAR LITTLE MARGARET.

I HAVE BEEN SENDING OFF
PARCELS FOR XMAS, AND
EXPECT YOU WILL ALL BE
EXCITED WHEN THEY ARRIVE

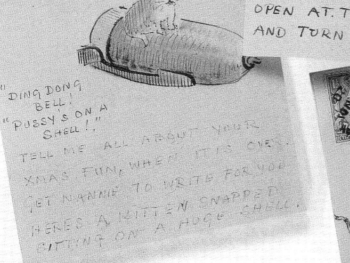

"DING DONG
BELL!
"PUSSY'S ON A
SHELL!"

TELL ME ALL ABOUT YOUR
XMAS FUN, WHEN IT IS OVER.
GET NANNIE TO WRITE FOR YOU.
HERE'S A KITTEN SNAPPED
SITTING ON A HUGE SHELL.

HERE IS A
PICTURE OF
THE UGLY,
FEROCIOUS
GRUBS OF THE
PRETTY RED
AND OF THE
BLUE AND
OF THE OTHER
PRETTY DRAGON-
FLIES. WHO WOULD THINK THAT
THE HIDEOUS THING WOULD
CLIMB UP A REED, BURST
OPEN AT THE TOP OF ITS BODY
AND TURN INTO A BRIGHT, AND

Dragon fly larva
Chasing a Waterbeetle
man!

PARTY, AS THEY
LIVES ON MOSQUITOES ETC ETC.
ONLY, FANCY, THAT IN THE
DAYS WHEN THE TREE-FERNS
WERE GROWING,
WHICH WE NOW
USE AS COAL,
THE DRAGON-
FLIES WERE
VERY LARGE,
ABOUT AS
BROAD ACROSS
THE WING AS
A PIGEON! I
SHOULD LIKE TO SEE ONE-(IN
THE COAL I MEAN)- IF ONE
CAME FLYING ROUND THE CORNER
I SHOULD FEEL INCLINED TO
TAKE COVER!
MUCH LOVE DEAR
FROM
KAKA.

MASTER TEDDY WESTMORLAND
WOOD DELHI.

NOV. 1920

MY DEAR TEDDY.

"A MERRY XMAS AND A HAPPY
NEW YEAR". THIS LETTER WILL I
HOPE REACH YOU ON XMAS DAY.
(MUCH LOVE WITH THE PRESENTS
FROM KAKA.) DONT FORGET TO
[THE UPPER
TUSHES OF THE
BARBARUSA
HOG - GROW
THROUGH
HIS SKIN.
AND NO
ONE CAN
GUESS
WHY, AS
THEY SEEM
USELESS FOR ATTACK.]
THROW SOME CRUMBS FOR THE
BIRDS' XMAS DINNER - DEAR THINGS.

ONLY MAKE SURE THOSE VUL-
GAR FELLOWS THE CROWS DONT
GET THEM ALL. YOU MAY FIND
AMADAVATS NESTS IN BUSHES.
IN DECEMBER : LÁLI' - THE NATIVES
CALL THEM - LOVELY, WEE BIRDS
A RULE, AND LAY SEVEN TO
TWELVE DEAR LITTLE EGGS.
YOU OFTEN SEE A LOT OF THEM
IN ONE CAGE. IF YOU SEE
ANY BIRDS YOU DONT KNOW
TELL ME ABOUT THEM, AND ASK

THE TEDDY-MONO-PLANE

WHICH LARGELY HELPED
TO WIN THE WAR.

WHO BUILD BIG-UNTIDY NESTS - MUMMIE TO DESCRIBE THEM TO ME.
LOW DOWN IN THORN BUSHES. AS LOVE, DEAR MAN FROM KAKA

WELLINGTON CLUB, WOOD
GROSVENOR PLACE, S.W.1. SIMLA
1920

ELIZABETH MAKES
MR HARE SOME
LOVELY PINK
NIGHTIES. HE
IS SO PLEASED
THAT HE WEARS THE
PANTALETTES AT THE
ANANDALE TENNIS TOURNAMENT!

> "I expect your dark snake was a 'dhaman', or rat snake, and, very likely, the one with the mark of an arrow was the Himalayan viper, who is poisonous but not very deadly. Anyhow, in India no one should go about, even in the house, without shoes or boots."
>
> *TO TEDDY – NOVEMBER 1920*

Something of the magic and wonder of early radio is communicated in Kaka's letter to Teddy about Dame Nellie Melba's wireless broadcast. This marked the first serious attempt to use radio as a medium of entertainment. Sponsored by the *Daily Mail*, it took place on 15 June 1920 at the newly built Marconi Company's transmitting station in Chelmsford, Essex. When the engineer explained to the famous *diva* that her voice would be carried far and wide from the wires at the top of the towering antennae masts, Melba expostulated: 'Young man, if you think I am going to climb up there you are greatly mistaken!'

In the station 'studio' she was placed before a microphone consisting of a telephone mouthpiece attached to a horn made of cigar-box wood. At 7.10 p.m. listeners heard a preliminary trill across the air waves as the engineers tested the distance between singer and microphone. There then followed, to the accompaniment of a small grand piano, Melba's inimitable rendition of 'Home Sweet Home', '*Nymphes et Sylvains*', and the '*Addio*' from *La Bohème*.

The broadcast was heard over a radius of one thousand miles and elicited a rapturous response. Letters of congratulation poured in from Europe, Newfoundland and even Persia. In Paris the reception at the Eiffel Tower station proved good enough to make a gramophone record.

EXCUSE ME"—AND SKIP. DO YOU REMEMBER OUR RIDES AT THE ZOO? HERE WE ARE AGAIN! D! HER TORN COAT RE-NDED ONE OF THE FOX WITH TEDDY LEADING KINS LADIES NOW ARE AND ELIZABETH AND EARING ACROSS TH KAKA HOLDING ON HOULDERS! AND I D.

NT HELP LAUGHING WITH BEHIND IT LOO OF COURSE I SHOULD NOT RISKY BUT IS O HAVE DONE SHE MIGHT NOT ALL RIGHT WITH JEER. TRAINED INDIAN STEED UED ME MUCH LOVE KAKA.

"Mr Frog brings a letter for Elizabeth"

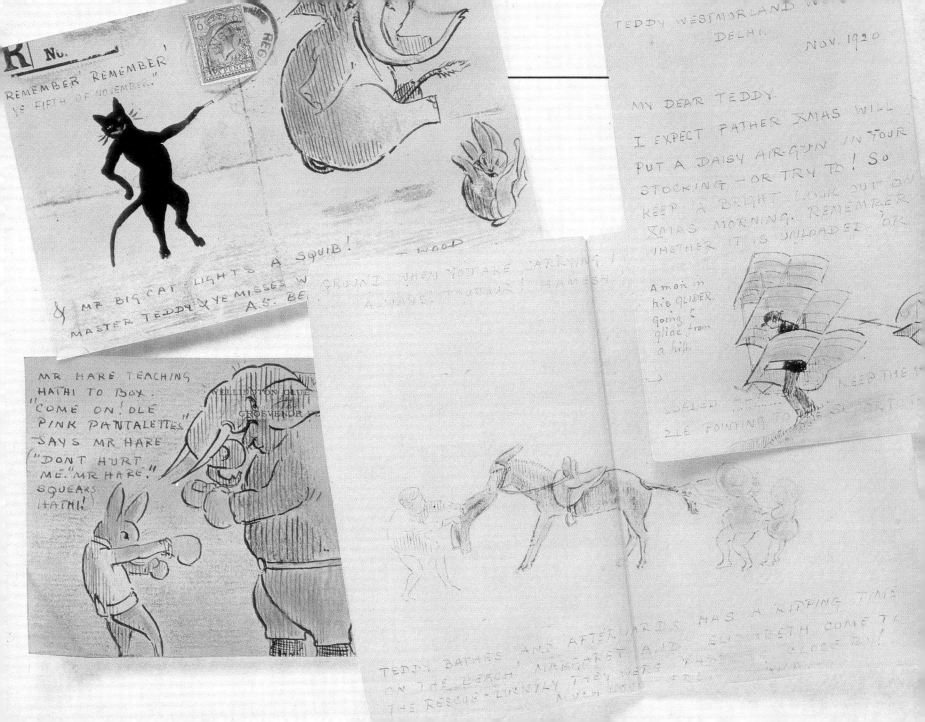

Overall, the letters from Kaka to Teddy describe a remarkable variety of inventions. Some were well proven – a French military device for signalling by means of invisible light rays, 'silent' typewriters (the first electric machines for commercial office use), a motor-tractor with caterpillar treads. Others, however, were clearly more fanciful and experimental – an ingenious Dutch idea for saving postbags from sinking ships, flying tanks, and the ill-fated Petroczy helicopter of 1916 (intended as a sort of hovering military observation post, it could stay aloft for about an hour but crashed after only fifteen ascents).

Even parachuting was a sufficiently remarkable feat in 1920 for Kaka to record instances in the letters. The first successful drop from an aeroplane, using a static line, occurred in America in 1912 and in Europe the following year. Not until 1919 did someone jump with a manual parachute (one not dependent on a line from the plane), chiefly because of misplaced fears that a faller would lose consciousness before he had time to pull the rip-cord.

> "I am going on Xmas day to the children's hospital here and will give them butterflies from my babas in India. I know you will all like that very much. And so will they I am sure!"
>
> *TO MARGARET – DECEMBER 1920*

The early pioneers had their fair share of disasters and Kaka does not hesitate to relay news of some of the more spectacular incidents. One can't help thinking he would have made a good contributor to the *Boy's Own Paper*.

Airship aviation in particular was plagued by calamity and the accident which befell the R34, the first airship to cross the Atlantic both ways, evokes some graphic illustrations in one letter to Teddy. The airship struck a hill in East Yorkshire in the early hours of 28 January 1921. There were no casualties but the craft limped back to its moorings at Howden in a badly damaged condition. Further buffeting from gale-force winds soon reduced the airship to a total wreck. Interestingly, Kaka does *not* relate the more serious accident which overtook the R34's sister ship R38 in August 1921. During flying trials over Hull a series of explosions ripped through the airship, killing forty-six officers and men.

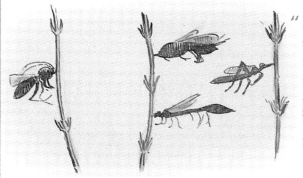

> "If you see bees or wasps sticking out like this from twigs – don't be surprised – they are resting, and probably are sleeping! What wonderful jaws they must have!"
>
> *TO TEDDY – DECEMBER 1920*

"Teddy coming down in his parachute"

Y DEAR TEDDY,

I HOPE THE 'DAISY' AIRGUN AND
THE PELLETS WILL ARRIVE IN
GOOD TIME. IT WAS THE ONLY ONE
THE STORES HAD, SO I WAS,
VERY LUCKY TO GET IT! HERE'S
A VERY HAPPY NEW YEAR TO YOU,

HE LOOKS
ALL BROWN
UNTIL H...
SUDDEN...
JUMPS UP
...SHOWS

THE PON...
HERON...
OFTEN S...
DURING...
IN THE...

"AN...
HA...
HE...

ELIZABETH GIVES
MR HARE A.
VERY CHASTE
JUMPER - AS A
REWARD FOR
HIS SNIFTNESS,
AND STUFFS
HIS STOCK-
ING FULL
OF NICE
PRESENTS
AT XMAS.

THOU...
BIRD OF PRE... RI... HAVE...
CATS, CATS AND RABBITS AND DOGS HAVE B...
RABBITS AND DOGS HAVE ...
KNOWN TO BECOME GREAT FRIENDS.
I LIKE THE KNIFE YOU AND
TEDDY BOUGHT FOR ME

SO PLEASED WITH THE
BUTTERFLIES I GAVE THEM
ON XMAS DAY FROM YOU
THREE BABAS. THEY LOVED
THEM VERY MUCH, AND WERE
SURPRISED TO FIND SWEETS

MY DEAR LITTLE MARGARET
THIS WILL I HOPE REACH YOU
ABOUT MY BIRTHDAY - WITH
A PARCEL OF - 'HUSH! KARA!'
THAT'S A SECRET'!! (SO IT IS!)
THERE IS SNOW IN ENGLAND
AND MUCH SNOW-BALLING.

AND WHEN I USE IT - I INSIDE THEM.
SEND YOU EACH A KISS! MUCH LOVE, DEAR,
THE LITTLE SICK GIRLS FROM
IN THE HOSPITAL WERE KARA.

"Hurrah!" Squeak's
HATHI ROY —
"HOORAY! I
SPY YOU old
FATHER
XMAS HARE!"
COME OUT
OF IT, DO.

MR HARE dresses up as
Santa Klaus & takes
presents TO HATHI
FROM
TEDDY, MARGARET
ELIZABETH AND
ANNE
WESTMORLAND
WOOD

A.S. BEMLOE
SIMLA
INDIA

WELLINGTON CLUB.
GROSVENOR PLACE. S.W.1

MISS MARGARET WESTMORLAND
WOOD.

DEC 1920

MY DEAR LITTLE MARGARET.
A VERY HAPPY NEW YEAR!
I THINK THIS LETTER WILL
REACH YOU ABOUT NEW YEAR'S
DAY, AND I SHALL BE THINK-
ING OF YOU ALL, AND WONDER
ING HOW YOU LIKE YOUR DOL-
LIES AND OTHER THINGS. IT
WAS GREAT FUN CHOOSING FOR

ARE THESE
PENGUINS
PRACTISING
XMAS DANCES?
YOU ALL, BUT ANXIOUS WORK
ALL THE SAME! HER...

A HAPPY NEW YEAR

Teddy & Ye
Misses Westmorland
Wood.
℅ Commander A. W. Wood
R.N.
A.S. Bemloe,
SIMLA.

I EXPECT SOON AFTER YOU GET THIS YOU WILL BE BACK AGAIN AT SIMLA. LISTEN FOR THE GIANT BARBET WHO CALLS OUT ALL DAY LONG. 'PIAO-PIAO. PIAO', IN THE MERRY SPRING TIME.

'KAIPHAL PUKKU' OVER AND OVER AGAIN. DONT YOU LOVE THE OWL WHO WHISTLES LIKE A BELL ALL NIGHT ANSWERING HIS FRIEND ACROSS THE VALLEY, OR HIGHER UP ON THE WOODED HILLS?

SOMEBODY SAYS MR HARE CANT RIDE A CLOCK-WELLINGTON CLUB. WORK WOOLLY LAMB = MR HARE GROSVENOR PLACE. S.W.1 TRIES - AND IS FLUNG OFF. HATHI, IS AMUSED.

ISN'T IT SAD THAT THIS SUB-MARINE HAS BEEN LOST WITH ALL HANDS. WE SI THE

INVENT SOME WAY OF SENDING S.O.S. SIGNALS FROM A SUNKEN SUB-MARINE.

IT IS ONE OF THE NEW TYPE WITH SUNKEN BOWS. HERE SHE IS ON THE SUR-FACE, AND A QUEER LOOKING CRAFT SHE IS. SOON I HOPE THEY WILL

AS THEY HAVE DONE FOR ORDINARY SHIPS IN DIS-TRESS. MUCH LOVE (AND HI HOPES THE DAISY IS A GOOD ONE) FROM KAKA.

WELLINGTON CLUB. 1921 GROSVENOR PLACE S.W.1.

ON ELIZABETH BIRTHDAY MR HARE AND HATHI USHER IN THE DAY WITH SOFT MUSIC.

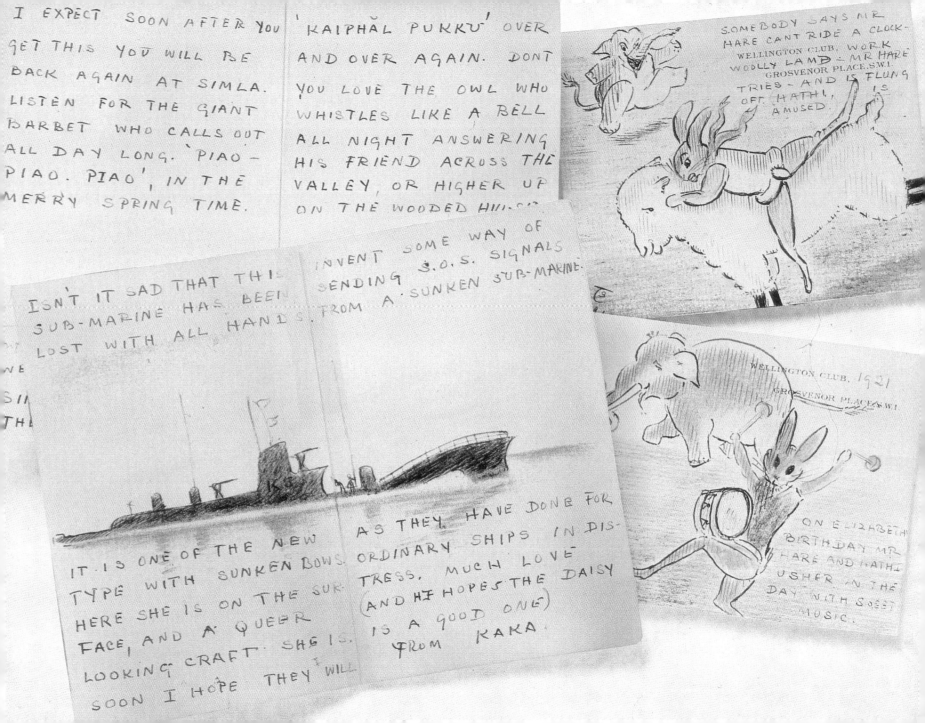

Sturdy outdoor pursuits were Kaka's recipe for a healthy life. As a talented sportsman himself, he was keen for Teddy to follow in his footsteps. The letters portray the boy in colourful little vignettes as a brilliant all-rounder excelling at cricket and tennis. He is also the hero of the hour in numerous aeroplanes (usually triumphing over the 'Hun' in a dogfight), motor-cars and other contraptions in which speed and danger are the essential elements. And of course the boy is a wizard with a gun, 'bagging' tigers, leopards, and crocodiles (appositely called *muggers* in Hindi), as well as a whole jungleful of game birds. Cud and Charlie had become very good shots under their father's tutelage and Kaka wanted Teddy to learn to shoot as early as he could. For Christmas 1920 he sent him a 'Daisy' airgun, and thereafter shotguns of varying sizes and calibres followed as the boy grew older. Shooting was then a fashionable sport, especially in India which, with its teeming wild game, offered unlimited opportunities for *shikar* or hunting. Kaka remembered good *shikar* at Dehra Dun, a hill-station within reach of Delhi set amid thick forests. Contrary to Raj legend, tiger hunts and pig-sticking were never more than minority pursuits but shooting wild duck, pea-fowl, partridge and other game birds proved popular with European hunters (*shikari*). As on the British grouse moors of the day, 'bags' of hundreds of birds at a time were commonplace, especially on V.I.P. shoots.

But Kaka always taught Teddy to shoot with restraint. Only certain birds were fair game. 'Remember to only shoot at crows in the summer months,' he advised. 'They nest early and are able – the cheery ruffians – to look after themselves!' Kaka believed crows worried other birds needlessly. And a golden rule was: never point a gun, even a toy one. It was one of the few transgressions that made him cross. The other, Teddy remembers, was more eccentric: 'failure to wash my face *before* getting into the bath. He thought it was unhygienic and disgusting.'

"Who are these three?"

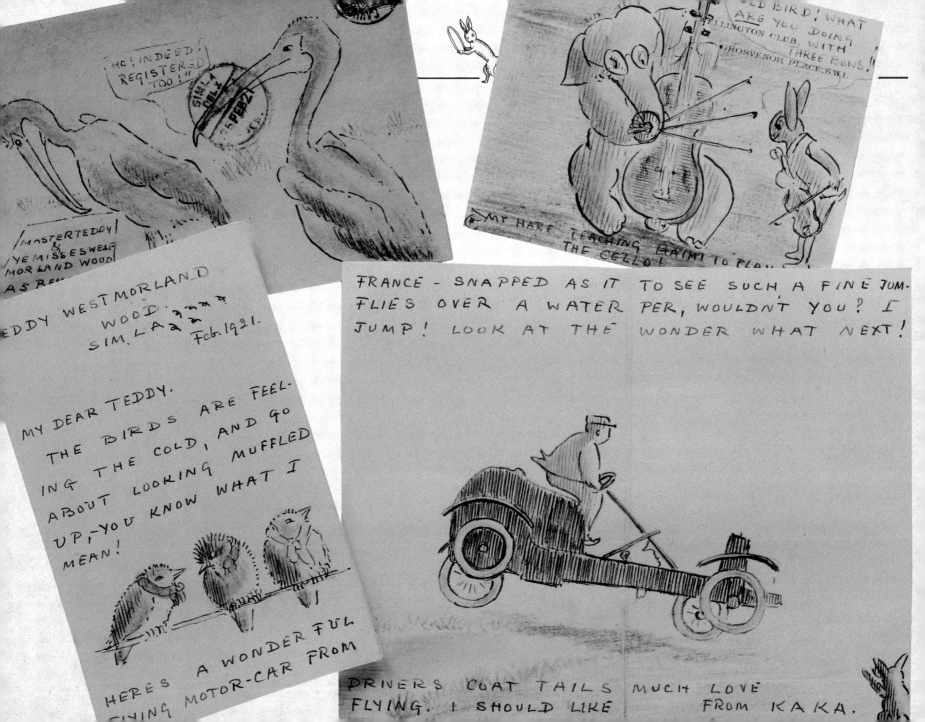

THE JALL CRAZE HAS CAUGHT MR HARE & HATH AND CO. (MR HARE CAN PLAY JAZZ TUNES!

Teddy & Ye Misses
Westmorland Wood.
C/o Commander A.W. Wood. RN
SIMLA.

...RET WESTMORLAND WOOD.

FEBY 1921

MY DEAR LITTLE MARGARET

HOW YOU WOULD LIKE TO GO WITH ME TO TALK TO THE POOR LITTLE BLIND CHILDREN — THEY ARE SO BRAVE — SO BRIGHT SUCH LITTLE

DEARS. I GO VERY, VERY

OFTEN, & IT MAKES ME VERY HAPPY. FOUR OF THEM WENT WITH ME TO THE PIER — NO MUSIC WAS ON SO WE GOT INTO THE ELECTRIC RAILWAY. THEY CUDDLED UP CLOSE TO ME & WT STROKED MY HANDS & COAT AND KISSED ME.

WHEN WE REACHED BLACK-ROCK THEY JUMPED FOR JOY ON THE SHINGLE AND THEN KNELNT DOWN AND

PATTED THE STONES WITH THEIR HANDS. THEY SHOUTED EVERY TIME THEY FOUND A MUSSEL SHELL. THEN WE HAD TEA AT A TEA SHOP-VERY HAPPILY, AND THE LITTLE PARTY SANG SONGS AND

DANCED ALONG THE ROAD TO THEIR HOME. SUCH A PLEASURE TO SEE THEM SO MERRY. WITH LOVE FROM RAHH.

MASTER TEDDY WESTMOR-
LAND WOOD,
SIMLA,
MARCH 1921

MY DEAR TEDDY.

THE SPRING IS COMING IN
WITH FLOWER AND BIRD
AND ALL THE WINTERS
ARE OVER, BUT I WISH
YOU WERE ALL HERE WITH
ME. WHAT FUN WE WOULD

What you sometimes
see. A heron after
poor old froggy—
Jump!!

...
HAVE TAKING OUT THEIR ...
...

TEDDY

MY DEA...

SHE IS AFTER BEING
KNOCKED ABOUT IN OUR
LAST GALE. LOOK AT

I SAW THE PRINCE OF
WALES TWICE TODAY
AND THERE WERE MANY

HER POOR NOSE! WE
ARE VERY SORRY FOR
HER SAD MIS-FORTUNE.

THOUSANDS OF SCHOOL
CHILDREN CHEERING HI...
IN THE PARK. MUCH LO...
FROM KAKA

HERE IS R34 SAILING
OVER ENGLAND ON HER
RETURN VOYAGE FROM
AMERICA, AND HERE

> "I was walking on the front and saw a little boy of about four petting the donkeys – then he put his hand into a donkey's mouth. Of course the donkey shut his mouth tight, and wouldn't let go though the boy yelled and screamed and tugged! I seized the naughty beast by the nostrils and forced open its jaws. Such a rumpus and racket!"
>
> *TO MARGARET – FEBRUARY 1921*

In general, the letters steer Margaret towards more homely virtues. Kaka was scrupulously courteous towards women, always insisting that hats be doffed to them and seats given up for them. Thus little Margaret is treated to tips on how to 'steam' a baked cake, or clean knitting needles, or is advised why washing stockings strengthens them. But she is by no means left out of all the fun. Knowing how much she loves cats, Kaka regales her with the doings of the Persian cat at The Holt. This 'rascal' is always chasing the birds in the garden and Kaka spends hours watching to see that no harm is done. Kaka also depicts Margaret playing tennis and golf, learning to shoot, flying her own aeroplane (which he nicknames the 'Baby-Avro'), and even parachuting. After all, post-war women were enthusiastically taking up and excelling at many sports, including flying. This clearly met with Kaka's approval. In June 1920, for example, a certain Miss Zetta Hills attempted to cross the Channel on an improvised water-bicycle. She had to give up when the contraption fell apart. Kaka was sufficiently taken by the idea to draw Margaret on *her* special bicycle 'paddle-boat' in a letter that followed shortly afterwards.

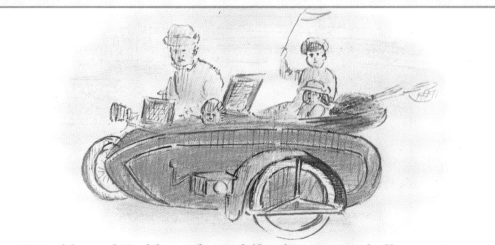

"Daddy and Teddy make a shikari motor and all go out for the day to shoot and catch fish for Mummie"

"Margaret fits paddles to her canoe"

TEDDY WESTMORLAND WOOD.
SIMLA.

April. 1921

DEAR TEDDY

THIS POOR OLD ROOK,
WHILE TUGGING AT A
TWIG FOR
HIS NEST,
WAS
CAUGHT
IN A FORKED
BRANCH,
AND THERE
HE HANGS
CLOSE TO HIS NEST.
ITS VERY SAD, FOR

ALL THE OTHER ROOKS.
WHO NO DOUBT FLEW
ROUND HIM CAWING
BUT DIDN'T KNOW HOW
TO HELP HIM. SOMETIMES

GET AWAY - POOR LITTLE
THINGS! WADING BIRDS
- SANDPIPERS, OYSTER
CATCHERS ETC - ARE OC
CASIONALLY CAUGHT BY

POOR LITTLE BIRDS WHO
LINE THEIR NESTS WITH
HORSE HAIR ARE CAUGHT
IN A LOOP, AND CANNOT

THE FOOT BY SHELL FISH
AND CANT ESCAPE.
MUCH LOVE
FROM KAKA.

WHAT DO YOU MAKE OF THIS AEROPLA

GROSVENOR PLACE, S.W.1

" Kaka is so glad you are going
to Simla again – Delhi is nice
for a change but the hills are
splendid in the spring. I love
the rhododendrons in flower – don't
you? Look out for the 'ayar' or lily of
the valley tree. The trunk is twisted
and the bark has deep lines in it."

TO TEDDY – MARCH 1921

CARNIVAL TIME.

Kaka rarely recommends books to the children – perhaps because they were too young for serious reading – but the one major exception, *Opal Whiteley's Diary*, is a thoroughly characteristic choice. This remarkable diary was published in England in 1920, having first appeared in serial form in the American journal *The Atlantic Monthly*. It had apparently been written by the adopted daughter of a poor lumberman from Oregon. From the age of six until adulthood she had painstakingly confided her thoughts and feelings to

> " I like your painting of a house and please make me a mountain. Not too much colour, nice and soft."

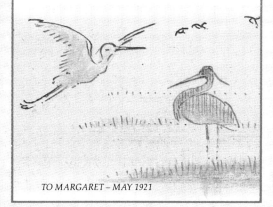

TO MARGARET – MAY 1921

scraps of paper in different coloured chalks. The total manuscript ran to some 150,000 words, though the published version was half this length and chiefly related to Opal's childhood at the age of six and seven.

> " The young robins look like frogs I always think! They are always hungry ('toojours' as Tommy says in his French)."
> *TO MARGARET – MAY 1921*

In recent years some doubt has been cast upon the authenticity of the diary, but it is not difficult to see why Kaka recommended it to his grandchildren. Quite apart from her qualities of imagination, Opal comes across as a skilled observer of nature, as someone who loved animals, and above all as a shining example of the spirit triumphing over the harsh realities of everyday existence. As the *Daily Telegraph* put it in 1920: 'Every true lover of childhood will read it spellbound, and the reader who fails to respond to its appeal has surely lost the secret of his own childhood.'

If Kaka's own personal enthusiasms provide the heart of the letters to Teddy and Margaret, taken as a whole the correspondence also affords an oblique glimpse of life in England in 1920–1. The small cameo illustrations in particular present a charming evocation of contemporary dress fashions, whether they are worn by the bird and animal characters or just children. A past era is fleetingly contained in references to newsboys, pier-end pierrots, donkey-rides on the beach, and grouse-moor shoots in the Scottish Highlands with Uncle Cud. Kaka never mentions politics but one letter (May 1921) contains a quaint drawing of a miner using his bicycle as a contraption for raising coal. It is Kaka's only reference to the bitter miners' strike of 1921, which collapsed in June and resulted in harsh wage cuts in many coalfields. Widespread distress was reported in the mining communities during the strike, with thousands of working men and their families dependent on soup kitchens and other charity hand-outs. We feel that if Kaka admired the miner's ingenuity, he also sympathised with his predicament.

"Oh Elizabeth! Do be careful!"

BE ALL RIGHT. A LITTLE BO
TUMBLED OFF A GROIN INTO
THE SEA, INTO DEEP WATER
A MAN WHO ALSO COULD NOT
SWIM MUST NEEDS JUMP IN

AFTER HIM. THEN THERE
WERE TWO OF THEM SPLUTTE
ING AROUND! A SOLDIER W
WAS PASSING PULLED THE
PAIR OF THEM OUT AND F
SAW THE CROWD AND ASKE
WHAT WAS UP. THE PIERR
HAVE STARTED IN THEIR LITT

Teddy S.S.E.
Missed Westmorland
Commanded Aylwood
A.S. Bombe Rn
Indra SIMLA.

THE LEECHES! I HOPE
YOU WILL LIKE YOUR BIRTH
DAY PRESENTS FROM KAKA

IT ALSO HAS ITS OWN
ELECTRIC LAMP! IT CAN
BE SUB-MERGED (SUNK

Air Inlet

Electric Lamp

Electric Motor

air Outlet

Collapsible Tank

air Storage Tank

Rubber Sleeves

Propeller

ISNT THIS A QUAINT SORT
OF A LIFE-BELT! IT ACTUAL-
LY HAS A MOTOR INSIDE
ITS FISH-LIKE EXTERIOR.

UNDER WATER)!
MUCH LOVE DEAR MAN.
FROM KAKA

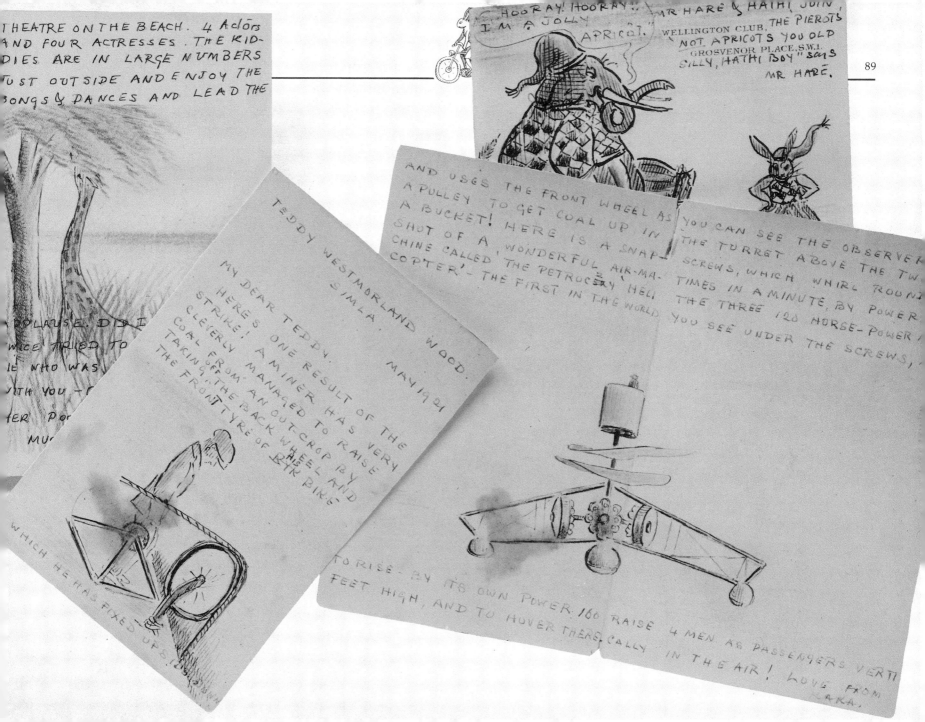

THEATRE ON THE BEACH. 4 ACTORS AND FOUR ACTRESSES. THE KIDDIES ARE IN LARGE NUMBERS JUST OUTSIDE AND ENJOY THE SONGS & DANCES AND LEAD THE

...PPLAUSE. DID I...
...WICE TRIED TO...
...E WHO WAS...
...ITH YOU — ...
...ER POO...
MU...

"HOORAY! HOORAY!! I'M A JOLLY APRICOT." "MR HARE & HATHI JOIN WELLINGTON CLUB. THE PIEROTS NOT APRICOTS YOU OLD SILLY, HATHI BOY" SAYS MR HARE.
GROSVENOR PLACE, S.W.1

AND USES THE FRONT WHEEL AS A PULLEY TO GET COAL UP IN A BUCKET! HERE IS A SNAP-SHOT OF A WONDERFUL AIR-MA-CHINE CALLED 'THE PETROCERY HELI-COPTER'— THE FIRST IN THE WORLD

YOU CAN SEE THE OBSERVER IN THE TURRET ABOVE THE TWO SCREWS, WHICH WHIRL ROUND ... TIMES IN A MINUTE, BY POWER THE THREE 120 HORSE-POWER ... YOU SEE UNDER THE SCREWS,

TEDDY WESTMORLAND WOOD.
SIMLA. MAY 19 21
MY DEAR TEDDY.
HERE'S ONE RESULT OF THE STRIKE! A MINER HAS VERY CLEVERLY MANAGED TO RAISE COAL FROM AN OUT-CROP BY TAKING OFF THE BACK WHEEL AND THE FRONT TYRE OF HIS BIKE

WHICH HE HAS FIXED UP...

TO RISE BY ITS OWN POWER. 160 ... RAISE 4 MEN AS PASSENGERS VERTI-FEET HIGH, AND TO HOVER THERE, ...CALLY IN THE AIR! LOVE FROM KAKA.

DEAR TEDDY. JUNE 192...

WE ARE STILL WITHOUT RAIN - A SERIOUS MATTER FOR THE COUNTRY. A WIRELESS MAN SAYS HE HAS BY MEANS OF A CONTRAPTION INVENTED BY HIMSELF CAUSED CLOUDS TO FORM AND RAIN TO RESULT. SPLENDID IF IT CAN BE GENERALLY APPLIED - AS IT WOULD MEAN THAT RAIN COULD BE MADE TO FALL JUST WHERE IT WAS WANTED. THIS IS NOT MORE WONDERFUL THAN TA-KING PHOTOGRAPHS BY THESE WIRELESS WAVES! JUST THINK OF IT! ONE ASKS "WHAT WILL THEY DO NEXT!" FANCY BEING ABLE TO SEE THE PERSON'S PHOTOGRAPH ONE IS WIRELESSING TO! SO WE COULD EXCHANGE GREETINGS ON YOUR BIRTH-DAY AND SEE ONE ANOTHER'S PHOTOGRAPH - WHAT WILL THEY CALL THEM - 'ELECTRO GRAPHS' OR WHAT?

MUCH LOVE

FROM KAKA.

THE BATH TENNIS WEEK. WELLINGTON GROSVEN...

HATHI GIVES MR HARE A SHOCK BY APPEARING IN A YELLOW JUMPER, RED TIE & STRAW HAT.

THIS IS WHAT MR HARE EXPECTED AT THE SEA-SIDE. THIS IS WHAT ELIZABETH TOLD THEM.

> " I wonder what you will call the new little sister! And what did Elizabeth and Margaret say when they first saw her! I expect you will all teach her all sorts of useful things!"
>
> *TO TEDDY – AUGUST 1921*

Something that gets more of an airing is the heatwave that hit England in the summer of 1921. By the end of June no rain had fallen for some five months after the driest spring since 1858. *The Times* warned:

THE TIMES, SATURDAY, JUNE 25

CER | **SAVE WATER.** | TRO W

CROPS IN GRAVE DANGER.

(Correspondent.) | SIN'

July proved even hotter, with temperatures soaring into the nineties and breaking all records. On 10 July the *Sunday Express* reported 200 cases of heatstroke in the London area alone. Even *The Times* was moved to pronounce on 'The Great Heat' in a leader on 12 July. And the *Daily Express* went so far as to charter a plane to bomb the clouds with cylinders of gun cotton. It still did not rain – but the *Express* got an exclusive.

The unusually hot weather prompted some curious experiments. It was claimed, for example, that tests with thermometers showed straw hats and panamas to be the coolest headgear, tweed caps and police helmets the hottest. Topees, made of pith, ranked well up the scale for coolness. Teddy remembers that in India a strict rule drummed into children was: *never* go out in the sun without your topee.

> " Soon you will have the monsoon on you, to cool the poor heated country and replenish the water in the rivers, wells and underground streams. The water that falls on the ground and makes everything grow gets out of sight and yet slowly moves at about one mile per year! Isn't that slow! This is how water springs are made and how water gets into wells. Some of the water on the ground gets drawn up by Mr Sun into the sky, and forms the lovely clouds we all admire. So when the rain pours and pours, think what a lot of good it is doing, and how we should starve without it."
>
> *TO MARGARET – JUNE 1921*

"Here's a funny snapshot in one of the papers"

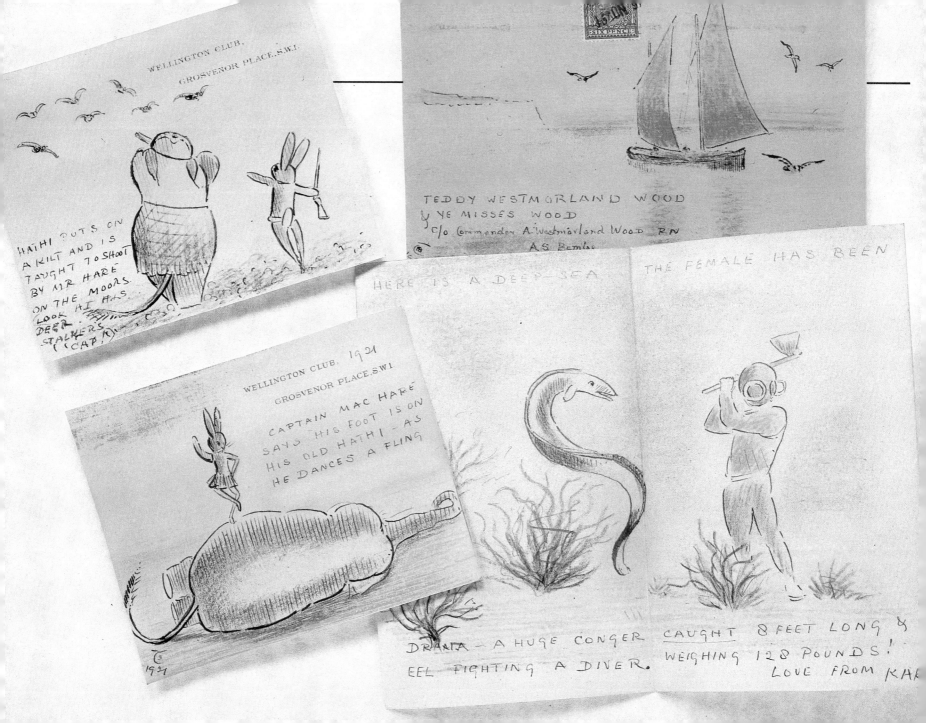

WELLINGTON CLUB,
GROSVENOR PLACE, S.W.1.

HATHI PUTS ON
A KILT AND IS
TAUGHT TO SHOOT
BY MR HARE
ON THE MOORS.
LOOK
DEER
STALKERS
(CAP?)

TEDDY WESTMORLAND WOOD
& YE MISSES WOOD
c/o Commander A. Westmorland Wood R.N.
A.S. Bembo

WELLINGTON CLUB, 1921
GROSVENOR PLACE, S.W.1.

CAPTAIN MAC HARÉ
SAYS HIS FOOT IS ON
HIS OLD HATHI – AS
HE DANCES A FLING

1921

HERE IS A DEEP-SEA THE FEMALE HAS BEEN

DRAMA – A HUGE CONGER CAUGHT 8 FEET LONG &
EEL FIGHTING A DIVER. WEIGHING 128 POUNDS!
 LOVE FROM KA

...R IN IN LONDON TO BE DELIVERED

STREAM LINE METALLIC HULL

FIXED RADIAL ENGINE

NEW YORK.

500 MILES AN HOUR.

LON...

SUSSEX. AND THIS IS AN IN ... NEW YORK NEXT MORNING
...DEAL) PICTURE OF THE AIR- THE TORPEDO WOULD FLY IN
...ORPEDO POST - CARRYING THIN AIR AT PERHAPS TEN
...AILS AND WIRELESSLY CON- MILES AN UP IN THINNER AIR.
...ROLLED WHICH WILL ENABLE MUCH LOVE
... EXPRESS LETTER POSTED
FROM NANA.

...AND HERE YOU...
...ARE RIDING A BACT... AT L...
...CAMEL - WITH TEDDY...

ELIZABETH WESTMORLAND
WOOD.
WELLINGTON CLUB, 1921
GROSVENOR PLACE, S.W.1.

AFTER MANY...
LESSONS MR HARE AT
LAST TEACHES HATHI TO
TAKE A PROPER HEADER.

WELLINGTON CLUB,
GROSVENOR PLACE, S.W.1.

JUST AS HATHI REACHES THE WATER WITH
A TREMENDOUS SPLASH, MR HARE TURNS
A DOUBLE SOMERSAULT AND THE BABAS
...TEST.

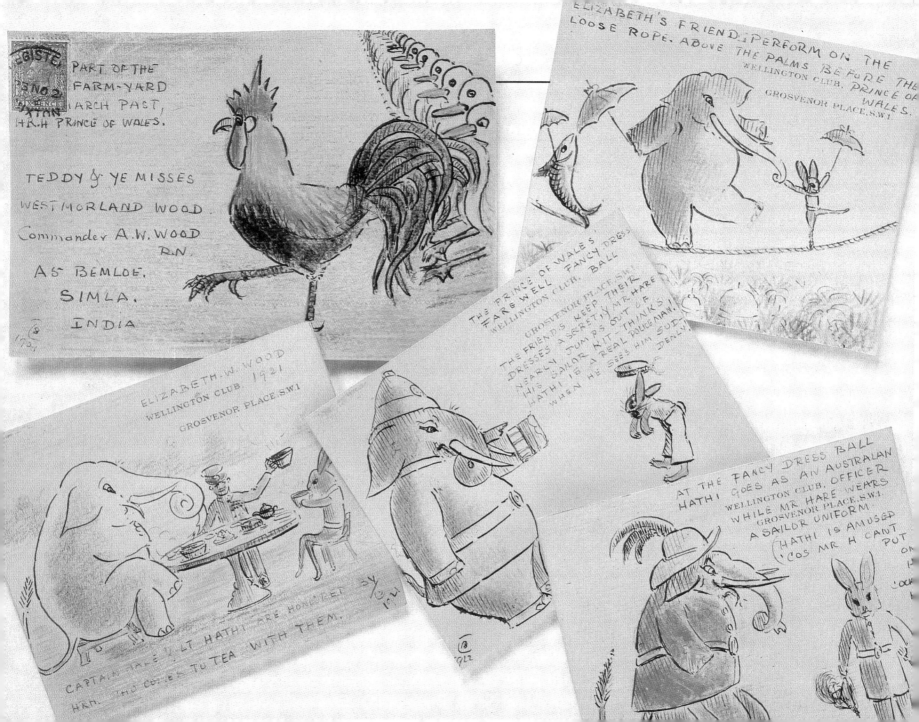

PART OF THE
FARM-YARD
MARCH PAST,
H.R.H PRINCE OF WALES.

TEDDY & YE MISSES
WESTMORLAND WOOD.
Commander A.W. WOOD
R.N.
AS BEMLOE,
SIMLA.
INDIA

ELIZABETH'S FRIENDS PERFORM ON THE
LOOSE ROPE ABOVE THE PALMS BEFORE THE
WELLINGTON CLUB PRINCE OF
WALES.
GROSVENOR PLACE. S.W.1

ELIZABETH. W. WOOD
WELLINGTON CLUB. 1921
GROSVENOR PLACE. S.W.1

CAPTAIN JALE & LT HATHI ARE HONOURED
H.R.H. WHO COMES TO TEA WITH THEM.

THE PRINCE OF WALES
FAREWELL FANCY DRESS
WELLINGTON CLUB. BALL
GROSVENOR PLACE. S.W.1
THE FRIENDS KEEP THEIR
DRESSES A SECRET. MR HARE
NEARLY JUMPS OUT OF
HIS SAILOR KIT - THINKS
HATHI IS A REAL POLICEMAN!
WHEN HE SEES HIM SUD-
DENLY.

AT THE FANCY DRESS BALL
HATHI GOES AS AN AUSTRALIAN
WELLINGTON CLUB. OFFICER
WHILE MR HARE WEARS
GROSVENOR PLACE. S.W.1
A SAILOR UNIFORM.
HATHI IS AMUSED
COS MR H CANT
PUT
ON

> **" You remember that storks have no voice muscles and cannot talk. They make a clatter-chitter with their mandibles (bills)."**
>
> *TO TEDDY - SEPTEMBER 1921*

The picture cards to Elizabeth continue the adventures of Hathi and Mr Hare – featuring Elizabeth as their companion rather than Teddy. The two animal characters seem suddenly to have developed very sporting interests, for they are now invariably swimming, diving, leaping, fishing, playing tennis – and even dancing the latest jazz step.

From time to time other animals put in an appearance, chiefly a large fish called Mughli Ji ('Mr Fish' in Hindi), Mr Purple Heron, Mr Frog, and Mr Wild Goose – their wives and daughters never seem to venture out – but Hathi and Hare remain the firm favourites.

Compared to the earlier cards, these contain superior illustrations and are generally much more elaborate. In some cases Kaka draws a set of cards which are linked by a common story, rather like a comic strip. Elizabeth would have to wait for the next post to find out how the story ended. Unlike some adults, who disapproved of children reading comics, Kaka happily treated his grandchildren to the popular *Rainbow* and *Tiger Tim* comic papers of the day.

The most ambitious card set Kaka sends Elizabeth contains no less than twenty-four cards celebrating the Prince of Wales' visit to India in the winter of 1921–2. The Prince, heir to George V and later to abdicate as Edward VIII, arrived in Bombay on 17 November 1921. Mahatma Gandhi's followers in the Indian nationalist movement appealed for strikes as a mark of protest, but the plea went largely unheeded except in Allahabad and Benares. The Prince's royal progress through the Indian sub-continent lasted four months and covered approximately eleven thousand miles. His total retinue numbered about one hundred European and Indian officials, and included twenty-five polo ponies lent by Indian princes. Three special trains were necessary to convey this small army about the country. The youthful Prince proved a popular figure, at least with the British community. In Nepal he shot his first tiger and at a ball in Lucknow delighted the gathering by taking over the drumsticks and beating out a jazz 'rag'.

> **" Margaret hooks a monster which plays splendidly, and is so strong that Teddy swims out with the landing net "**

Miss Elizabeth Westmorland Wood.

> **"Yet another letter for Elizabeth"**

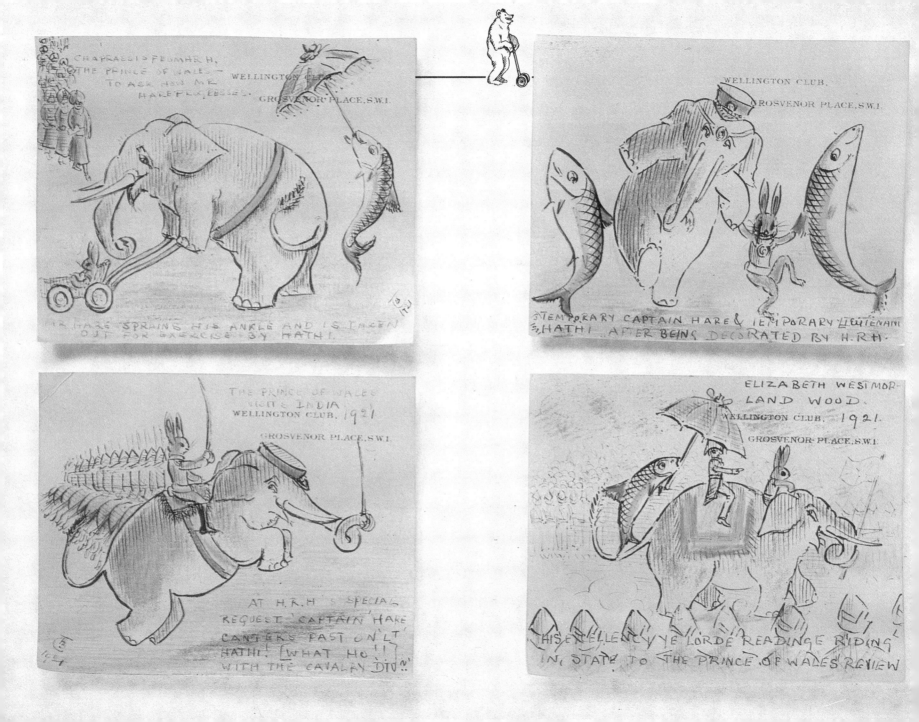

The India correspondence, finally, shows Kaka's fondness not merely for his own grandchildren but for all children everywhere. The letters are full of encounters with unfortunate children met with by accident or on casual visits to hospitals and children's homes. In London he sometimes gave away gifts at the Children's Hospital in Great Ormond Street, while in Brighton he was a regular visitor at a home for blind children. 'Poor mites', he writes to Margaret,

summer and winter they are plunged in darkness, can never enjoy the sight of flowers, trees, meadows, streams, and purple hills in the blue distance. No faces smiling and happy can they ever look upon, they can only hear their voices and feel their kisses on their cheeks. Yet they are so patient, so cheerful and so thoughtful for others.

Teddy recalls accompanying his grandfather to this home on one occasion and coming away 'feeling miserable. I particularly remember a blind girl called Rebecca. I was so sorry for her that I thought I might marry her!' This girl had a remarkably sweet disposition and was a great favourite with Kaka – as he confides:

Becky sometimes kisses my hand and says, 'I love you.' We had chocolate cake at tea one day on the pier and she said, 'Oh, I do like chocolate cake!' I asked her, 'Which do you love best – me or chocolate cake?' She hugged my arm and said very firmly, 'I like chocolate cake and I love you.' Poor mite.

Kaka always wore a distinctive eucalyptus scent on his handkerchief. He arrived one Christmas Day at the home disguised as Santa Claus, but as soon as he entered the room the blind children 'nosed' his presence and rushed up to him shouting, 'Sir Henry! Sir Henry!'

But however much he enjoyed the company of other children, Kaka greatly missed his own 'babas', Teddy, Margaret, Elizabeth – and Ann, who was born in Simla on 20 July 1921, and whom he had never seen. So though he always endeavoured to give a robust and cheerful performance, at times the correspondence cannot disguise a terrible underlying poignancy. Here he writes on Christmas Day 1921:

I called out when I awoke, 'A Merry Xmas to you all!' and can picture the fun you are having with the parcels and the presents! I wished I could join in the fun and frolic! I hope the parcels all arrived in time. I had a great time running round shopping! You would have laughed to see how puzzled Kaka was! 'Would they like this?' 'Is this any good?' And so on, until the old man was quite bewildered!

"Kaka & the hornet"

Kaka's wireless —
"The Compliments of the Season 1921-22
to
Teddy & ye Misses
Westmorland Wood."
c/o Commander A.W. Wood
R.N.
A.S. Bembe.
SIMLA,
INDIA

CHAPTER THREE

HOMEWARD BOUND

1922 – 1923

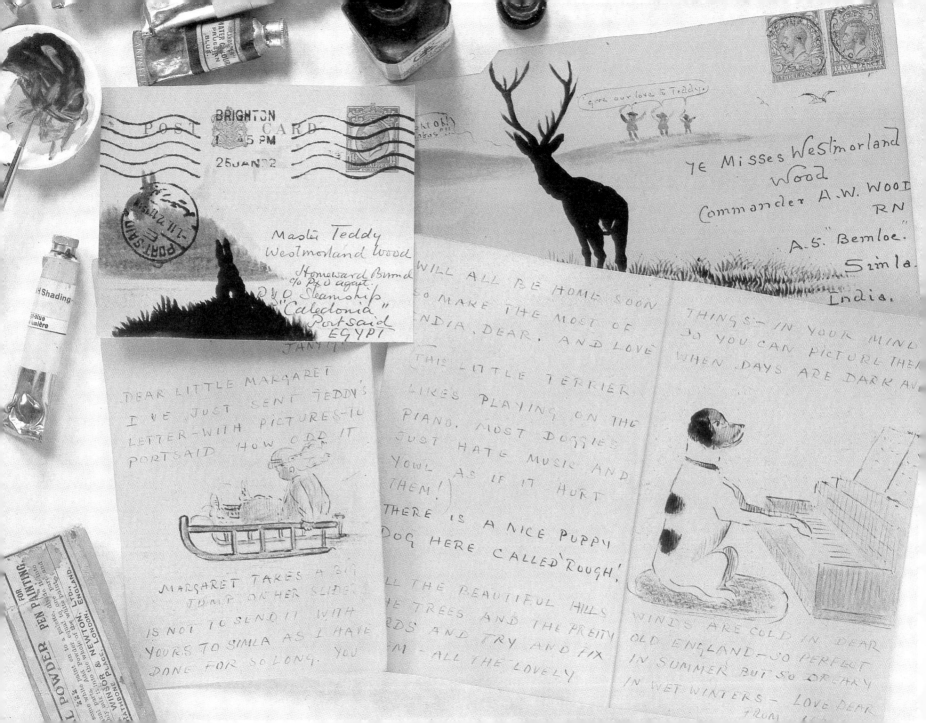

> " Kaka shooting with Teddy's gulail"

MARGARET, ANN, TEDDY AND ELIZABETH

By 1922 Teddy, now nearly ten, was considered old enough to be sent to boarding school in England. This strange British custom, practised throughout the Empire, involved colonial families in long separations. If it was painful for the parents, it was doubly painful for the children. Kaka himself had been sent away to England as a young boy and he knew how his grandson must be feeling as the time approached to embark on this most dreaded of Anglo-Indian rituals. At least Teddy could console himself that he would see his family within the year, for the Woods were due home on leave in 1923. Kaka wrote to Teddy on the eve of his departure from India:

The leaving home will be hard but you are a brave little man, and will look forward to seeing Mummie, Daddy and all the girls when they come home a few months later. What fun that will be, and you will soon forget the parting.

He added cheerfully: 'If you can bring home your gulail – it would surprise folk, wouldn't it! (Also rascals of cats ill-treating poor little birds!)'

Teddy had learned to use a *gulail* (or *gulel*) in Simla, shooting the round clay pellets at crows and kites. When he boarded the S.S. *Caledonia* at the end of January 1922, he duly brought the bow with him and, as he recalls, spent much of the voyage firing at flying fish.

Although aeroplanes had made the flight to Karachi in India in 1921, flying home to England did not become fashionable for some years. Besides, sea travel at this date was relatively fast, reasonably comfortable, and very cheap. For less than £50 (Second Saloon) the black- and buff-coloured P.&O. steamers took some eighteen to twenty days to reach London from Bombay, the voyage providing both a welcome period of rest for colonials starting their leave and an ideal way of slowly acclimatising to the cooler temperatures of Europe.

Hurrah! Teddy is coming home!

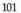

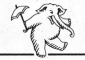

Teddy was accompanied on his journey by Mrs Venn-Ellis, a friend of his parents who was also returning home. The *Caledonia* was a relatively small, old ship (7,558 tons, built in 1894), and as second-class passengers they probably had to share their cabin with one or two others.

> " Gibraltar was so called by a Saracen general (Tarik Ben Zyaad) 'Jabalul Tarik'. We shortened this into 'Gibraltar'. The Moors held Gibraltar for 500 years, and introduced the apes you may see!" *TO TEDDY – FEBRUARY 1922*

A basin-holder and a camp stool constituted the only furnishings in these cramped quarters. Ventilation and heating were primitive. Electric fans operated only in the public saloons, while the dining-room, smoking-room and music-room were the only places to keep warm in cold weather owing to the steam pipes running through them beneath brass grills. The ship was capable of over nineteen knots and had a reputation for speed, having broken the record to Bombay, Calcutta and Colombo in her early years.

Two features of the *Caledonia* particularly struck passengers. One was the seven-course dinner, which always came with a menu printed in French. At a fitting moment between each course the head

waiter would solemnly bang a gong and an army of stewards would descend as one man on the empty plates.

The other feature, common to all P.&O. passenger ships plying the India route, was the dusky lascar crew, *khalassies* as they were known, recruited from India's coasts or the Laccadive and Maldive islands. Being Moslems, they were never drunk, and they worked better than Europeans in the intense heat east of Suez. In their dark-blue tunics, red waistbands and red-embroidered caps, the lascars lent an exotic flavour to shipboard life, a reminder of India accompanying passengers all the way to England.

S.S. CALEDONIA

> "The hoopoe builds in holes, and has (phew!) such a very smelly nest"

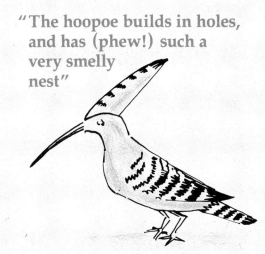

"Jekkho Kaka,
Kaisa tamasha!!"

...ys carry a
...berella' at
...mberley!"
...ys Mr Stork.

...e Misses
... Westmorland Wood
...mmander A.W. Wood, RN
 A.G. Bomboe,
 Simla.
 India.

ELIZABETH WESTMORLAND
WELLINGTON CLUB. WOOD.
GROSVENOR PLACE.S.W.1 10.22.
WHEN ELIZABETH TO T...
'RAMP, MR HARE PLUNGED
NTO THE WATER-JUMPER
AND ALL, AND HE DED...
HER. BRAVE MR HARE ...
BECAUSE HE WAS REAL...
 AFR...

MARGARET WESTMORLAND
 WOOD.
 SIMLA
 Feb. 1922
DEAR LITTLE MARGARET!
ONLY THINK OF IT! TEDDY
ARRIVES THIS WEEK!!
HURRAH!!! I SAW THIS

A Scoter Duck.
11. 2. 22.

POOR OLD BLACK WILD-DUCK
PREENING HIS FEATHERS ON
THE BEACH. NEXT MORNING
HE WAS DEAD. A MARINE
DUCK WHICH ONLY COMES

AWAY—VERY FAST WHEN
THE GULL COMES ALONG.
THE PLOVER LOOK ALL
FLUFFY
AND
VERY LIKE
LITTLE
FEATHER
BALLS
ALL

HUMPED UP BY THE
COLD. HERE YOU ARE
ON YOUR CAMEL. BUT
I EXPECT YOU LIKE AN
ELEPHANT BETTER. YOU
RODE ON SEVERAL ANI

ALS WITH KAKA AT THE
OO. A LLAMA TOO WAS
I THE ROAD. FUNNY OLD
THING. THE
LITTLE BLIND
GIRLS LOVED
THE DONKEY
RIDES ON
WEDNESDAY
AND EACH
ONE HAD
FOUR OR FIVE
MUCH LOVE
DEAR FROM
KAKA.

WELLINGTON CLUB.
GROSVENOR PLACE, S.W.1.

FIVE PENCE THREE HALFPENCE

YE MISSES
WESTMORLAND
WOOD
Commander
A. W. WOOD
RN
AS Bemloc.
SIMLA

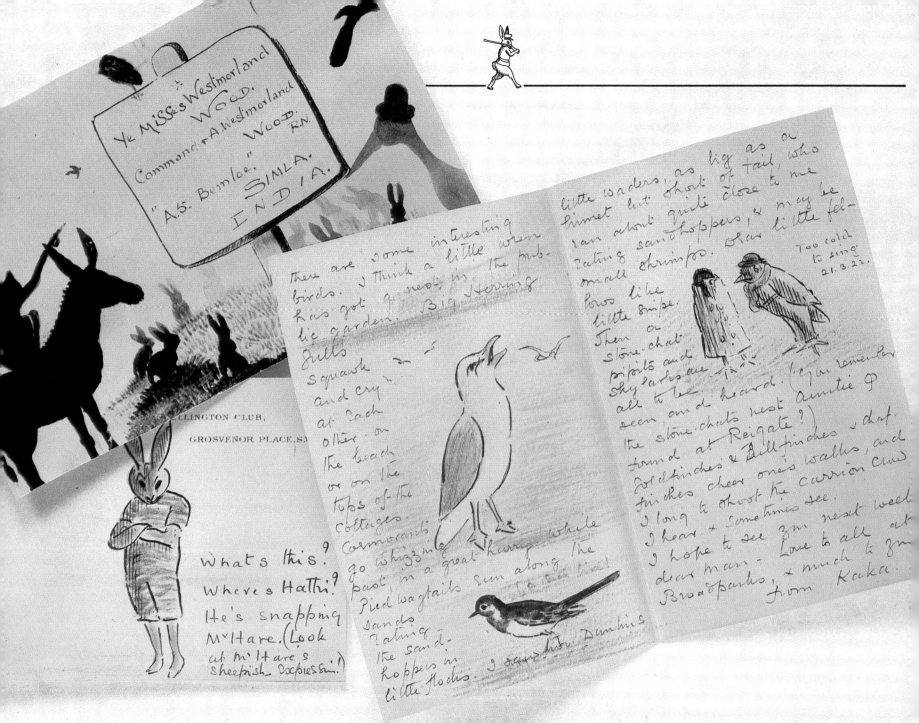

WELLINGTON CLUB,
GROSVENOR PLACE, S.W.

What's this? Where's Hatti? He's snapping Mr Hare. (Look at Mr Hare's sheepish expression!)

There are some interesting birds. I think a little wren has got a nest in the pub-lic garden. Big Herring Gulls "Squawk and cry" at each other — on the beach or on the tops of the cottages. Cormorants go whizzing past, in a great hurry while Pied wagtails run along the sands eating the sand-hoppers in little flocks. I saw two Dunlins

little waders, as big as a Linnet but short of tail, who ran about quite close to me eating sandhoppers, & may be small shrimps. Dear little fel-lows like little snipe. Then a stone-chat, pipits and Sky larks all to be seen, and heard. (you remember the stone-chats nest found at Reigate?) Goldfinches & Bullfinches & chaf-finches cheer one's walks, and I long to ghost the carrion crow I hear & sometimes see. I hope to see ym nest week dear man — Love to all at Broadparks, & much to ym from Kaka.

Too cold to sing 21.3.22.

Auntie P

The first port of call after leaving Bombay was Aden, where the ship restocked with coal. This was brought on board by the sackful from lighters alongside, an operation which left the decks covered in a black grime that had to be washed down by the crew afterwards. Traders also came aboard at Aden selling coral and ostrich feathers,

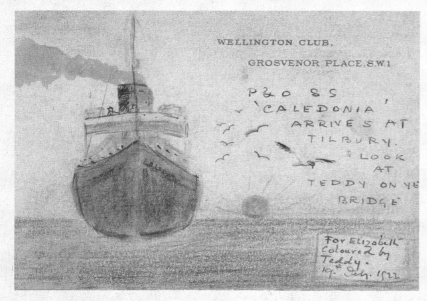

WELLINGTON CLUB,
GROSVENOR PLACE, S.W.1

P&O SS
'CALEDONIA'
ARRIVES AT
TILBURY.
LOOK
AT
TEDDY ON YE
BRIDGE

For Elizabeth
Coloured by
Teddy.
19th Sep. 1922

and passengers had their first sight, familiar by Suez and Port Said, of the scores of little naked Arab boys who, despite the sharks, swam beside the ship and dived for coins thrown into the water. By the time the boat left Port Said the cries of *Baksheesh!* and 'Lily Langtry' – the name by which every European

woman was addressed (later it would be 'Mrs Simpson'!) – would have become all too monotonous. Something that never quite lost its fascination, however, was the curious chant that Arab children seemed to believe was the English national anthem. Dancing precariously in their fragile canoes, they would sing and clap to the tune of 'Tara-ra-boom-de-ay',

'Twintle, twintle little star, Oh I wonder what you are…'.

The hottest part of the journey lay in the Red Sea crossing from Aden to Suez, and only slightly less so along the Canal itself, where the blazing noons were relieved by the sight of flocks of pink flamingos gathered on the low-lying banks. Once into the Mediterranean, however, the weather turned perceptibly cooler. 'Be wise and put on your warm undies soon after you leave Port Said,' Kaka warned Teddy in a letter sent to meet the ship. The sun-awnings were taken down and passengers who had been sleeping on deck at night now returned to their

cabins. Committees sprang to life organising every variety of recreation and entertainment, from deck cricket to concerts, theatricals and bazaars. Some ships even got up their own newspapers.

With characteristic thoughtfulness, Kaka made sure that a letter awaited Teddy at each main port of call. In these he suggested landmarks the boy should look out for and explained the history behind the famous places he would pass *en route*, such as the Rock of Gibraltar. He also, as always, kept Teddy alert to natural phenomena:

On the sea you will admire the lovely blue light seen on the waves at night and in the wake of the steamer. This blue light is made by millions of tiny creatures which by our naturalists are called 'plankton'. The wee things are sea babies, and turn into crabs, oysters, star fishes and all sorts of sea animals!

"Teddy diving head over heels"

Margaret Westmorland Wood.
Simla.

March 1922

Dear Little Margaret.

I am making a collection of
fossil shells for Teddy, & for
you and for Elizabeth. Such won-
derful things. Thousands and
thousands of years - it may
be millions - those shells were

*fossils for
Margaret
from
Kaka.*

alive and lived under the sea -
making the most lovely houses
for themselves - you will see
some when you come home -

beautiful things.
Today I picked up about
15 fossils. Some loose in the
black mud & some in stones

(A heavy sea - striking
the Cobb - Lyme Regis)
You will see them in your collection
when you & Teddy meet.
I was with him at Pinhoe yester-
day & he is very good on his
bike now - goes downhill on the

peddle & — oh! I've spelled it
wrong! pedal I meant - to have
put - & looks very much at
home - rushing about.

I hope you will tell me if you
cannot read this small writing.
It is not easy to read.
Much love dear from Kaka.

Mr Hare & Hathi
help the Babas to get
fossils.

"Khabardar!
Baba!"

Master Teddy Westmorland Wood
at Broadparks.
Pinhoe
Devon.

As the *Caledonia* steamed into the stormy Bay of Biscay – which well-to-do passengers avoided by taking the Blue Train overland from Marseilles to Calais – Kaka reported to the girls in India:

Only think of it! Teddy arrives this week!! Hurrah!!! I heard from Mrs Ellis. She said Teddy was very well but it had been very rough the day before.

The ship anchored briefly off Plymouth to disembark some passengers before heading up the Channel. Babies were

> **" This amazing looking car is very light indeed and goes very fast. It is driven by a propeller just like an aeroplane. But how very ugly it is to be sure."**
>
> *TO TEDDY – MARCH 1922*

> **" There is talk of a steam-driven giant aeroplane. One wonders what they will do next!"**
>
> *TO TEDDY – FEBRUARY 1922*

held high to be shown their first view of England, and as the *Caledonia* finally docked at Tilbury on 17 February returning parents were reunited with children whom they had not seen for years.

Teddy greeted his grandfather shortly afterwards at Fenchurch Street Station. As Kaka proudly related to Margaret:

Teddy rushed across the platform as soon as the train stopped and knew me, though he had never seen me out of uniform. It was grand fun and soon you will all be home too! Hurrah! Teddy has grown! But he's just the same to me.

The England to which Teddy returned was fast losing the grey air of austerity that had marked the immediate post-war years. Eleven days after his arrival Princess Mary married Viscount

Lascelles in the first big state pageant to be seen in the country since before the war. Practically all wartime regulations – registration of individuals, food rationing, restrictions on drinking – had been wholly or partially lifted during 1921. Travel abroad was once again permitted, though from now on only with a passport. More people drove motor-cars. Mass production, however, lay in the future. There were ninety-six different car manufacturers in 1922 and many vehicles were still produced by hand, one at a time.

"Mr Hare goes for a ride"

Margaret Westmorland Wood,
Simla.

Ap. 1922

Dear Little Margaret,

We had such a wet Easter Day — it pelted and poured! and it was Oh! so cold! now it is lovely and Teddy is on the sands all day — digging wonderful castles & forts, & drainage canals to let

Teddy's dog!

the sea water run off the works. The storm on Easter Eve was very bad, and a four masted ship lost her sails and one anchor, so the

IN
RAINING.

Life Boat went out and was away 12 hours. The ship was towed away by two tugs. There are some children here but not nearly as many as at other seaside places. Teddy has

"OH! MISS MARGARET! I AM NOT A SWEETMEAT!"

A Happy Easter Egg.

found lots of fossils, and we are sure you will like them, and he

very interested in them. Perhaps someday you and Elizabeth may find some yourselves to add to your own collections! We think we are going to see The Pirates of Penzance if we can get tickets. Teddy has

seen it in India & likes the music.
Much love — dear — from,
Kaka.

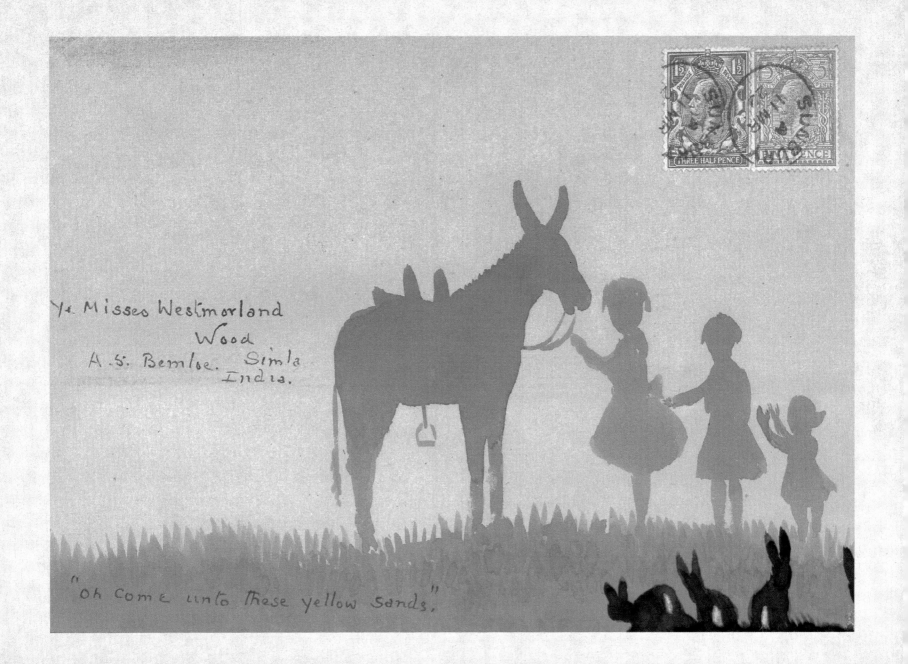

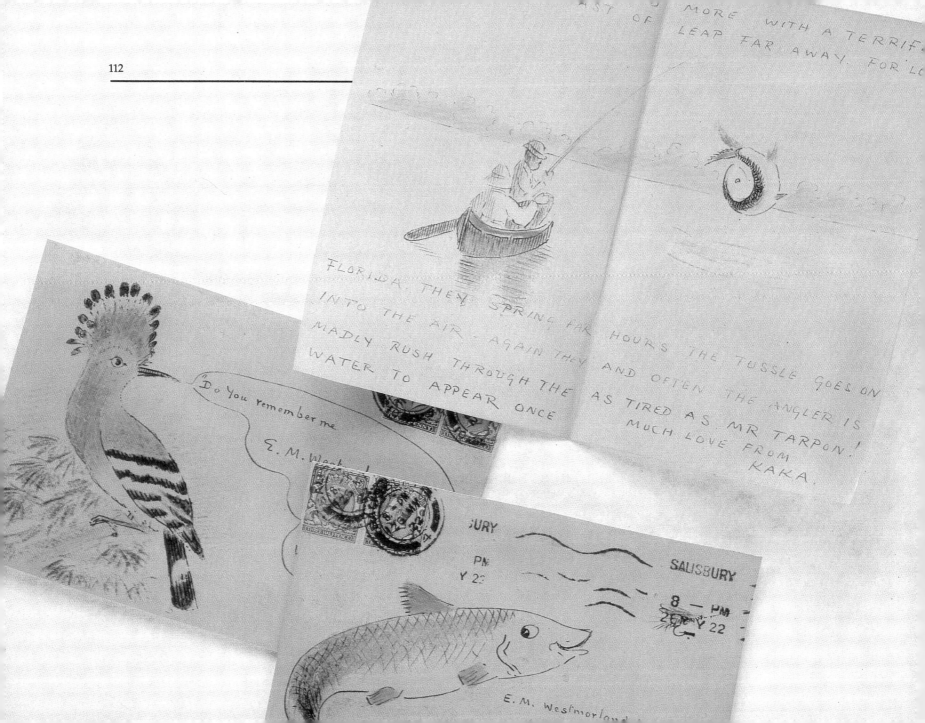

MORE WITH A TERRIF...
LEAP FAR AWAY FOR LO...

FLORIDA. THEY SPRING FAR HOURS THE TUSSLE GOES ON
INTO THE AIR - AGAIN THEY AND OFTEN THE ANGLER IS
MADLY RUSH THROUGH THE AS TIRED AS MR TARPON!
WATER TO APPEAR ONCE MUCH LOVE FROM
KAKA.

"Do you remember me
E. M. West...

SALISBURY

PM
Y 23

8 - PM
Y 22

E. M. Westmorland

Dress revealed less about social class. The frock coat had almost entirely disappeared and smart men-about-town now sported lounge suits. Women's clothes flattened out in search of the ideal boyish figure, skirts dropping to

> "Work hard at your lessons and learn all you can – 'knowledge is power' as the men of old time used to say. A wise saying."

TO MARGARET – MAY 1922

> "A rare bird came in from the sea and flew over this garden. A very large kind of wheatear called the 'Greenland wheatear' which passes up through Britain on its way to Iceland and Greenland where it nests. You remember the 'wheatear' was called 'whit-aer' – 'White Rump' – long ago by the Saxon swineherds from the white patch over its tail – hence our name 'wheatear', which sounds so silly!" *TO TEDDY – MAY 1922*

ankle-length. Cigarette smoking, a wartime habit picked up by men in the trenches, now became universal, Virginian tobacco replacing Egyptian or Turkish. Smoking was permitted in cinemas and on the upper decks of buses. The first Elizabeth Arden advertisements appeared and aeroplanes began to be employed for sky-advertising, using streamers or coloured smoke.

New forms of public entertainment were changing the patterns of English life. Cinema was the great new medium. Silent films attracted a huge following, eclipsing the popularity of pubs, football and the declining music halls. Wives could join their husbands, children their parents, in a way that had been inconceivable in previous public amusements. Hollywood dominated the cinema and British audiences filled the picture palaces to watch 'Felix the Cat' cartoons, Westerns, swashbuckling dramas and American slapstick comedies. But an English cockney, Charlie Chaplin, reigned supreme as 'The King of the Silver Screen'. *The Kid*, which Kaka took Teddy to see in Lyme Regis in April 1922, was by far the most popular film of the Twenties. One hang-over from the war did not disappear. Theatres and cinemas continued to play the national anthem at the end of performances.

> "When Charlie Chaplin first saw Hathi and Mr Hare"

MARGARET WESTMORLAND
WOOD.
SIMLA.
MAY. 1922

DEAR LITTLE MARGARET.

TEDDY IS AT PINHOE
THE DAY BEFORE
AND

LITTLE GIRL
WONDERING
AT THE
LAUGHING
Parrot
at
LYME
REGIS
WE

I WENT WITH HIM — WE
WERE OUT IN A
ROW BOAT. TEDDY ROWS

QUITE WELL AND LOVES
IT. HE IS A GREAT LAD
AN OLD BROTHER OFFICER
OF KAKA'S, WHO IS NINE-
TY YEARS OLD, LIKES

FAST, AND AS HE SAID
"GOOD-BYE" GAVE HIM A
BOOK OF ADVENTURE.
EVERYONE LIKES OUR TEDDY.
AND WE LOVE HIM MUCH.

Teddy rowing
Kaka & sailing
his boat.

HIM SO MUCH. HE WALKED
UP HILL TO THE STATION, VERY

LOVE DARLING
FROM KAKA.

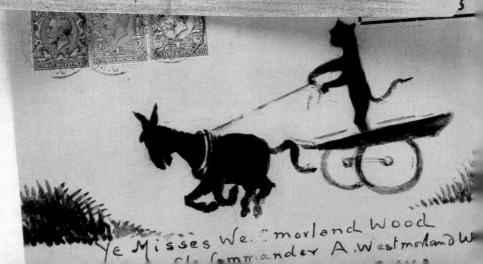

Ye Misses Westmorland Wood
c/o Commander A. Westmorland W

Envelope:

R | Tenbury Wells
No. 211

Ye Misses
Westmorland Wood

Commander A. W. Wood
R N

A.S. Bombe
Simla
INDIA.

Letter (left):

MARGARET WESTMORLAND.
WOOD,
Simla
May 1922

DEAR LITTLE MARGARET.

I WENT IN THE SAME
TRAIN WITH DEAR TEDDY
FOR AN HOUR. WHEN AUNTIE

Margaret feeding her Gull.

MARY TOOK HIM ON HIS
SEVEN HOUR JOURNEY TO

Letter (middle/right):

SCHOOL. HE IS A BRAVE
MAN IS OUR TEDDY, AND
WILL WORK HARD. HE
LOOKS SO BIG IN HIS
NEW GREY SUIT — AND HAS

AND SEE HIM AT SCHOOL
LATER ON. HOW PLEASED HE
WILL BE WHEN YOU ALL COME
HOME. AND WHAT A LOT THERE
WILL BE TO TALK ABOUT !!!

GROWN A GREAT DEAL SINCE
HE CAME HOME. I SHALL GO

The reason there was no
bathing at this spot.

MUCH LOVE

'Left shoulder forward - please!'

E.M. Westmor...

E.M. WESTMORLAND WOOD
TENBURY
JUNE 1922

MY DEAR TEDDY.
I LOOKED FOR A PEEWIT'S EGGS YESTERDAY AT OLD SARUM - WHERE THE CATHEDRAL USED TO BE - BUT THOUGH THE OLD BIRDS GOT VERY

"Off!"
EXCITED - POOR DEARS - I COULDNT FIND THE HAND-SOME EGGS - ALL POUR POINT-

ING INWARDS - AS ALL PLOVER'S EGGS DO. I WONDER IF YOU FOUND ANY NESTS I WILL SEND YOUR TWO BOXES OF EGGS TO PINHOE AND YOU WILL LOVE THEM AS MUCH A I DID. BIRD'S NESTING TEACHES ONE A LOT OF THINGS, TO PATIENCE AND USING ONES EYES AMONGST OTHERS! THE BIRD SAYS "OLD FELLOW YOU WONT FIND MY NEST."

Toddy Palm harvest of Toddy (re Tadi)

AND YOU SAY "RIGHT O! OLD BIRD LETS SEE"! AND THE FUN BEGINS! IF ONE CAN GET UP EARLY AND WALK ABOUT QUIETLY - THE BIRD IS SEEN LEAVING THE NEST, OR ONE SEES THE BIRD CARRYING BUILDING MATER...

ONE SOON R...
MEMBERS WHERE TO LOOK FOR THE NEST OF THE BIRD ONE IS AFTER AND NO TIME IS LOST LOOKING IN A TREE OR BUSH FOR A GROUND BUILDING BIRD UNCLE CUD AND CHARLI... WERE SPLENDID OBSERVERS MUCH LOVE DEAR MAN FR... KAKA...

> "They are putting up an air beacon at Dijon in France (look it up in your map) which has 1000 million candle power and throws its light 200 miles (i.e. a distance equal to that between London and Torquay). The famous light we see from Dover at Cap Gris Nez, France (map again, please) is only of 25 million candle power. The Dijon beacon will light the airways between Paris and Algiers, and between Italy and Switzerland (map once more)."
>
> *TO TEDDY – JUNE 1922*

Radio, by contrast, remained something of a technical curiosity in 1922. Experiments in controlling aircraft by wireless from the ground proved unsuccessful and domestic listeners to public broadcasts still used headphones. However, by the end of the year the British Broadcasting Company ('Corporation' came later) had been set up, acquiring a broadcasting monopoly that would soon give it an unprecedented 'cultural' influence across the nation. Like the cinema, radio appealed to a new family audience, its highly respectable tone under John Reith, the B.B.C.'s autocratic manager, taking its cue from announcers who wore dinner-jackets to address the microphones.

Kaka's letters to the girls left behind in India (in the summer of 1922 he began sending illustrated postcards to one-year-old Ann) are now full of Teddy's doings in England. Shortly after his arrival Teddy went to stay with the Liveseys, Great-Aunt 'Georgie' and Aunt Mary. Aunt Georgie was the sister of Arthur Wood's father and a great favourite in the family. Teddy recalls her as 'very correct, religious and patriotic. We all had to stand up if "God Save the King" was played on the wireless. She led prayers which we all, including the maids, had to attend in the dining-room before breakfast and again in the evening.' Aunt Mary was Aunt Georgie's daughter, the second of seven children. She acted as Teddy's guardian, 'almost a second mother to me.... She was strict, fair and very kind.'

WELLINGTON CLUB.
GROSVENOR PLACE. S.W.1.

Mr Hare & Hathi have a race on the motors they have made themselves. Hathi's wheel comes off & he helps himself with his hind leg. (Mr. Hare does laugh!)

"Mr Hare has a bad cold, so Elizabeth shows him her tame bulbulla"

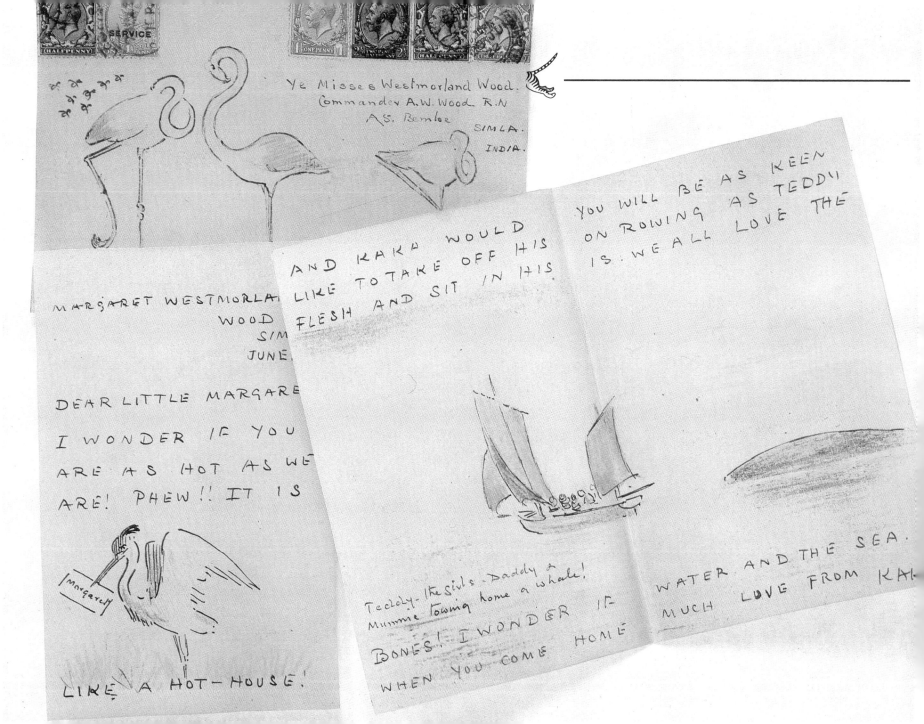

Ye Misses Westmorland Wood.
Commander A.W. Wood. R.N
A.S. Bombe
SIMLA.
INDIA.

MARGARET WESTMORLA
WOOD
SIM
JUNE

DEAR LITTLE MARGARE

I WONDER IF YOU
ARE AS HOT AS WE
ARE! PHEW!! IT IS

Margaret

LIKE A HOT-HOUSE!

AND KAKA WOULD
LIKE TO TAKE OFF HIS
FLESH AND SIT IN HIS

Teddy - the girls - Daddy &
Mummie towing home a whale!
BONES! I WONDER IF
WHEN YOU COME HOME

YOU WILL BE AS KEEN
ON ROWING AS TEDDY
IS. WE ALL LOVE THE

WATER AND THE SEA.
MUCH LOVE FROM KAK

Aunt Georgie had been left a wealthy widow. Teddy remembers a picnic outing with the family to Box Hill at the end of the war in which the hired Rolls-Royce had to reverse up the steepest part of the hill (reverse being the lowest gear). By 1922 the Liveseys lived at Broadparks, a large house set in its own grounds at Pinhoe, near Exeter. In a letter to Margaret Kaka describes Broadparks as standing on a hill, 'always cool and pleasant', and commanding views of the sea. But Teddy thought the house itself rather ugly. When it was first pointed out to Aunt Georgie from a distance, she exclaimed: 'Surely *not* that great red institution on that hill!'

Teddy cherishes a memory of the long drive up to the house. 'One of the "toys" that, like stilts, were part of Broadparks was a small solid-tyred bicycle – but the pedals didn't drive the back wheel. Aunt Mary promised that when I could ride it from the house to the bottom of the drive (downhill all the way) without falling off, she would have the pedal mechanism repaired, which she duly did!' Another 'toy' that amused Teddy at this time was the pogo-stick, a craze that swept England from the autumn of 1921. Stage stars were photographed bouncing up and down on these contraptions and the *Daily News* ran a children's pogo-stick championship. It was won by a boy who did 1600 hops in fifteen minutes.

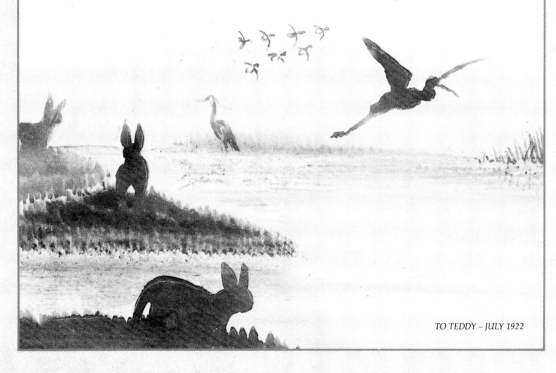

" Will you jot down the birds you see or hear, and we will compare notes? I expect you will have quite a long list. And see how many different wild flowers you can find – I will do the same, and I wonder who will get the most."

TO TEDDY – JULY 1922

"Teddy hop-hopping about on his pogo stick"

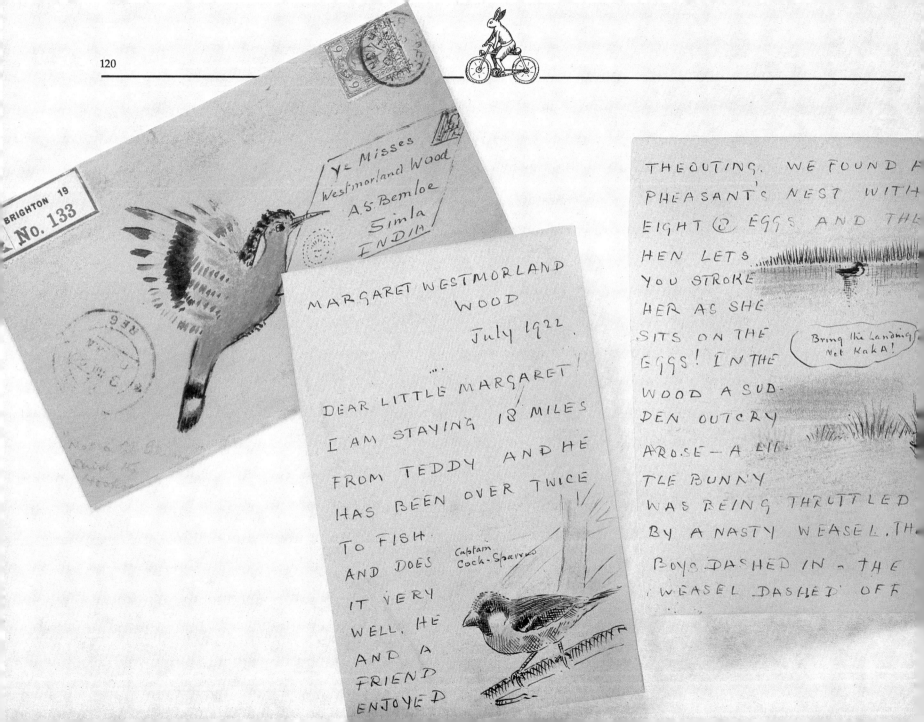

Yᵉ Misses
Westmorland Wood
A.S. Bemloe
Simla
INDIA

MARGARET WESTMORLAND
WOOD
July 1922.

...

DEAR LITTLE MARGARET
I AM STAYING 18 MILES
FROM TEDDY AND HE
HAS BEEN OVER TWICE
TO FISH.
AND DOES
IT VERY
WELL. HE
AND A
FRIEND
ENJOYED

Captain
Cock-Sparrow

THE OUTING. WE FOUND A
PHEASANT'S NEST WITH
EIGHT © EGGS AND THE
HEN LETS
YOU STROKE
HER AS SHE
SITS ON THE
EGGS! IN THE
WOOD A SUD-
DEN OUTCRY
AROSE — A LIT-
TLE BUNNY
WAS BEING THROTTLED
BY A NASTY WEASEL. TH
BOYS DASHED IN — THE
WEASEL DASHED OFF

Bring the Landing
Net KahA!

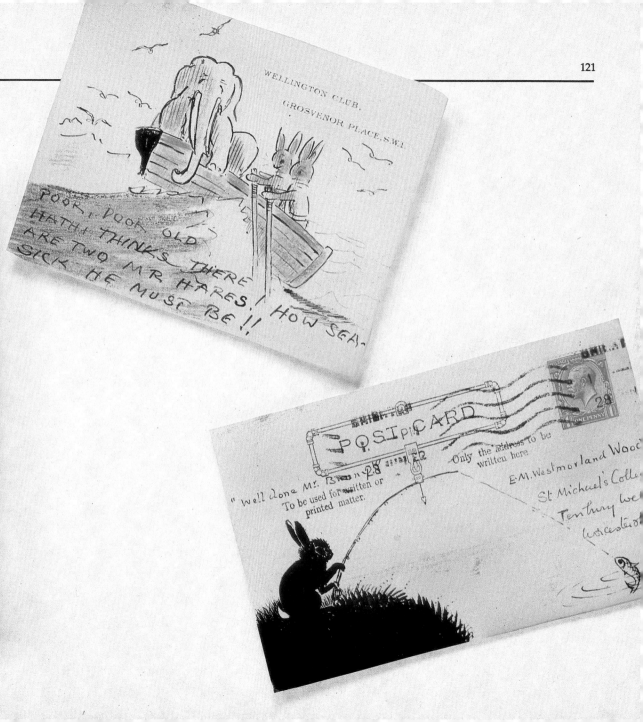

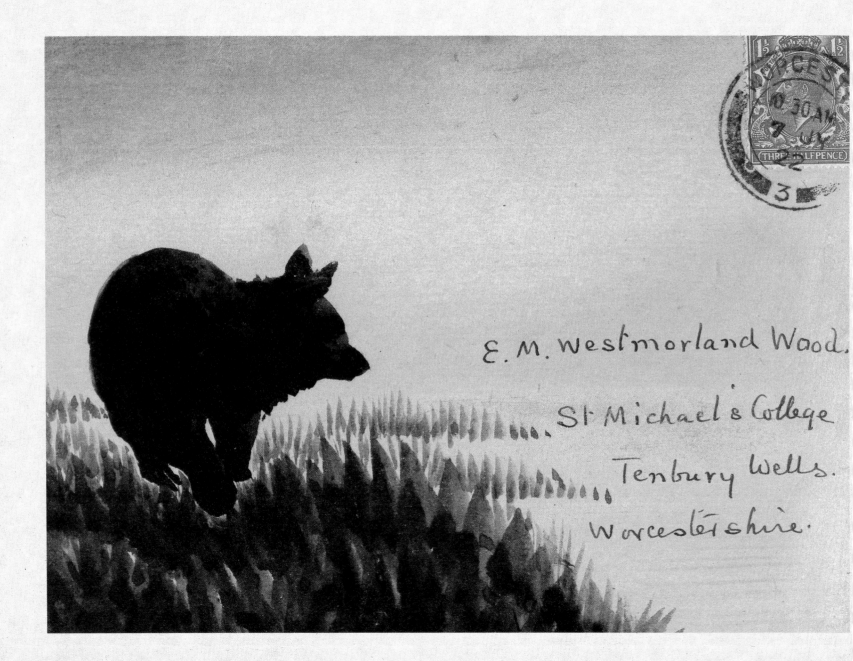

E. M. Westmorland Wood.

St Michael's College

Tenbury Wells.

Worcestershire.

" When you go to an aquarium ('aqua' means water, you know) you may see a very quaint fish called the 'Sun-fish' from its shape. Who would ever have thought a fish could be so comical!"

TO MARGARET – JULY 1922

WELLINGTON CLUB.

GROSVENOR PLACE, S.W.1.

WHAT'S THIS?
Only Mr Hare &
Hathi dancing a
fandango because
Teddy is first in his
form.

In April 1922 Kaka took Teddy to Lyme Regis where they spent much of the time hunting for fossils along the bottom of the cliffs. On one occasion 'about forty pieces were carried home in a sack and in one of Kaka's hankies!' Kaka told Margaret. One of these pieces was the almost complete head of an ichthyosaurus. Later in the year Kaka bought Teddy a small antique chest of drawers in which to keep his fossil 'museum'. He gave even smaller chests to Elizabeth and Margaret for their dolls' clothes. It was at Lyme Regis that Kaka purchased for Teddy an old model of a two-masted schooner that they saw in a shop. They nicknamed it *The Britannia*. 'We took it out in Lyme Bay in a fisherman's boat,' Teddy recalls, 'and how well it sailed.' Teddy's own daughter, Margaret, inherited this model ship many years later.

"Who is this on a stork's back?"

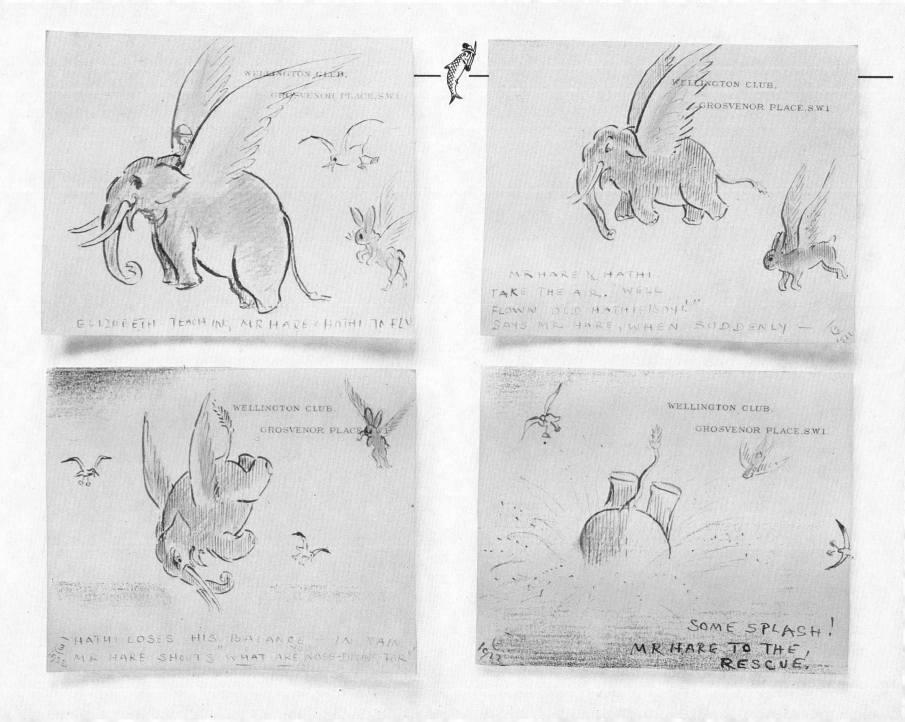

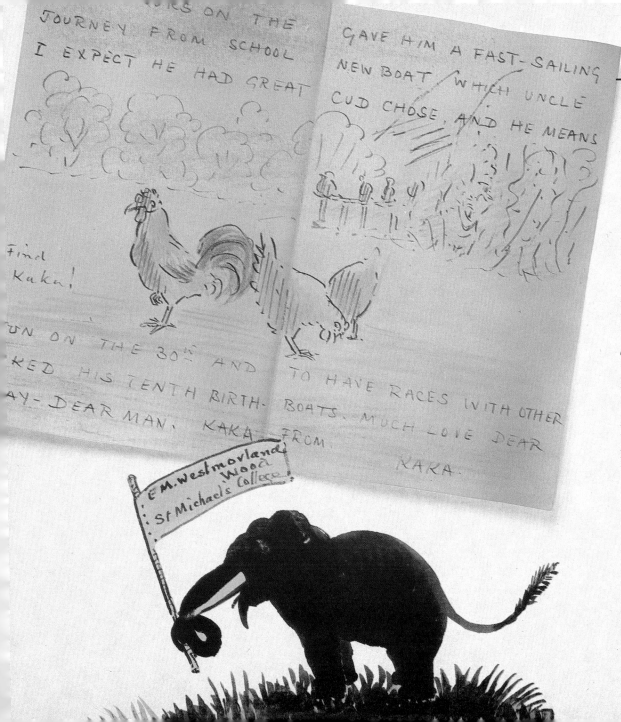

At the end of April the time came for Teddy to start school. The school chosen for him, on Aunt Mary's recommendation, was St Michael's College, Tenbury Wells, a small place in Worcestershire some ten miles south-east of Ludlow. St Michael's was a choir school and Teddy's parents hoped he would win a chorister's scholarship, but this was not to be. Teddy remembers the school's rather monastic character without much affection. 'We all had to wear gowns and mortar boards, and Eton suits on Sundays. We had services lasting about three quarters of an hour *every* morning and evening, and on Sundays we were in church for several hours. Enough to put anyone off religion. It certainly put me off. I hated St Michael's.' When his parents came home in 1923 Teddy was transferred to Amesbury School in Hindhead, which he much preferred.

"Margaret in the skies"

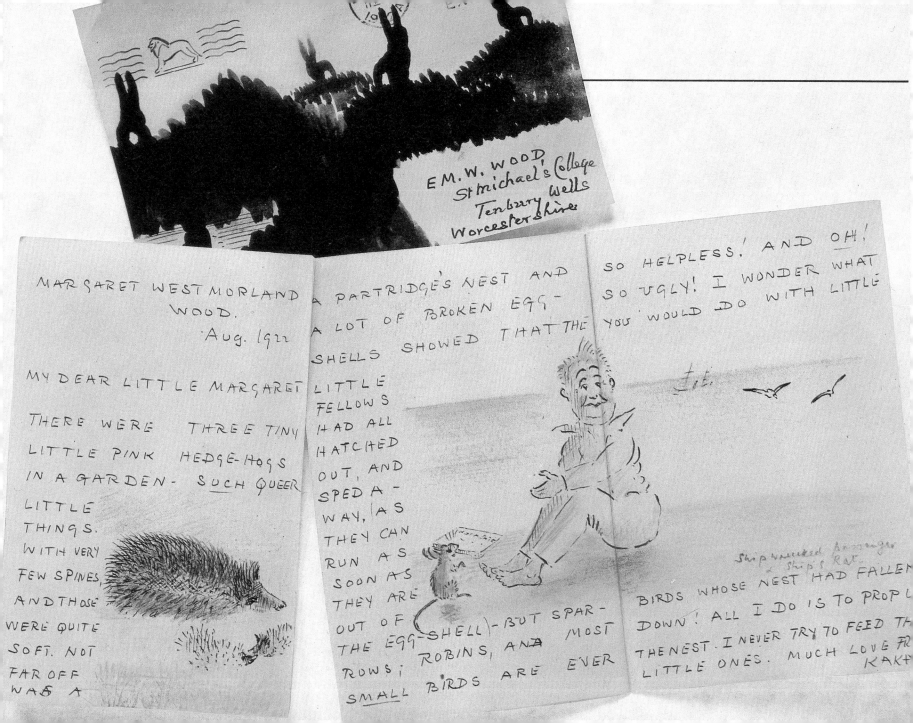

E.M.W. WOOD,
St Michael's College
Tenbury Wells
Worcestershire

MARGARET WESTMORLAND
WOOD.
Aug. 1922

MY DEAR LITTLE MARGARET

THERE WERE THREE TINY
LITTLE PINK HEDGE-HOGS
IN A GARDEN — SUCH QUEER
LITTLE
THINGS.
WITH VERY
FEW SPINES,
AND THOSE
WERE QUITE
SOFT. NOT
FAR OFF
WAS A

A PARTRIDGE'S NEST AND
A LOT OF BROKEN EGG-
SHELLS SHOWED THAT THE
LITTLE
FELLOWS
HAD ALL
HATCHED
OUT, AND
SPED A-
WAY, AS
THEY CAN
RUN AS
SOON AS
THEY ARE
OUT OF
THE EGG-SHELL — BUT SPAR-
ROWS, ROBINS, AND MOST
SMALL BIRDS ARE EVER

SO HELPLESS! AND OH!
SO UGLY! I WONDER WHAT
YOU WOULD DO WITH LITTLE

Shipwrecked passenger
& Ship's Rat.

BIRDS WHOSE NEST HAD FALLEN
DOWN! ALL I DO IS TO PROP U
THE NEST. I NEVER TRY TO FEED TH
LITTLE ONES. MUCH LOVE FR
KAKH

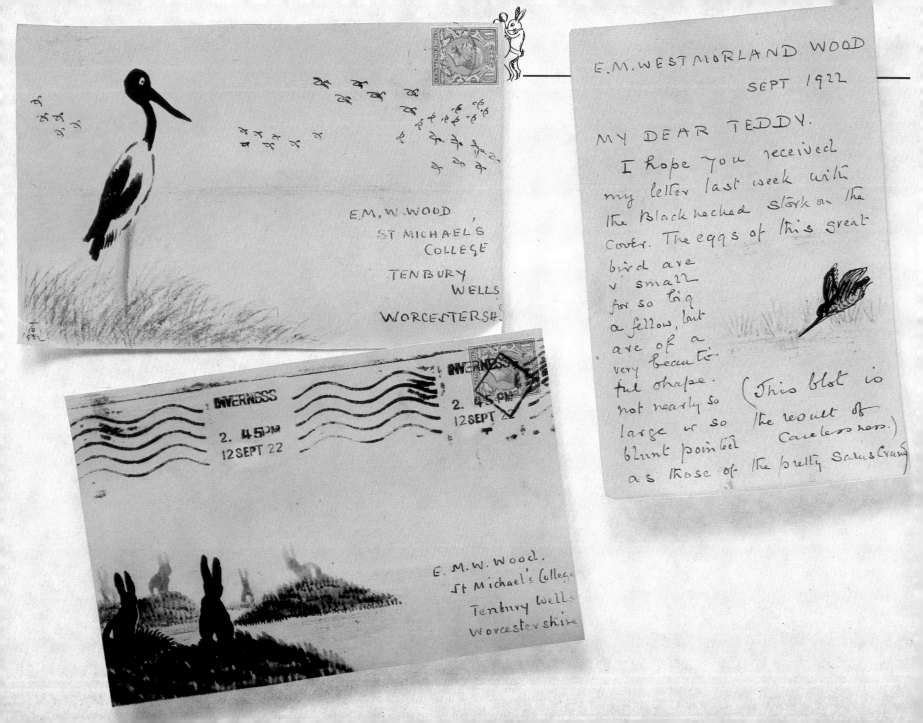

E.M.W.WOOD,
ST MICHAEL'S
COLLEGE
TENBURY
WELLS
WORCESTERSH.

INVERNESS
2. 45 PM
12 SEPT 22

E. M. W. Wood.
St Michael's College
Tenbury Wells
Worcestershire

E.M. WESTMORLAND WOOD
SEPT 1922

MY DEAR TEDDY.
I hope you received my letter last week with the Black necked Stork on the cover. The eggs of this great bird are v small for so big a fellow, but are of a very beautiful shape. not nearly so large or so blunt pointed as those of the pretty Sarus Crane

(This blot is the result of Carelessness.)

> " Here is a recipe to prevent eyes watering. Peel onions near an open window, or under a running tap. This will be of use to you when you have the luck to help Mummie to cook!"
>
> *TO MARGARET – SEPTEMBER 1922*

Kaka visited Teddy at St Michael's when he could, usually staying at nearby Stokesay Court with an old army friend, General Rotton, but mostly the two kept in touch, as before, by letter. Kaka wrote to Teddy every week – while continuing simultaneously his posts to the girls in India. He insisted that Teddy send him at least a postcard a week in return. The envelopes Kaka sent to St Michael's are as inventive and colourful as ever, but the letters themselves are no longer always written in capitals and contain far less illustration than previously. The tone is less 'tutorial', more confiding, more like a friend writing to a friend. Some of the 'nature' letters that date from this time are among the best Kaka wrote. This passage, for example, suggests in its modest way just how expert a bird-man he really was:

> *I am writing at a little before 4 a.m. – summer time – and I can hear a robin and two thrushes singing gaily, while a startled blackbird cries 'chink–chink–chink' – at some prowling cat, I expect. And now a greenfinch, a*

> " Fancy if the rose-blight (or 'aphis') had no enemies – in a very short time they would weigh as much as five hundred millions (think of it – 500,000,000) of fat men! There would soon be no room on the earth for anyone else!!"
>
> *TO MARGARET – OCTOBER 1922*

wren and some cheery little sparrows are raising their voices in melody.

Kaka could mimic the sounds of many birds and animals. Teddy remembers him causing an uproar in the monkey house at London Zoo by imitating various monkey calls.

"A quaint one-sided glider – with no engine!"

MARGARET WESTMORLAND
WOOD.
SIMLA.
15th SEPT 1922

MY DEAR LITTLE MARGARET

TEDDY LOOKS VERY
WELL AND WE PLAY A
LOT OF CRICKET. HE IS
VERY GOOD
AND BOWLS
AND BATS
VERY WELL
INDEED. I
EXPECT WE
SHALL ALL
PLAY WHEN
YOU COME HOME — WHICH

The three little chests
of drawers
EMWT. M.W.W. Elizabeth

WILL BE VERY SOON;
I HOPE. TEDDY HAS
GROWN A LOT AND
LOOKS
VERY
WELL I
THINK.
HE HAS
FIXED A
SEAT UP
IN A PINE
TREE AND
SITS UP A-
LOFT LIKE
A SAILOR OR
A SAILOR ON A MAST
WE UNPACKED THE THREE

CHESTS OF DRAWERS.
ONE FOR EACH OF YOU
THREE AND KAKA IS
LOOKING
OUT FOR
A TINIER
ONE THAN
ELIZABETHS
FOR ANNE
FOR SHE
WILL WANT
ONE TOO.
THEY ARE
SMALL
BUT WILL
DO VERY
WELL FOR
DOLLIES' CLOTHES. MUCH
LOVE DEAR FROM KAKA.

Mr Hare & Hathi visit Hathi's Cousin at the Zoo — (Mr Hare doesn't like WELLINGTON CLUB, his looks.)

GROSVENOR PLACE, S.W.1

HILLS, AND SOME OF THE WILD GRASSES ARE VERY SWEET-SCENTED. UNCLE CUD AND I VISITED THE ZOO

"Oh dear! what can the matter be?"

YESTER DAY & THE O- rang-u- tang WAS VERY AMUSING

HE TIED UP A ROPE AND USED IT AS A SWING — HE TOOK FOOD FROM CHILDREN AND

SEEMED TO SMILE AT THEM. WITH HIS BLAND AND COMICAL LOOK ING COUNTEN- ANCE! (VERY LIKE SOME OLD GENTLE what ever can it be?

(But it was only the peli- cans way of combing his hair!)

MEN ONE MEETS SOME TIMES! MUCH LOVE DEAR FROM KAKA.

GROSVENOR PLACE, S.W.1

The African Cousin is surprised when Mr Hare & Hathi dance a pas de deux.

E.M. Westmorland Wood.

St Michael's College.

Te...

M. Westmorland Wood.
Tenbury Wells.
Inverness.
12 Oct. 1922.

My dear Teddy.

I received your P.C. &
wrote to Miss Man and
asked her to kindly send
you your
aëroplane.
as it has
been over
two years
unpacked
it will be
as well to
look over
it carefully and see if it is
(a bird we all like —
The Oyster Catcher)

all right. I hope it will
fly but if you remember we
had to send it to the makers
more than once.
General & Mrs Rotton have
asked me to stay at Stotesay
Court when I come to see you
which is very kind & nice
so I told you I will
of them.
And our.
poised then
all of his
shooting
with his
twenty eight
bore. I hope
& think you
will be a
good shot
as you have
got a good eye. what fun it will

be when you have got your
.410 bore double barrel! what
will the girls say!! They
are all out at Bhági 2
marches beyond Simla. I
hope the leopards wont carry
off their dogs! They are astonish-
ingly bold beasts in the
interior. Sometimes in the
hill stations
they snap
up a dog,
under ones
nose in
broad day
light! A
horrible
way to
lose one
friend
Love dear mum from Nako

> " Will you please note the last date you see the house-martins which hawk for flies and moths round the chapel and college buildings?"
>
> *TO TEDDY – OCTOBER 1922*

ANN AND ELIZABETH

Another letter to Teddy in the summer of 1922 reveals Kaka's powers of observation in a different light. He relates a visit to see a juggler

who picked up a top hat on his foot – kicked it up into the air – it twisted round and round and – fell upon his head! Then he lighted a big cigar, threw the hat onto the ground – again picked it up with his foot and kicked it high in the air and it twirled round and fell – on its brim – onto the cigar – and remained balanced there! Suddenly he jerked the cigar up high in the air – it [the hat] twiddled over and over and – fell upon his head as if he had put it on with his hand! He then threw the top hat behind his back and again it fell edge on onto the cigar. Once more the cigar gave a jerk – away went the hat into the air to fall edgeways on his head and after dancing on its brim twice and turning head over heels – it settled itself quietly upon his head!

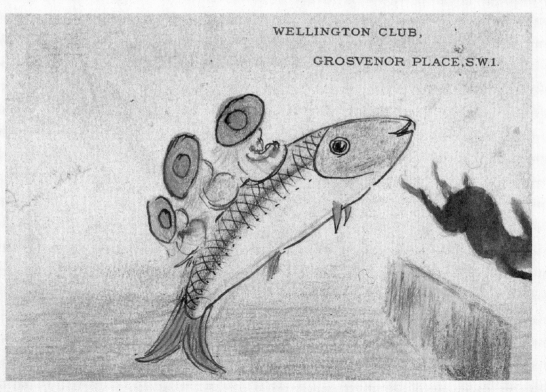

WELLINGTON CLUB,

GROSVENOR PLACE, S.W.1.

"Mr Hare juggles with 6 balls"

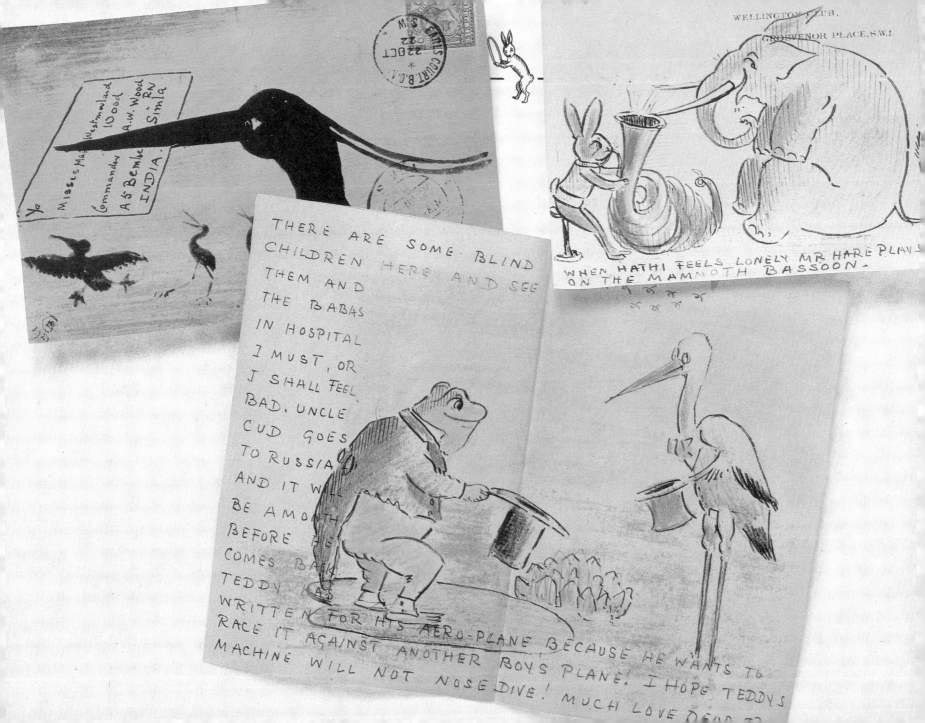

WELLINGTON CLUB.
GROSVENOR PLACE, S.W.1.

WHEN HATHI FEELS LONELY MR HARE PLAYS
ON THE MAMMOTH BASSOON.

THERE ARE SOME BLIND
CHILDREN HERE AND SEE
THEM AND
THE BABAS
IN HOSPITAL
I MUST, OR
I SHALL FEEL
BAD. UNCLE
CUD GOES
TO RUSSIA
AND IT WILL
BE A MONTH
BEFORE HE
COMES BACK.
TEDDY HAS
WRITTEN FOR HIS AERO-PLANE BECAUSE HE WANTS TO
RACE IT AGAINST ANOTHER BOYS PLANE! I HOPE TEDDYS
MACHINE WILL NOT NOSE DIVE! MUCH LOVE DEAR 33

> " We can see the sea and the hills are blue, purple, green, brown, orange and all shades of pink and yellow, according to the things growing on their sides. I expect you are looking at very much the same colours in the grand old Himalayas that we all love so well."

TO MARGARET – OCTOBER 1922

At the end of September Uncle Cud joined Kaka for their annual foray to the Scottish grouse moors. They first stayed at Murtle, near Aberdeen, then went on to Inverness, the 'capital of the Highlands', where the castle (built in 1835) dominated the town from the top of a low cliff. The Jacobites had blown up a previous fortress on the same site in 1746 and the town's museum contained Jacobite relics. Kaka was more concerned by the condition of some of Inverness's contemporary inhabitants. He wrote to Teddy:

> *There are numbers of poor and rather ill-cared for children here, and one feels very sorry they cannot be taken to Devonshire for a long holiday. Perhaps some day our people will wake up and see that every child has a fair chance and a happy time for at any rate part of the summer.*

No doubt some of these children found themselves the recipients of Kaka's famous chocolate 'butterflies'.

MR HARE & HATHI VISIT ST MICHAEL'S COLLEGE & ENTERTAIN TEDDY'S FRIENDS
MR HARE PLAYS HATHI'S SONGS ON YE SPINNET

"Mr Pheasant goes out shooting"

E M. Westmorland Wood.
Tenbury Wells.
Oct 1922

Dear Teddy.

I was watching the young Herring. Gulls on the river Ness, They are brown birds —and take 4 years to put on the full dress of lovely blue and white. You never saw such bickering! And what huge pieces of bread they can gulp down! No wonder big fish and birds disappear down their big gullets! The Little Black Headed Gull is as peaceable as he is pretty & graceful. & the Great Black Backed Gull is a fearsome butcher, and has been known to swallow a grouse! no wonder he is proclaimed, and I fear,—egg stealers & They live much on shore. The lovely little

Kittiwake however loves the open sea, and is a dear little fellow with no bad tastes.

In the museum here they have relics of Prince Charlie, and when your mother was a girl she took photographs of his shoe buckles The Castle is a recent building but looks very imposing as it sits on a hill top overlooking the Town The river Ness is fast & loud— and shallow Love, dear, from

Kaka.

What a muddle he is flying up he wrong in this bird? he is flying up are up the down hill

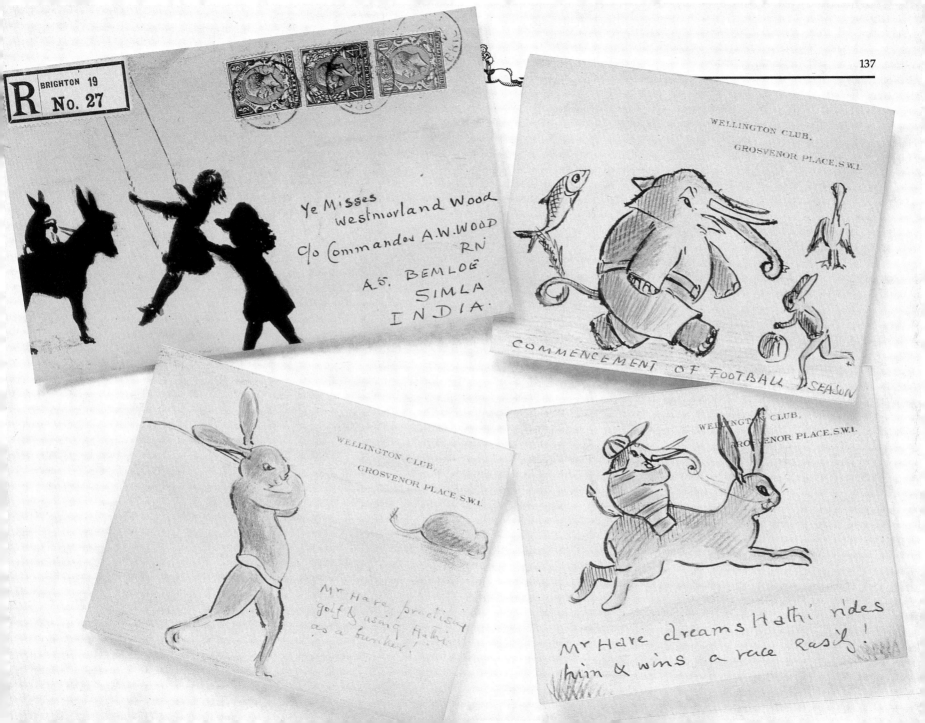

R BRIGHTON 19
No. 27

Ye Misses
Westmorland Wood
C/o Commander A.W.WOOD
RN
A.S. BEMLOE
SIMLA
INDIA.

WELLINGTON CLUB.
GROSVENOR PLACE.S.W.1.

COMMENCEMENT OF FOOTBALL SEASON

WELLINGTON CLUB.
GROSVENOR PLACE S.W.1.

Mr Hare practises
golf using Hathi
as a bunker!

WELLINGTON CLUB.
GROSVENOR PLACE.S.W.1.

Mr Hare dreams Hathi rides
him & wins a race easily!

R THEM. THE PIER AND ONCE GO

AND THEY BACK HIS HALFPENNY E-

TELL THE LEVEN TIMES IN SUCCESSIO

RIVE VERY -THERE'S A LONG WORD-TW

C s AND TH

S s. (POSSES-

SION IT AS

NO LESS THAN

FOUR S s.)

DON'T FORGET

THAT DEAR.

EDDY FISH

D OFF THE

PIER BUT

NO LUCK A

JE MAN

D

Y

CI-

Teddy dream
after fishing on the Pier

Ye Misses
Westmorland Wood.
C/o Commander A.W. Wood
RN
A.S. Bembe
Simla.

POSSIBLY COULD AND D

MU

TEDDY PLAYS ALL SORTS
OF A
ATIC GAMES ON

HATHI AND MR HARE GOING
THEIR 5ᵗʰ ENCORE!

WELLINGTON CLUB.
GROSVENOR PLACE. S.W.I

WELLINGTON CLUB.
GROSVENOR PLACE. S.W.I

Mr Hare & Hathi
after seeing the Cir-
cus are always play-
ing at Ye Circus game.

Like his father, Cud was a skilled exponent of small-bore shooting, firing a 28-bore gun at partridge and grouse when everyone else used 12-bores. Together Kaka and Cud were evidently a deadly combination. 'Yesterday', Kaka reported to Teddy, 'the bag was 65 head and Uncle Cud shot very well and he and I accounted for more than half the total bag of six guns, which was quite

> " I have been to the zoo
> several times. The mandrill
> is a friend of mine and gets
> very fierce if anyone
> pretends to hit me!"
>
> *TO TEDDY – NOVEMBER 1922*

good as my right eye is no longer any use.' Teddy remembers that Kaka, with typically sporting gusto, would flap his arms vigorously at rabbits and birds to make them go faster before shooting them. But even Kaka could not always fulfil everyone's high expectations of his prowess. 'The rabbits here are all over the Park,' he wrote to Teddy on another occasion, 'and Col Lang wants me to see if I can shoot more than six at one shot near the larch plantation! I think I will be content to shoot at one and if he is running very fast I shall be quite pleased if he goes head over heels, poor beastie.'

TEDDY BAGS A RABBIT

Kaka thought Teddy too had a good eye with a gun and would make a fine cricketer. On both counts his forecast proved correct. At Amesbury School Teddy captained the cricket team and won, among other sporting trophies, the cup for shooting (his targets are still framed in the school corridor). Hours of practice with a mechanical clay pigeon thrower which had been installed in the grounds of Broadparks paid off. 'Later when travelling on the Italian liner *Rix* to New York I won a large silver cup, to win which I had to get 100% of clay pigeons shot out over the stern of the vessel!'

> " Sharks whose young are born alive (viviparous it is
> called) open their mouths when danger threatens,
> and all the little sharklets rush inside for
> shelter! The pretty little pilot fish hide
> in the same capacious retreat!
> What a very
> extraordinary
> manoeuvre
> to be sure!"
>
> *TO TEDDY –*
> *NOVEMBER 1922*

"Teddy and Kaka
at ye stores"

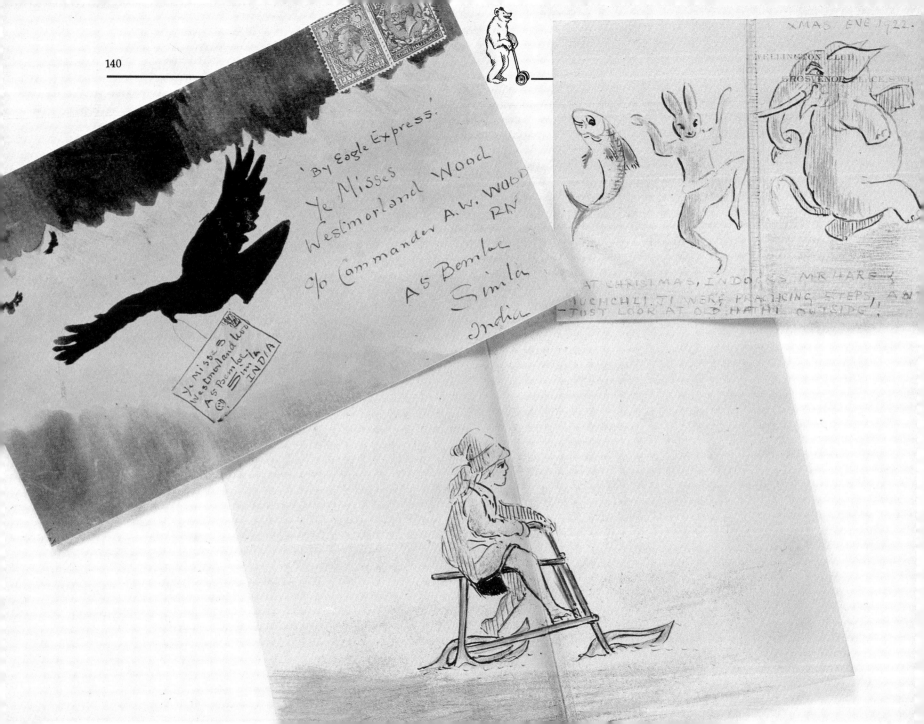

'By Eagle Express.'

Ye Misses
Westmorland Wood
c/o Commander A.W. Wood RN

A5 Bemloe
Simla
India

Ye Misses S Wood
Westmorland Wood
A5 Bemloe
Simla
INDIA

XMAS EVE 1922.

WELLINGTON CLUB
GROSVENOR PLACE SW1

AT CHRISTMAS, INDOORS MR HARE &
JUCHCHLI.JI WERE PRACTICING STEPS, AN'
—JUST LOOK AT OLD HATHI OUTSIDE!!

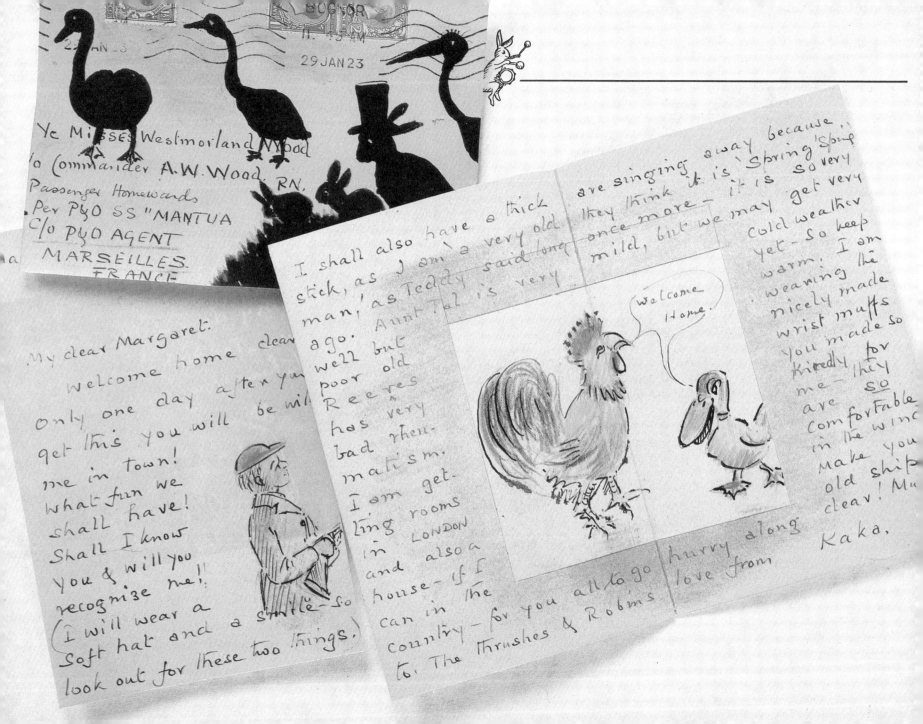

Envelope:

29 JAN 23

Ye Misses Westmorland Wood
c/o Commander A.W. Wood. R.N.
Passenger Homewards
Per P&O SS "MANTUA
c/o P&O AGENT
MARSEILLES.
FRANCE

Letter:

My dear Margaret.

Welcome home dear—

Only one day after you
get this you will be with
me in town!
What fun we
shall have!
Shall I know
you & will you
recognize me!!
(I will wear a
soft hat and a smile—so
look out for these two things.)

I shall also have a thick
stick, as I am a very old
man, as Teddy said long
ago. Aunt Tal is very
well but
poor old
Reeves
has very
bad rheu-
matism.
I am get-
ting rooms
in LONDON
and also a
house—if I
can in the
country—for you all to go
to. The Thrushes & Robins

are singing away because
they think it is Spring Spring
once more—it is so very
mild, but we may get very
cold weather
yet—so keep
warm. I am
wearing the
nicely made
wrist muffs
you made so
kindly for
me—they
are so
comfortable
in the wind
make your
old ship
clear! Mu—

hurry along
love from

Kaka.

Welcome Home.

Teddy's Christmas holidays began on 18 December – one day after the departure of the last British troops from the newly independent Irish Free State and a day before the resignation of Lloyd George as Prime Minister: the 'Welsh Wizard' would never hold office again. A new era dawned for the Wood family too. In February they would be coming home to England for good. Or so they planned, for Arthur Wood had decided to abandon his job with the Indian Audit Service to read for the Bar.

Kaka took Teddy to Brighton for New Year and they amused themselves playing the penny slot-machines on the pier. They also saw a poor seagull caught in a tree by a piece of string, an incident Kaka relayed to Margaret.

A boy had to climb the tree to cut off the piece of string which had somehow got entangled with his leg. I suppose the string was in the water when it got twisted round his leg and he flew too near a tree and was hung up!

> " If you are not a good sailor stuff cotton-wool into your ears before you get to the Bay of Biscay!"
>
> *TO MARGARET – JANUARY 1923*

" How would you like to go out yachting on the ice? They say the pace is tremendous – and the wind terrific, so the passengers lie low and only the coxwain looks ahead."

TO TEDDY -- DECEMBER 1922

As the end of January approached Teddy grew increasingly excited at the prospect of seeing his family once again. They were shortly to embark on the S.S. *Mantua* at Bombay and take the same long journey that Teddy had made the previous year. One prospect the boy did not relish, however – having to go back to St Michael's College, which he now detested. Writing to Teddy the day after his return to school, Kaka tried to be cheering:

I hope you will have a very successful term and get on famously and please Daddy. I miss you very much and am looking forward to hearing of you from Daddy when he goes to see you. I will send you news about them all and about Uncle Cud after I have seen them. What fun we had these holidays! And now we shall all be together for the Easter holidays! I expect the girls will be very excited about the journey home and seeing you again. Send me a line now and then when you have time. Much love, dear old Ted – and keep smiling and pegging away. Much love from Kaka.

" Teddy & I are so excited to hear you will all be home so soon"

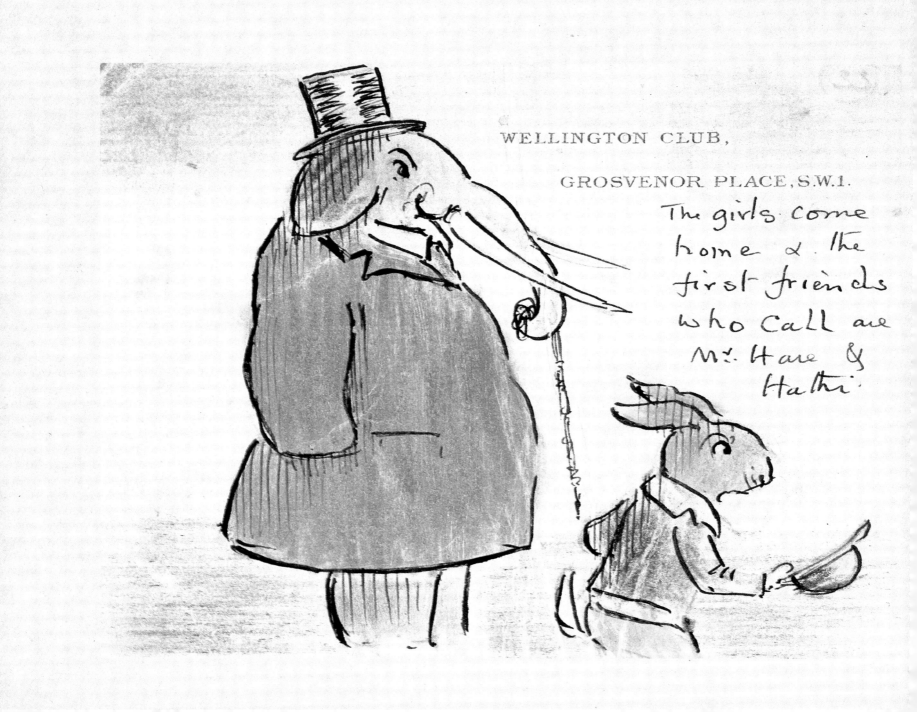

WELLINGTON CLUB,

GROSVENOR PLACE, S.W.1.

The girls come home & the first friends who call are Mr. Hare & Hathi.

POSTSCRIPT

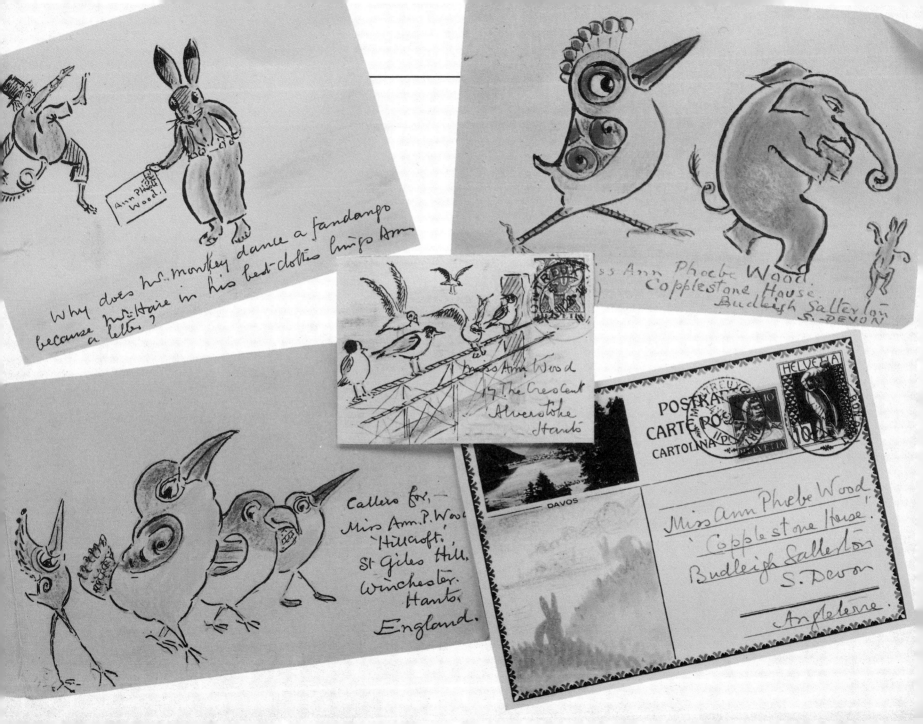

Why does Mr. monkey dance a fandango
because Mr. Hare in his bed-clothes lingo Ann
a letter?

Miss Ann Phoebe Wood.
Copplestone House.
Budleigh Salterton
S. DEVON

Miss Ann Wood
17 The Crescent
Alverstoke
Hants

Callers for,—
Miss Ann. P. Wood
'Hillcroft,'
St Giles Hill
Winchester.
Hants.
England.

DAVOS

POSTKARTE
CARTE POS
CARTOLINA

HELVETIA

Miss Ann Phebe Wood,
'Copplestone House,'
Budleigh Salterton
S. Devon

Angleterre.

Few of Kaka's letters written after 1923 have survived. Perhaps now that the Wood family were reunited and based in England he simply wrote less often. That from time to time he continued to write to all four children, however, is certain. Teddy admits that at Haileybury, where he went to school in 1926, he was embarrassed to receive Kaka's illustrated envelopes for fear of being mocked by the other boys.

In fact, the Woods did not stay long in England. Arthur read for the Bar in six months but, without independent means, he found practising as a barrister difficult. For a year he served as secretary to the Navy League and was able, with Kaka's assistance, to buy a house for the family in Weybridge. In 1925, however, he returned to his old job in India, becoming eventually auditor of the Jodhpur Railway. He finally managed to practise law in Madras, where the family moved in the early 1930s after inheriting a tea estate in the Nilgiri hills. Arthur died in 1958.

As the girls grew older, they too went to boarding schools in England, experiencing the periodic separations and reunions, the round of relatives and guardians, that was the common lot of 'colonial' children of their generation. Madge Wood came home when she could, usually for the summer holidays, but Aunts Tal (until her death in 1929), Georgie and Mary invariably filled the gaps. These separations from their parents, especially those spent at Broadparks, were not always unwelcome to the children, for the Woods appear to have practised Victorian standards of discipline. Teddy remembers being confined to the nursery for meals until he was fourteen, and he was only allowed in the drawing-room on Sundays.

In 1925, at the age of seventy-one, Kaka married a woman called May Jobson. For the first time in seven years he moved out of his 'bachelor' quarters in the Wellington Club. As it turned out, May proved unpopular with the family. 'We all felt she just wanted to be Lady Thornhill who ran white elephant stalls for charity' is how Teddy puts it. This slight rift acquired a physical reality in 1928 when, for the sake of Kaka's rheumatism, the Thornhills moved to Montreux in Switzerland.

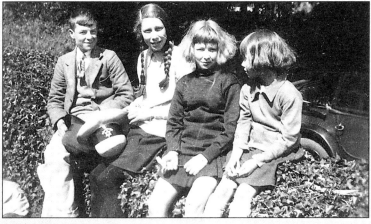

TEDDY, MARGARET, ELIZABETH AND ANN

" By the way, tulip comes from 'tulipan'. The Persians – quaint turbaned fellows – thought the flower looked like a turban. A turban!! Me thinks a turban is the last thing a tulip resembles."

TO ANN – MAY 1929

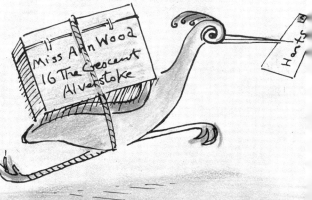

Miss Ann Phœbe Wood

17 The Crescent.

Alverstoke.

"go away! You rude Batrachian you! or I'll send for Mr. Stork!"

Miss Ann Phœbe Wood.
"The Holt".
Angleterre. Nr. CAMBERLEY
 SURREY

...Here is Mr. Rat who in a dream thought he had a lovely peacock's tail and was ever oo disappointed when he woke up and found his own old caudal appendage (don't that a funny thing to call a tail!!!!) It comes from the Latin (like so many of our words) — 'cauda' = a tail. 'Rat' is an old anglo-saxon word for this mischievous little rodent (which word also means a gnawer) also from the Latin. Baba! So gay! Bus! ji Bus! Enough Sir enough! the girl gone to sleep...

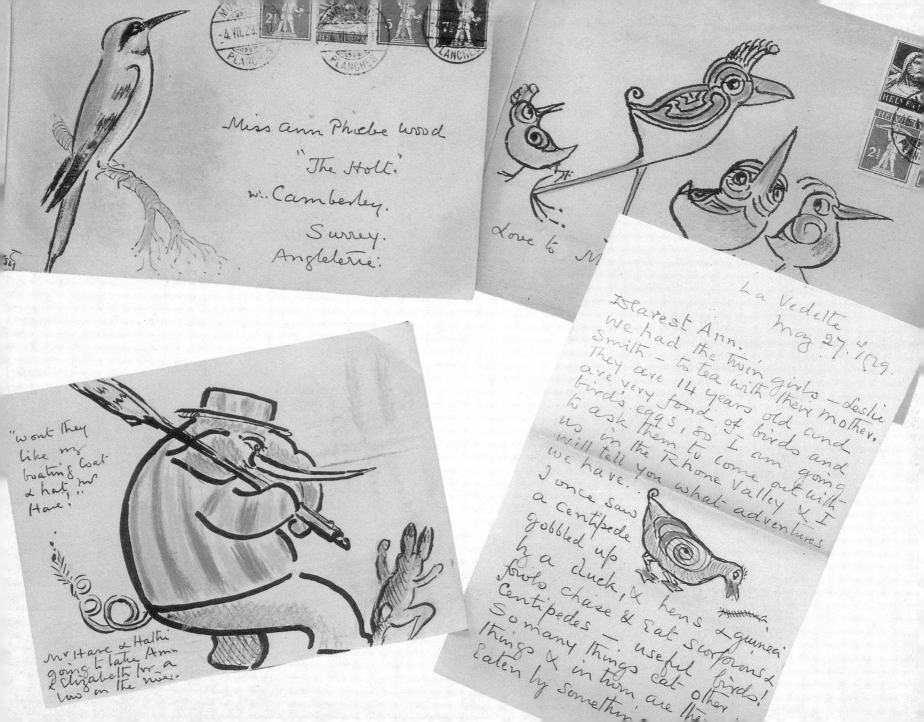

Miss Ann Phoebe Wood
"The Holt."
w. Camberley.
Surrey.
Angleterre.

Love to M...

"wont they
like my
boating coat
& hat," said
Hare.

Mr Hare & Hathi
going to take Ann
& Elizabeth for a
row on the river.

La Vedette
May 27. 1929.

Dearest Ann.
We had the twin girls — Leslie
Smith — to tea with their mother.
They are 14 years old and
are very fond of birds and
birds. eggs, so I am going
to ask them to come out with
us in the Rhone Valley & I
will tell you what adventures
we have.
I once saw
a centipede
gobbled up
by a duck, & hens & guinea
fowls chase & eat scorpions &
centipedes — useful birds!
So many things eat other
things & in turn are the...
eaten by somethin...

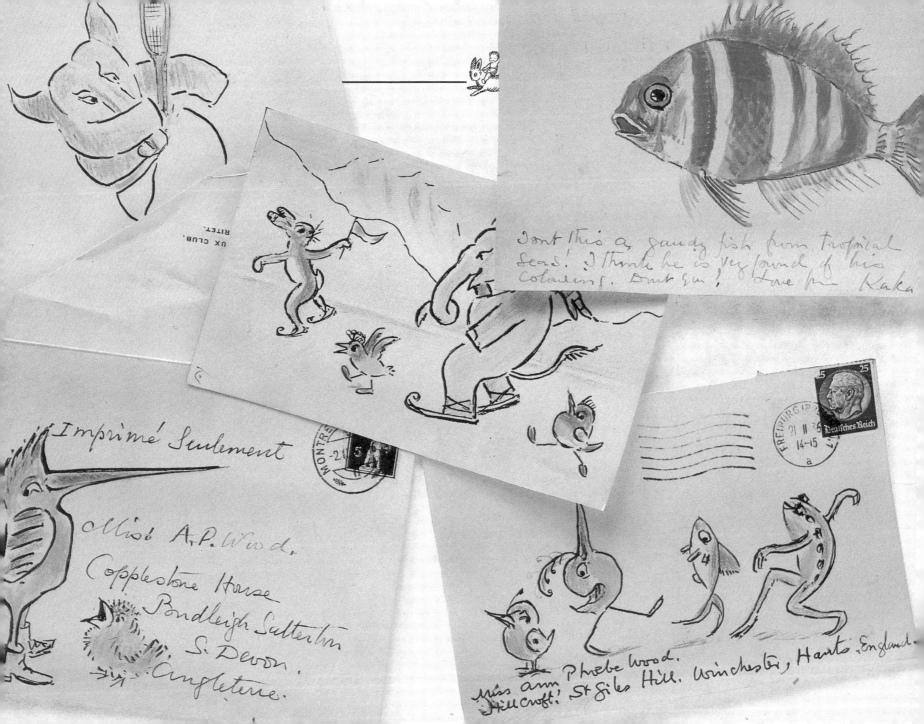

Isnt this a gaudy fish from tropical
seas! I think he is very proud of his
colouring. Dont 'em! Love from Kaka

Imprimé Seulement

Miss A.P. Wood.
Copplestone House
Budleigh Salterton.
S. Devon.
Angleterre.

Miss Ann Phebe Wood.
Hillcroft. St Giles Hill. Winchester, Hants. England.

Deutsches Reich

UX CLUB,
RITET.

> "Here's a calamity! I stick my etching pens into a potato and now the tuber has become so hard and dry I cannot get my poor pen out!"
>
> *TO ANN – MAY 1929*

KAKA IN SWITZERLAND (Second left)

Sad as this fresh separation from his grandchildren must have been for Kaka, it inspired a renewed burst of letter-writing that continued well into the late 1930s. Almost all the letters (strictly speaking, there are more postcards and illustrated envelopes than letters) that have survived from this period are addressed to the youngest child, Ann. The flavour is familiar, with Hathi and Mr Hare as robust as ever and natural phenomena continuing to evoke an enthusiastic response from Kaka. To his delight he discovers a golden oriole's nest in the locality of Montreux, befriends a sparrow whom he nicknames Philip, speculates on the origin of the word 'tulip', and marvels at the size of raindrops. Only in the style of Kaka's drawings has a change taken place. In his pictures of birds in particular he has forsaken accuracy for character, imparting a humorous, fantastic quality to each creature.

"The Cockiolibolli bird"

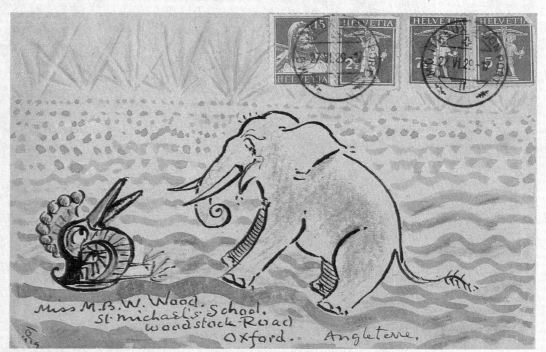

Miss M.B.W. Wood. St. michael's School. Woodstock Road Oxford. Angleterre.

The fact that so many of Kaka's letters have survived shows how fondly each of the four children cherished his memory. But, sadly, in his last years he saw little of them. Madge Wood became estranged from her father and did not encourage contact. Only Teddy, always Kaka's favourite, tried to keep in touch with his grandfather. While a Cambridge undergraduate he stayed with Kaka in Montreux for Christmas 1933, just before joining the Colonial Service and going overseas.

A final reunion between the two of them took place in Switzerland in 1938. Kaka was now very old and the prospects for peace in Europe appeared gloomy. After that visit Teddy wrote a letter to Kaka in which he called him 'the best friend I ever had'. He expressed his thanks for all the love and kindness he had shown him throughout his life, adding: 'If we do not meet again in this world, Kaka dear, we will meet someday in the happy hunting grounds.' 'The happy hunting grounds' was a favourite Kaka expression. War in 1939 made further contact impossible. Kaka died in 1942, aged eighty-eight.

Christmas Greetings
and Best Wishes for a Happy
New Year

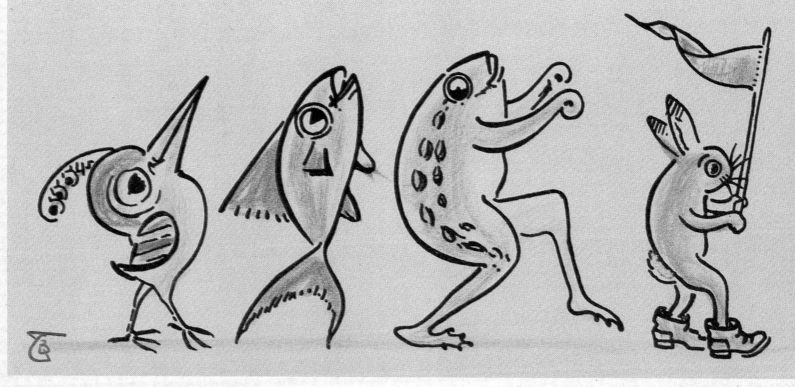

GLOSSARY

Most references in Kaka's cards and letters – to contemporary people, places and events – are elucidated in the accompanying text. Those that are not, in particular Indian or Anglo-Indian words and expressions, are explained in the following glossary.

MAHSIR

LANGUR MONKEY

CHAPTER ONE

chakor (or **chukor**)	red-legged partridge found in the western Himalayas and the Punjab.
ayah	native nursemaid.
mahsir (or **mahasir**)	large fish about the size of a big salmon common to the rivers of northern India.
fandango	old Spanish dance for two.
baba	baby, small child.
The Den	name of the Woods' house when they lived for a time in Shortlands, Kent.
Gamages	big department store, rather like a modestly-priced Harrods, situated in Holborn. It boasted it had everything, which was almost true. Its pets section was a particular attraction, displaying a veritable menagerie of animals.

CHAPTER TWO

tippari (or **tipari**)	gooseberry-like fruit which makes excellent jam.
'Blue Birds'	Anglo-Indian counterpart of the Brownies. Despite the name, the girls in fact wore brown uniforms.
Himalayan blue jay	also called the 'roller' because of the dives, tumbles and somersaults it performs during courtship or when attacking enemies such as the hawk.
salaam	term of salutation.
Domine Sampson	lugubrious character in Sir Walter Scott's novel *Guy Mannering*.
langur monkey	very common in India, where it is venerated because of its association with the monkey-god Hanuman.

JACKAL

OONT

General Money	Major-General Sir Arthur Money, K.C.B., K.B.E.: a fellow member of the Wellington Club whose father, like Kaka's, had served in the Bengal Civil Service.
jackals	the curious howl made by jackals is a common night sound in India. British children under the Raj were taught that the jackals were crying, 'I smell the blood of a dead Hindu! Where? Where? Here! Here! Here!'
jampanees	the popular Anglo-Indian term for rickshaw pullers, though the **jampan** was actually the rickshaw's predecessor, a curtained sedan chair strung on poles and carried by four bearers. It was not a very popular mode of conveyance, being likened by some to an 'upright coffin'.
breakdown	a noisy, vigorous Negro dance popular with jazz-step enthusiasts.
mugger (or **muggur**)	crocodile.
oont	camel.
hamesh	always.
Kutab	deserted tower of red sandstone and marble still standing outside Delhi. A mosque at its foot, the first to be erected in India, houses a seven-metre-high pillar of pure rustless iron.
submarine K5	a mysterious accident, probably an explosion on board, occurred on 20 January 1921 while the Royal Navy's 3000-ton vessel was submerged off the Scilly Isles. All six officers and fifty-one men perished.
monsoon	the heavy rains that sweep across the Indian sub-continent from south-east to north-west during the months of June and July.
chaprassi	government messenger.
'Ye Lorde Readinge'	Lord Reading, Viceroy of India 1921–6.

CHAPTER THREE

HOOPOE

hoopoe	despite its splendid appearance, the hoopoe has some nasty habits. Unlike most other birds, it does not remove the faeces of its young from the nest. Nestling hoopoes will squirt their faeces at intruders as a means of defence.
'Dekko Kaka! Kaisa tamasha!'	'Look Kaka! What a spectacle!'
Auntie Q	Aunt 'Queenie', one of Great-Aunt Georgie's daughters.
khabadar!	look out!
tarpon	giant fish related to the herring, caught off the Florida coast and in the Gulf of Mexico.
bulbulla	Indian song-thrush, related to the Persian nightingale (from Persian **bulbul**).
Mrs Man(n)	the Manns were close friends of Kaka living in Brighton.
Muchchli Ji (or **Mughli Ji**)	Mr Fish.

POSTSCRIPT

BATRACHIAN

tulipan	Old French for tulip. The Turkish (not Persian) derivation is **tulbend**, meaning a turban. The old Ottoman turban *did* look rather like a tulip.
batrachian	frog.

ACKNOWLEDGEMENTS

Thanks are due to Sir Henry Thornhill's present-day
relatives and descendants for their support and
encouragement. We are especially grateful to Ted
and Esme Westmorland Wood, whose enthusiasm,
advice, and generosity in lending letters,
photographs, and other memorabilia was invaluable.

The book's high standard of design and production
represents a labour of love by many people.
Andy Clements, Chris Coles, Stuart Dickinson,
Nick Hockley, Nick Kaminsky, Howard Shaw,
Alan Stratford and David Wayman deserve
particular mention.

Finally, we would like to thank the following for
their permission to use certain photographs:

P.&O. (*S.S. Caledonia*, p.103).

The India Office Library (*The Mall at Simla*, p.59 and
Jampanees at Simla, p.65).